Elizabeth Wilson is the author of *Adorned in Dreams: Fashion and Modernity* and *Bohemians: The Glamorous Outcasts* (both I.B.Tauris), as well as *Hallucinations* and *The Sphinx in the City*. She has also published a series of crime novels, *The Twilight Hour, War Damage* and *The Girl in Berlin*. She is currently Visiting Professor of Cultural Studies, London College of Fashion, University of the Arts, London, and she lives in London.

ELIZABETH WILSON

CULTURAL PASSIONS

FANS, AESTHETES AND TAROT READERS

I.B. TAURIS

LONDON · NEW YORK

Published in 2013 by I.B.Tauris & Co Ltd
6 Salem Road, London W2 4BU
175 Fifth Avenue, New York NY 10010
www.ibtauris.com

Distributed in the United States and Canada Exclusively by Palgrave Macmillan
175 Fifth Avenue, New York NY 10010

ISBN 978 1 78076 285 2 (HB)
 978 1 78076 286 9 (PB)

A full CIP record for this book is available from the British Library
A full CIP record is available from the Library of Congress

Library of Congress Catalog Card Number: available

Typeset by 4word Ltd, Bristol
Printed and bound in Great Britain by T.J. International, Padstow, Cornwall

*At the root of this sacred rite we recognise unmistakably the
imperishable need of man to live in beauty. There is no satisfying
this need save in play.*

JOHAN HUIZINGA: HOMO LUDENS

*Criticism ... should confine itself to scholarly incursions upon the very
realm supposedly barred to it, and which, separate from the work,
is a realm where the author's personality, victimised by the petty
events of daily life, expresses itself quite freely.*

ANDRÉ BRETON: NADJA

Contents

Part Four: Magic Moments

Illustrations

(Images are author's own unless otherwise stated)

PART ONE

Cultural Diseases

1 Introduction

The Roman theatre in Orange with its towering back wall of ochre stone, the only one to survive in Europe, was once an entertainment centre for the flourishing colonial colonies of southern France. I sat on the top row, where the rabble used to sit, and listened as the disembodied voice from the audio guide told me that at first the Romans had followed the Greeks and Etruscans, performing serious drama, but later they grew tired of tragedies, preferring jugglers, clowns and gymnasts. Later still, the shows were devoted entirely to pornographic displays, until the early Christians came along, smashed up the theatres and banned all secular entertainment. Distant in time though these events might be, they seemed tellingly to prefigure a possible future for contemporary culture. As pornography floods the internet and celebrity culture swamps the global media, perhaps it is only a matter of time before Evangelicals or Islamists bring a decaying Western culture crashing to the end it deserves.

Late Roman culture was in fact by no means entirely given over to trash any more than is our own. After the Romans, with their mosaic flooring, central heating and vineyards, left Britain, the island took 500 years to recover. Today, innovative culture and learning flourish in all sorts of places. Religious fundamentalists have certainly denounced contemporary Western consumer societies as decadent. However, a society is not a single organic entity like a vegetable marrow, but is a complex conglomeration of multiple systems and formations. Some may be flourishing, others in decay. Sometimes new forms grow from the dead, just as the florid vitality of a cemetery's ivies and flowers draws nourishment from human

remains. Contemporary culture is diverse and contradictory, yet even if the Western world avoids being plunged into a new dark ages in the near future, a sense of anxiety and melancholy pervades cultural comment. Pundits and politicians alike view the society of consumption with ambivalence.

Consumption was a vernacular nineteenth-century term for tuberculosis, then an incurable wasting disease. It would be tempting to suggest that we do in that sense live in a society suffering from consumption. The individual suffering from consumption experienced periods of exaltation and sometimes creativity. John Keats and Emily Brontë owed the intensity of their writing in part to their fatal illness.

By the time they were writing, markets were already developing for the commercial provision of the arts and 'entertainment industries'. This produced a division between what came to be seen as 'high' art and 'mass' culture. That division continues to set the terms of cultural debate.

In the following chapters, I focus on the emotional commitment audiences and users bring to the objects of their desire and to the performances in which they find meaning. By focusing on this, I hope to transcend the division between 'high' and 'low'. In practice,

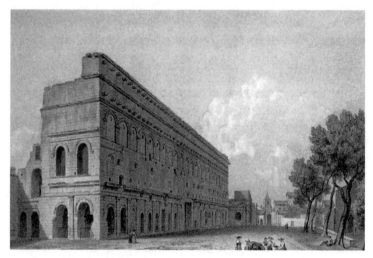

Figure 1: The Roman theatre at Orange in the eighteenth century.

Figure 2: Today the Roman theatre is once again the arena for opera and other spectacles.

the tastes of many, perhaps the majority of individuals, do cross this boundary, yet the division between 'high' and 'low' culture continues to set the terms of debate.

This divide has always been moral and political as well as aesthetic. Two well-established positions set the parameters. On

5

one side stand those who bewail the 'dumbing down' of culture. This was the position taken by Frank Furedi in his *Where Have All the Intellectuals Gone?*, published in 2004. Furedi argued that the role of the intellectual and respect for the figure of the intellectual have been undermined as education has been transformed from a search for truth to a managerial training. Students are to be inducted into a role in which they will not question the utilitarian status quo – the idea, for example, that the chief goal of society is economic expansion. Furedi further argued that contemporary society is characterised by a deep philistinism – a philistine being an individual 'devoid of liberal culture and whose interests are material and commonplace'. He illustrated this philistinism with the words of former British education minister, Charles Clarke, who expressed the opinion that the teaching of history and indeed any sort of 'education for education's sake' was 'a bit dodgy'. Furthermore, suggested Furedi, 'democracy' in the allegedly democratic societies is little more than a façade masking deep social inequalities. This façade is partly created precisely by the philistine and supposedly 'anti-elitist' suspicion of the pursuit of learning, and includes a preference for mass culture over high art. Traditional 'high art' is also, after all, 'a bit dodgy'.[1]

Contempt for learning as an end in itself is one aspect of a rhetoric that claims to speak for the majority, presenting this as democratic, when it is in fact merely populist. The populist is an important ally of the philistine, aiming to speak for and include 'ordinary people', to cater to and share the tastes of the mass public and to respect the authenticity of the ordinary. There would be nothing wrong with that – on the contrary – were it not that it slides into the rejection of anything that is assumed to be above the heads of 'ordinary people': the patronising assumption that they are too thick to enjoy anything complicated. A love of classical art is cynically denounced as snobbery. Minority tastes for complex works are viewed with suspicion as pretentious and 'highfalutin'.

Such a position can masquerade as progressive in speaking for the majority. Yet surprisingly often it is related to a second 'progressive' view that deems cultural works acceptable only when they produce the right attitude of mind in their audiences. For example, in March 2004 another former education minister (and,

like Clarke, a member of the Labour Party), Estelle Morris, was invited, when she became Minister for the Arts, to guest edit the cultural section of the left of centre magazine *The New Statesman*. As minister, Morris understandably focused on issues surrounding state provision. Predictably too, the articles she commissioned privileged 'inclusion': a review of a play performed by children with learning difficulties; an assessment of changing attitudes towards black and minority performers; a debate about the value of the Arts Council. She needed, she thought, to 'cover everything: each of the art forms, nothing too London based, a balance of men and women, and a proper acknowledgement of the diversity of the arts sector'. All perfectly acceptable, if rather bland, and speaking for all sections of society – and displaying the right social attitudes. The minister's choices illustrated not that 'political correctness' is wrong in promoting neglected sections of society, but in censoring out anything deemed too unacceptable, effectively too radical.

But as Hans Arp, the Swiss Dadaist sculptor, once said: 'Art just *is*.' It cannot automatically be recruited to a progressive – or for that matter a conservative – agenda. The Estelle Morris agenda is not culture; it is social engineering. Also, as Furedi suggested, the well-meaning intentions of the Estelle Morrises of this world succeed only in being very patronising. As an Afro-Caribbean student once expressed it after a lecture on modernism: 'why have we been excluded from all this?'

The populist critic takes for granted that the 'ordinary people' can never warm to works that he (himself almost certainly the product of advanced higher education and with a doctoral degree) has designated as 'elitist'. But if whole sections of the population have never been to an art gallery or listened to Beethoven this is at least partly because the educational system and commercial pressures act to keep them away. A crippling sense of 'it's not for the likes of us' is reinforced by a narrow idea of 'relevance': the belief that what is designated as high culture can never mean anything to working class or ethnic minority students.

Frank Furedi was equally critical of a relativism that rejects any cultural hierarchy – the idea that some cultural works could be better than others. Yet the origins of cultural relativism were in themselves intended as progressive or potentially progressive.

7

Until the 1950s a strong boundary between 'high' art and popular culture was maintained, along with an assumption that 'great art' was to be the more valued. F. R. Leavis, for example, was a leading advocate, both before and after the Second World War, of culture, specifically literature, as a realm in which there were absolute standards of excellence, and which expressed absolute moral values. In the 1930s he warned of the dangers arising from the massification and commercial exploitation of culture and in his critical works on English literature he defended many of them as great moral texts. Above all, great art taught universal values. It had to have a universal character. The plays of Aeschylus (or indeed of Seneca) were as relevant today as they had been when written.

The 1960s saw the rise of cultural studies in universities. This pioneered the analysis – not necessarily the uncritical endorsement – of popular forms. Going beyond television and film to include the study of 'subcultures' such as teddy boys and later punk, the new cultural research sought to explain their appeal and investigate their social meanings. This project not only discovered new objects of research but also had different goals, being more interested in the effects on audiences of mass culture and what new forms said about the society in which they appeared than in the quality of paint or the humanistic moral message of a given work. This was a step away from the detachment that had long been considered the proper stance when confronting a work of art. The new generation of cultural researchers were interested in how the audience *felt*.

This emphasised the subjective element in the reception of culture and it followed from this that the new researchers effectively broke with universalism. Frank Furedi defended the idea of universal truth and criticised the way in which this was abandoned in favour of relativism – the idea that there is no 'truth' but only a plurality of 'truth claims', all or none of which may or may not be valid (but which even if they are not may somehow still be emotionally valid). The development of relativist views – one aspect of what came to be loosely termed postmodernism – by influential writers, perhaps most of all Michel Foucault, was essentially an attack on the whole Enlightenment project, the belief in reason and progress, and in particular on its Marxist variant. In view of the history of the twentieth century such disillusionment is understandable, but to

abandon all effort to find common ground and a common cause, and to reject also the idea that any one assertion can be truer than any other, is in the end to endorse a Hobbesian view of human life as the war of all against all, and to reproduce at the level of thought and cultural production the competitive anarchy of capitalism.

In the 1970s the 'new art history', following in the footsteps of cultural studies, 'prioritised social and political contexts over older concerns of authorship and appreciation or connoisseurial value'.[2] In literature too, claims about 'objective' standards of beauty and perfection of technique were supplanted by the view that such objectivity was false, and served largely to prioritise the work of an elite over that produced by women, 'minorities' and working-class writers.

One variant of the new approach was to claim that there can be no hierarchy of art forms, that – to use a clichéd example – Beethoven cannot be judged better than The Beatles, but simply different. Yet it is quite possible to recognise the differences and the merits of both while at the same time arguing that Beethoven really is 'better' than The Beatles, because, for example, his music addresses a wider and deeper range of thought and emotion than the Fab Four; or, on the other hand, to criticise The Beatles' sometimes fey whimsy, but also the clunking facetiousness of Beethoven at times.

In any case, Beethoven is today one of the most popular of all composers, while the fictions of many writers who belong to the 'canon' of the classics, such as Jane Austen and Charles Dickens, have proved to resonate with contemporary readers, encouraged by television and film adaptations to return to the books themselves. The narratives remain fast and compelling and their meaning, if not universal, at least transcends a century or two.

It would not be difficult to develop an argument suggesting that *Pride and Prejudice* is better than *Harry Potter*, but this would be to move outside the parameters of what is polite to say. The 'soft' policing of cultural taste means that understandably no one wants to appear a snob. By contrast, it is fine to say that you watch *The X Factor* because it is so camp. Cultural positioning of this sort has nothing to do with criticism, but is a function of social fashion; which may also have been the reason for Charles Clarke's remark about history.

The serious study of popular culture took on a systematic form when in 1964 Richard Hoggart set up the Centre for Contemporary Cultural Studies at Birmingham University. This was an attempt to widen the parameters of cultural debate – and to challenge not only the divide between 'high' and 'low' culture, but also that between the active producer and passive consumer set up by the cultural theorists Theodor Adorno and Max Horkheimer, discussed later. Yet by the 1980s the enterprise had too often degenerated into an uncritical endorsement, by at least some cultural researchers, of almost any popular form and an automatic self-distancing by tastemakers and social elites from anything approaching 'elitist' culture. 'Elitist' and 'elitism' have become simply terms of abuse, a label for those who are said to consider themselves superior to other people and who sneer at the low tastes of others, but who have no rightful claim to their positions of cultural power. This seems to be due to a confusion of two meanings of the word: 'elite' in the sense of individuals or groups who excel in some field – for example, a great musician or scientist, each of whom could be said to belong to an elite of the brightest and best in that field; and 'elite' simply in the socio-economic sense of belonging to a group in society who are privileged not on account of talent and hard work, but merely by reason of inheritance, whether of wealth or lineage.

In any case, the term elitism came originally from the idea of election. The elite consisted of persons who had been chosen, which implies a democratic process. Surely there is nothing wrong – on the contrary – in acknowledging the outstanding achievements of certain individuals; of allowing, for example, that Pavarotti was a great singer who *sang better* than most other singers. Yet today, to endorse 'elitism' is allegedly to be undemocratic. It is also old fashioned and uncool, to the extent that politicians, those weather vanes of the fashionable, might be more likely to cite *Harry Potter* than Trollope or (heaven forbid) Proust as their holiday reading. One can only feel satirical about these pretentions, when at the same time many cabinet ministers attended private schools and when it is virtually impossible to succeed in the media industries without an Oxbridge degree.

No one seems to have noticed that the celebrity culture to which craven obeisance is paid is also, of course, entirely elitist.

It bears no relation even to a meritocracy, since individuals are shot to fame and notoriety often for no other reason than their novelty or, at best, on the basis of a charismatic personality or that most undemocratic of attributes: beauty, or striking looks. And if television programmes or sports with high ratings and huge followings crowd out the less popular, then this too is considered democratic, when it may be rather the tyranny of the majority.

So to object to the use of 'elitism' as a form of condemnation is not a simple reversion to the position that high culture is better than mass culture. The objection is to the bad faith and disavowal with which it is used and its lazy failure to admit that some artistic works are better than others, or at least that it is legitimate to make a case for discrimination.

Some postmodern relativists are, or were, not content simply to claim that all cultural forms are different and cannot be compared. One popular way of expressing this is to claim that if Shakespeare were alive today he would be writing soap operas. There is merit in this claim to the extent that Shakespeare wrote for a popular audience and for profit in his day and might well have embraced the many virtues of the soap opera format. On the other hand it seems unlikely that future generations will be reading the scripts of *East-Enders* in 500 years time. As literature they simply do not stand up.

Nevertheless, there were postmodern fundamentalists who promoted a populist view of all high culture as inherently oppressive. Theodor Adorno and Max Horkheimer, authors of a scathing attack on American mass culture in the 1940s, were the enemy. In *The Dialectic of Enlightenment* they had denounced mass culture as a form of brainwashing. It pacified the masses and induced a false consciousness that prevented the proletariat from engaging in revolutionary struggle. Their postmodern critics judged the argument as illegitimate since it was, they maintained, uttered from a position of high-minded, patrician contempt.

An individual's (or a group's) tastes are certainly influenced by class position, upbringing and education. Yet to argue, as John Fiske did, that 'taste is social control and class interest masquerading as a naturally finer sensibility' positions an elite in permanent control of high culture and everyone else – the 'masses'? – the working class? – as incapable of appreciating what is labelled as high culture. This is

also a political project: the idea that *any* meaningful aesthetic judgements are possible must be destroyed in order to destroy the hierarchy of value implied in the judgement of art. This is considered necessary because it is cynically assumed that to judge a cultural work is also to judge – morally – those who like it. If you read Proust you are a snob; if you watch *EastEnders* you are a man (or more likely, woman) of the people.

These are themselves, of course, moral judgements. To take up such positions fails to acknowledge that individuals may appreciate both. It also ignores how it is neither a cultural elite nor a mass audience that controls taste, but to a large extent commercial interests.

It may be that Fiske himself has moved on from the rather ludicrous positions he took up at the end of the 1980s. Such judgements, however, filtered down into the broadsheet press and journalism, to the extent that in 2011, for example, the British *Observer* devotes most of its arts section to popular music and celebrities.

To position 'low' against 'high' as crudely as Fiske did assumes that not only audiences but art forms themselves can never migrate from one category to another. Yet cultural works are no more static than taste itself. In pre-unification Italy, for example, opera was a popular form, expressing in works such as Verdi's *Nabucco* revolutionary nationalist aspirations. In Brussels, in 1830, a performance of Daniel Auber's *La Muette de Portici*, the plot of which concerned an uprising against the Spanish, inflamed the audience to such an extent that they rioted, hanged the Spanish representative from the nearest lamp post and set in train the revolt of this part of the Netherlands against Spain, leading to the formation of modern Belgium.

The contemporary view of opera as 'elitist' (perhaps particularly in Britain) has more to do with the expense and difficulty of obtaining seats, and its association with corporate hospitality and wealth in general, than with the opera form itself. The content of the majority of operas is perfectly accessible and the reverse of 'elitist', since it combines catchy tunes with romantic and melodramatic plots; the Puccini aria 'Nessun Dorma' was even chosen as the theme tune for the 1990 football World Cup, held in Italy, the home of opera, and topped the charts as a result. More recently an experiment

by the Royal Opera House, Covent Garden, when tickets were offered at much reduced prices, resulted in a new, different and enthusiastic audience. Filmed performances of the New York Met's productions have also been very popular.

Another example of movement from 'low' to 'highbrow' is cinema in general and 'film noir' in particular. The French cinema journal, *Cahiers du Cinéma*, coined the label after the Second World War to refer to a series of mostly Hollywood films made during the 1940s, but shown in France only after 1945. Whether film noir constitutes a genre has been disputed. Typically, nevertheless, these films combined thriller plots, crime, femmes fatales and weak heroes in often melodramatic narratives. Many, though not all, had originally been made as low-budget B-movies and were ignored by critics. In the 1980s these movies were revived on late night television and this may have been what aroused the interest of students and critics, their attention drawn to these forgotten works. A whole academic literature on film noir developed and films such as *Double Indemnity*, *Cat People* and *The Big Sleep* were subjected to advanced critical analysis. Their moody, downbeat and often misogynistic tales could be interpreted as expressive of a post-war mood of cultural pessimism and reaction, while the edgy glamour of their off-beat photography, unusual looking stars (Joan Crawford, Robert Mitchum), strange camera angles and use of mirrors and shadows became a widely recognised style. To watch film noir now became a matter of connoisseurship rather than escapism. Film noir became highbrow, became high art rather than low culture.

Equally dramatic was the move in the opposite direction of impressionist and post-impressionist painting. Greeted with horror when first viewed in the Paris salon, by the mid-twentieth century the paintings of Monet and his peers had become a staple of popular taste, reproductions found not only on sitting-room walls, but on biscuit boxes, birthday cards, tea towels, jigsaw puzzles and calendars.

The postmodern populists, however, at least in the heyday of postmodernism, refused to recognise the changing status of art forms. Fiske argued that 'the popular ... can be characterised by its fluidity', as if what is traditionally labelled as 'high art' were incapable

of 'fluidity' – whatever that means. With similar inflexibility, other critics asserted that 'rigid hierarchical divisions' are 'embodied in traditional elite culture'.

The rigid separation of 'high' and 'low' culture assumes that not only cultural forms, but also audiences themselves, are permanently cordoned off into clear and unchanging categories, thus preserving the class system Fiske presumably dislikes. Fiske recognised that an individual 'may at different times form [different] cultural allegiances', yet the 'people', the 'subordinate', remain forever separated from the 'elite' by the latter's insistence on the disciplinary system of aesthetics, which illegitimately tries to establish standards of excellence: 'Aesthetics is naked cultural hegemony'. If this is the case, then logically no one can ever even write a film review – much less a book, as Fiske himself did – without claiming 'hegemony' over his readers. [3]

Fiske was also a subjectivist who claimed that the cultural value of a given work lies exclusively in the meaning it has for a particular person's life at a particular moment. While it is true that every work of art has meaning for the individual who responds to it and that each individual varies in their ability to respond to this or that artwork, Fiske appeared to deny the possibility of any collective aesthetic experience. He also failed to acknowledge that there is a value in understanding cultural artefacts beyond our own subjectivity. Yet cultural artefacts and spectacles are, after all, our history and the history of others.

In a sense technology encourages a solipsistic subjectivism, the individual's iPod playlist expressing his or her taste and no one else's. Indeed, iPod owners talk not about 'music', but about 'my music': the playlist they have constructed. Your tastes express your personality, rather than even joining you to a taste community – although such communities exist and continue to flourish.

Ironically, beneath the claims Fiske made for pluralism and choice (i.e. democracy) lurked – and still lurks – a more sinister agenda. For him, as for Estelle Morris, the determining criterion for art is 'social relevance' rather than aesthetic quality; 'the evaluative work of popular criticism becomes social or political, not textual', says Fiske. He seems oblivious to the way in which this could lead straight to Stalinist 'socialist realism', which I suspect he would not favour.

And who decides what is 'relevant'? Is it John Fiske? The government? It certainly is not, except in the restricted sense of purchase, the 'ordinary people', since the consumer can only buy what has been offered by those who run the 'creative industries'.

Arguments against 'high culture' were in part a move to legitimate the academic disciplines of cultural studies and media studies as the study of mass culture, and as such constituted at times rather blatant political special pleading. This was understandable, given the hostility to these new disciplines from those who labelled them as 'dumbing down'. The populist defence was nevertheless often guilty of crude overstatement. Even more seriously, the arguments as often as not simply inverted categories of 'high' and 'low' rather than seeking to move beyond them.

Fiske was writing when postmodernism was at the height of its popularity and today postmodernism has waned. Academics grew bored with the dead end to which it led them and simply forgot about it. Its formulations have nevertheless become sedimented into a default cultural posture: Elitophobia. As Furedi partly defined it: 'the denunciation of "Western rationality" or "male logic" assumes that ... the path to truth is above all through subjective experience rather than theorising or contemplating'.[4]

The importance of Furedi's arguments notwithstanding, it would be a mistake to present an uncritical picture of the whole Enlightenment project, or mount a seamless defence of universalism. Pope Benedict, spoke as fervently as Furedi for universalism and has on several occasions preached against relativism. Yet his universal truths – or rather beliefs – directly conflict, one assumes, with Furedi's. Of course, many individuals adhere fervently to the truth of beliefs that cannot be verified. That does not mean, however, that there exist *no* truths that *can* be verified. Nor does it mean that no aesthetic judgements can ever be made, for, after all, aesthetic judgements are made all the time in everyday conversation. A meal in a restaurant will invariably include a discussion of the merits or otherwise of the food; friends and bystanders comment continually on the fashion choices made by those around them.

The optimism of the eighteenth-century Enlightenment can appear complacent, to say the least, as for example when Edward

Gibbon wrote at the conclusion of his history of the decline and fall of Rome:

> *The experience of four thousand years should enlarge our hopes and diminish our apprehensions. We cannot determine to what height the human species may aspire in their advance towards perfection; but it may safely be presumed that no people ... will relapse into ... barbarism... We may therefore acquiesce in the pleasing conclusion that every age of the world has increased and still increases the real wealth, the happiness, the knowledge, and the virtue of the human race.*

But reason has not brought harmony to humankind and it can barely be imagined what Gibbon would have thought had he returned to this earth during the Nazi period, or indeed the present day. On the other hand, we cannot abandon reason altogether. We have to persist with the Freudian project of trying to bring reason to bear on the unruly and rapacious realm of the emotions.

There would be no need to revisit this debate, were it not that it continues. A 2011 example of the continued existence of the high art/low culture divide was a debate on the demise of the professional critic in the London *Observer*. There, Neal Gabler argued that passionate engagement has replaced the reasoned assessment of trained writers and that this amounts to the triumph of populism over an elite of pundits, as 'amateur' critics launch themselves across the web in blogs, Facebook, Twitter and a host of opinion sites of all kinds. John Naughton and Philip French disagreed and did attempt to move beyond the high/low division, arguing respectively that deference disappeared long ago and that the divide between elitist critics and 'ordinary people' is a false one; but Jessica Crispin of the website *Bookslut* set the enthusiasm of internet contributors against official critics, the real role of the latter, she suggested, being economic – to sell the product.[5] So while Naughton and French strove to move forward, they were still constrained by the very traditional parameters of the other contributors to the debate. It is still the 'people' versus the 'elitists'.

In the following chapters I discuss certain artefacts, practices and performers, some of which are both popular *and* despised, or at

least viewed ambivalently. This raises a further issue: of a general suspicion of beauty itself, of the aesthetic, which subtly relates to both 'high' and 'low' culture.

Suspicion of the aesthetic dimension of life has a long history. It has taken a specific form now that we live in a consumer society increasingly viewed with ambivalence and even alarm. So too populism may be added to the Puritanism that surreptitiously informs so much cultural and social criticism. The moral fervour that fuels the indignation of those both for and against high art/low culture seems often related to this suspicion of the aesthetic itself.

Devotees of high culture used to be known as 'aesthetes', but the aesthete was always a dubious figure, caricatured as an essentially frivolous character focused on the fripperies of life rather than on serious matters such as politics and making money, and concerned with decoration rather than with meaning. Even if not a dilettante, the aesthete represented the *aesthetic approach to life*, which was accused of lacking moral depth. Suspicion of the aesthete expressed the traditional separation of the material and the spiritual. Too great a preoccupation with the material world, even in the sense of works of art, was equated with materialism and hedonism.

A further criticism of the 'classic' aesthete was that he was essentially an individual who already *had* money, typically a *rentier*, but possibly an aristocrat and anyway a gentleman of leisure, whose wealth freed him to enjoy the refinements of art. He was aloof from the toiling poor, whose lives were consumed in labour, who were shut out from his rarefied existence, even as they worked to support his way of life and produce the beautiful objects he worshipped. This is certainly a valid point, since the enjoyment of cultural experiences has largely depended on the availability of both education and leisure. What care assistant, working a 60-hour week on the minimum wage, has time to loiter through Marcel Proust's immensely long novel, *In Search of Lost Time*? It is, of course, not Proust's fault if no one has time to read his novel. Often, however, resentment at the terms and conditions of a life of toil are directed at the wrong target: instead of blaming 'the system', cultural commentators (who, ironically, *do* have time to read) focus on those pretentious individuals who sneer at *Big Brother* and *The X Factor*. Moreover, as we shall see, Proust himself

17

was for long not taken seriously because he himself was viewed as a dilettante and aesthete.

Yet the advance of technology has saturated the environment with visual images and music and has made available a wider variety of the written word than ever before. Today, the urban, and to a large extent (and in a different way) the rural environment, are more highly aestheticised than it has ever been. In a sense, therefore, today we are all aesthetes whether we like it or not.

In addition, the cultural industries and new media permit the emergence of the fan as a more democratic kind of aesthete. And, although the aesthete has traditionally been pictured as a detached and rarefied creature, it is perfectly possible for him to be politically engaged – as Marcel Proust was in the stand he took on the great *fin de siècle* political scandal in France, the Dreyfus case. The fan, as I shall suggest later, is wholly committed to an emotional engagement with culture, but that does not mean that s/he is uncritical or apolitical.

The aesthete has come to be associated primarily with the Aesthetic Movement of the 1870s to 1890s in Britain and also in France, where the movement, significantly, was known as the *Décadence*. Fatally associated in Britain with Oscar Wilde, the denunciations of its opponents were essentially against its morals, not its taste.

The movement arose as a critique of and protest against what artists and connoisseurs felt was the ugliness of much of Victorian life: its social system and its culture. They objected to the way in which the wealth of the society they lived in was built on the exploitation of the poor, who were condemned to lead lives of bitter want in hideous and unhealthy surroundings. It was not even as if the consumer products of this wealth were beautiful or even sometimes useful; the aesthetes rejected Victorian bourgeois taste as much as their Gradgrind hard-heartedness and economic utilitarianism.[6]

The Grosvenor Galleries in London became a rallying point. Painting and poetry were at the forefront of the movement, Dante Gabriel Rossetti, for example, expressing its ideals both on his canvases and in his verse – but its social dimension meant that aesthetic values were particularly expressed in the domestic

interior and in dress. The beautiful aesthetic interior was lighter and simpler than the conventional Victorian drawing room, but it was not simply a question of decoration. The styles developed by the aesthetic movement exemplified an ideal of appropriateness and the relationship of form to function as well as the cult of beauty. The aesthetes did not merely swoon over the beauty of a flower or a vase; they desired that their ideals for an appropriate way of life be extended to all members of society.

Aesthetic clothing also played a central role: beautiful garments following the form of the body without the distortions and exaggerations of Victorian female fashion and made from materials in soft, 'indescribable' colours. Male followers of the movement equally rejected the utilitarian garments of their peers, opting for more picturesque styles and in particular breeches, which showed the form of the male leg.

All aspects of the aesthetic movement were savagely satirised. The Victorian poet Robert Buchanan penned an outright attack on what he called *The Fleshly School of Poetry* as early as 1872, but although his wrath focused on the poetry of Rossetti, he effectively denounced the whole of the aesthetic movement; and, slim as his volume is, it contains only a single idea: the aesthetic movement is pornography.

George du Maurier's cartoons in *Punch* and in the Gilbert and Sullivan operetta, *Patience*, first performed in 1881, weighed in. These satires expressed a real fear of the sexual radicalism that the aesthetic movement was also suspected of expressing. Rebecca Mitchell has shown how in *Punch* caricatures the aesthetic woman not only defied the conventional prettiness of the Victorian woman, but was also portrayed as hysterical and a bad mother who had, moreover, abandoned her role as 'angel in the house' – paradoxically, given that the aesthetes were so anxious to design and promote harmonious interiors. But *Punch* versions of the aesthetic woman show her as scrawny and almost diseased, with dangerous feminist and perhaps immoral intentions.[7]

Male aesthetes on the other hand were shown as effete. The hints of homosexuality came luridly into the light of day with the Oscar Wilde trials, aestheticism fatally tainted by the fear of the sexual deviant, the absolute opposite of the Victorian and Edwardian

muscular Christian. So aestheticism challenged established and conventional beliefs in the stability and above all the social and moral necessity of traditional gender roles.

Walter Pater's *The Renaissance*, published in 1873, is the clearest statement of radical aestheticism. The aesthetes' slogan of 'art for art's sake' had been interpreted as a demonstration of a lack of purpose and meaning in their work, an absence of a moral centre. This is not so surprising when you read Pater, who announced that 'to burn always with this hard, gem-like flame, to maintain this ecstasy, is success in life', and who seems to advocate the cultivation of sensations and new experiences at all costs. His famous description of the Mona Lisa smile attributes to it something sinister and definitely decadent; he even claimed that 'like the vampire she has been dead many times and learned the secrets of the grave', and saw in her enigmatic expression 'the return of the Pagan world, the sins of the Borgias'.[8]

Pater's overripe rhetoric has tended to win out over the radical dimension of aestheticism, while William Morris' sincere commitment to socialism tends to be questioned in light of the fact that his enterprise, designing and producing aesthetic wallpapers and fabrics, became a massive commercial success with the Victorian bourgeoisie he despised. In fact, the political right quite often has had less difficulty with the aesthetic than the left, always bedevilled by another either/or question: whether art should be subordinated to politics, or whether politics should have a duty in regard to art whether art, if it is to be considered 'good', must always purvey a progressive message, or whether the artist's first duty is to be true to his or her vision.

The following essays discuss the aesthetic dimension of a range of cultural experiences and practices and in particular their emotional significance for participants. The anthropologist Georges Devereux once wrote that all academic research is a form of autobiography and has roots in the personal, and it is obvious to supervisors that doctoral students (at least in the humanities) usually have an emotional investment in the subject of their PhDs. Enjoyment of all cultural works – from Agatha Christie to Schoenberg – is emotional. Cultural criticism may lay claim to detachment, but it is emotion that draws the audience to follow a star or 'devour' the

work of a favourite author: love – actually. Yet this does not conflict with the impulse to analyse and to judge. The two are mutually reinforcing, not opposed. The cultural experiences I discuss are freighted with autobiographical memories and connections, and a significant, even if minor, part of the friction of excitement and engagement aroused by attending a concert or exhibition, is – of course – that connection between art and life.

I once dreamt that I was in the music wing of my former school. Traversing a corridor and descending a short flight of steps, I found a door I had never before noticed, painted white, unlike the wooden doors of the corridor through which I had just passed. Through this door there was, I realised, another whole wing of the building, which I had never known existed.

At the time I interpreted this dream as a representation of my thwarted relationship with my mother, who had recently died. 'In my house are many mansions' and those mansions, those rooms, that could never now be explored, represented what might have been and could not now be.

But the house with many mansions stands also for the diversity of cultural experience. To classify culture as 'high' or 'low', 'populist' or 'elitist' is to cut off possibilities, to not open the door into the unexplored rooms. Elitists and populists alike graft their political prejudices onto aesthetic works and events. On the other hand, what cultural criticism has taught us is that each work, each event does carry a political, an ideological and moral meaning. There is no such thing as 'just entertainment'.

2 Pleasure's Dangers

... in the very temple of delight
Veil'd Melancholy hath her Sovran shrine.
JOHN KEATS: ODE TO MELANCHOLY

The twenty-first-century Western world is dedicated to pleasure. Consumer society unfolds a dream of beauty, novelty and self-enhancement, an aesthetic universe in which display is everything. Billboards and neon, the snaking shimmer of motorways at night; music everywhere; on screen the delights of high cuisine and high fashion, the excitement of sport and the spectacle of pop concert, opera or religious celebration. Ceremonies that were once religious or political have been transformed into global entertainment, with audiences of billions watching Pope John Paul II's funeral or the latest royal wedding. Virtually, if not actually, this world of pleasure increasingly pervades the whole globe, presided over by a pantheon of celebrities. These prance about their man-made Olympus, much as the gods and goddesses of the ancient Greeks and Romans presided in the centuries before Christ, and with the same colourful excess, fuelled by lust, greed, revenge and arbitrary authority. Everything is turned into entertainment in the society of the spectacle, including theatres of war. Economic collapse and austerity is the nightmare Other of the thrilling scene.

This millennial world is far removed from the rational world hoped for by the leaders of the Enlightenment and is no more 'secular' than the ancient, pagan world. It has even been suggested that the 'secular' idea of 'consumer sovereignty' and 'the customer

is always right' actually has evolved from and remains dependent, philosophically, on deeply buried beliefs in the divine right of kings.[1]

Today, as always, superstitions, beliefs and obsessions of all kinds flourish. For humankind, to state the obvious, is driven not by reason, but by passions and emotions resistant to the secular virtues of reason and balance.

The colourful world of pleasure incites and entices these passions. But passions are dangerous and reason continually struggles to keep them under control. It is therefore not surprising that this world, so hedonistic on the surface, does not rationally and reasonably accept pleasure as an unchallenged good.

The Shorter Oxford dictionary defines pleasure in terms of 'what is felt or viewed as good or desirable ... delight'; emphasising desire and its gratification. The entry quickly moves on, however, to 'the indulgence of physical (especially sexual) desires or appetites; sexual gratification'; and then degenerates further to 'the pursuit of sensuous enjoyment as a chief object of life or end in itself'. Pleasure is identified with 'lesser', bodily sensations. It is associated at best with the erotic and at worst with moral laxity and self-indulgence.

Cultural experiences are major sources and providers of pleasure. They are aesthetic and so are associated with sensation and often eroticism. Pleasure is seduction. At best it is amoral, unconfined by intellectual or moral critique. There is an implied division between pleasure and the spiritual dimension of life. It is the concrete, visual, aural and tactile nature of pleasure that is so dangerous, and cultural works, appealing as they do to the senses, readily become suspect. Because they excite and inflame the audience through the senses, their – possibly immoral – message seduces the viewer or reader; so that in the twenty-first century videos and computer games have been held responsible for crimes committed by the young, just as in the eighteenth century novels were blamed for female frailties.

The public discourse that surrounds pleasure of all kinds is therefore, unsurprisingly, highly moralising. The word, as thus defined, does not even cover the whole range of feeling to which it is applied. The pleasure you take in a hot shower or a good meal seems very different from that resulting from an intense erotic relationship, from listening to music or from watching a football match.

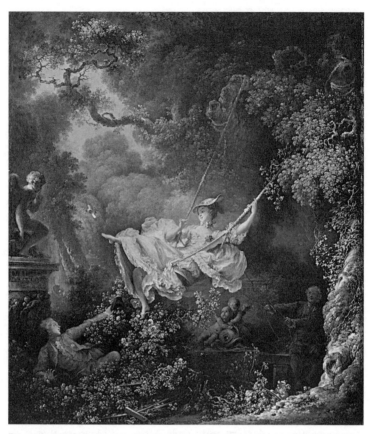

Figure 3: 'The Swing', painted by Jean-Honoré Fragonard: The '*jouissance*' of the swing, together with the lost shoe and the view of the woman's underskirts, signal the dangers and moral laxity associated with pleasure and suggest that the subject is a woman of easy virtue.

But pleasure is defined by its opposite in two different ways: pain is the opposite of pleasure and yet there are pleasures so intense that they come very close to pain. (Certainly to watch a football match that 'your' team loses is pain rather than pleasure.) Pleasure is also defined by another opposition: duty. If duty is the opposite of pleasure, then the dictionary definition of pleasure as *pleasant*, as hedonistic, seems appropriate. When pleasure becomes more intense it is likely to be shifted into a different dangerous category, of addiction or madness.

Duty represents reason and the control of feelings and appetites; it is a married person's duty, for example, to reject the pleasures of adultery. Reason continually draws lines between 'right' and 'wrong' forms of pleasure. Pleasures that are immoral or even go too far used to be denounced in religious terms as sins or crimes. In today's more secular world they, or many of them, are as unacceptable as ever, but have been medicalised. Promiscuity, for example, once a sin, is today 'unsafe' behaviour that will damage your health, as is over-indulgence in food, alcohol and drugs.

Enjoyment 'as a chief object of life' is hedonism. In the contemporary world hedonism implies acquisition, consumption, the continual chasing after excitement. The classical hedonism of Lucretius and the Epicurean school was very different. This prescribed the maintenance of serenity, and freedom from excess. Lucretius, indeed, was critical of a life of constant seeking after new sensations and experiences: 'such a life as we see all too commonly – no one knowing what he really wants and everyone forever trying to get away from where he is, as though travel alone could throw off the load'. For Lucretius, acceptance of the inevitability of death will free human beings of the 'deplorable lust for life that holds us trembling in bondage to ... uncertainties and dangers'. It is our 'unquenchable thirst for life [that] keeps us always on the gasp'.[2]

Epicureanism recommended a 'steady state' pleasure, reliant on moderation and elimination of the fear of death. This is not so far distant from Freud's view that desire was essentially a state of unpleasure and that the satisfaction of a desire returned the individual to stasis or nirvana.

The long Western tradition of suspicion of pleasure, which included the pleasures of culture, was already firmly in place in Plato's *The Republic*, where the philosopher argued that representations were 'two removes from the truth'. They represented reality, but did not actually constitute that reality, and were therefore, in a sense, agents of deception. Worse than that, poetry, say, encouraged the over-indulgence of emotions that human beings trained themselves to restrain:

A poet satisfies and gratifies ... an aspect of ourselves that we forcibly restrain when tragedy strikes our own lives – an aspect that hungers

after tears and the satisfaction of having cried until one can cry no more ... When the part of us that is inherently good has been inadequately trained in habits enjoined by reason, it relaxes its guard over the other part, the part which feels sad ... the same goes for sex, anger and all the desires and feelings of pleasure and distress which, we're saying accompany everything we do: poetic representation has the same effect in all these cases too. It irrigates and tends to these things when they should be left to wither and it makes them our rulers when they should be our subjects.[3]

Long before the Enlightenment, then, Plato strongly distinguished between reason and feeling, very much to the detriment of feeling. It followed that poetry and other arts had no place in education. Poetry and drama were 'lies' (a view revived in eighteenth-century hostility to the developing novel form). There was no sense here that poetic and fictional works could produce insights and truths about life and human nature, even if not literally true. (Aristotle argued against this view, when in his *Poetics* he suggested that the emotions sustained by an audience when watching a tragedy or listening to music, had a purgative effect, purifying and uplifting the audience by the expression and resolution of emotions that might be upsetting in everyday life. This, for him, was 'catharsis'.)

In excluding the arts as politically and morally dangerous, Plato prefigured future politicians, not least Lenin, who, according to Gorki, was united with the strictest Muslims in his rejection of music. For some Islamic traditions music is 'un-Islamic', taking the believer away from godliness; for Lenin it involved a fatal weakening of revolutionary resolve, softening the listener. He loved Beethoven, but said: 'I am often unable to listen to music ...[for then] I would like to stroke my fellow beings and whisper sweet nothings in their ears for being able to produce such beautiful things in spite of the hell they are living in.'[4] Asceticism, for religious believer and revolutionary alike, must be the chosen path.

The modern debate on aesthetic judgement and whether or not it can be objective – whether there are general standards that can be applied to determine which works are 'better' or 'worse' than others – developed in the eighteenth century and was also concerned with the nature of pleasure. David Hume, in

his essay 'Of the Standard of Taste', wished to 'mingle some light of the understanding with the feelings of sentiment' and, quite apart from issues of objectivity, to unravel the puzzle of why aesthetic experiences affect us in particular ways (views explored by Simon During, whose *Modern Magic* I discuss later). Other eighteenth-century writers – Joseph Addison and in particular Edmund Burke in his essay 'Our Ideas of the Sublime and the Beautiful', developed the distinction between the way in which beauty operates on us and the 'sublime', which refers to experiences, sights and music that seem to represent something greater than beauty, more awesome, even threatening and terrible. A tremendous, mountainous landscape, for example, can seem overpowering, reducing the human figure to nothingness, yet the experience of it can also be exciting, uplifting and inspiring. It is not unpleasurable.

Addison called this 'agreeable horror'. In Immanuel Kant's work this idea develops a moral grandeur. Kant maintained the distinction between the sublime and the beautiful. The appreciation of each, though, required a disinterested judgement. The true recognition of beauty was *not* kinaesthetic and did not involve desire. That sensation Kant described as merely 'agreeable'. Beauty brought pleasure, but the sublime something more elevated and spiritual. This was one way of distinguishing between 'lower' and 'higher' pleasures.

Only in pure, disinterested contemplation did aesthetic judgement achieve freedom: 'taste in the beautiful may be said to be the one and only disinterested and *free* delight; for with it, not interest whether of sense or reason, extorts approval'. Once the enjoyment of art was defined as a pure form of contemplation, poets and painters no longer threatened the moral stamina and backbone of the impressionable. At the same time universal standards of taste were retained to save the audience from sinking into subjectivism.

In his *Critique of Judgment*, Kant also maintained a *gendered* distinction between the sublime and the beautiful:

The beautiful is directly attended with a feeling of the furtherance of life and is thus compatible with charms and playful imagination. On the other hand, the feeling of the sublime is a pleasure that only arises indirectly, being brought about by the feeling of a momentary check to

the vital forces followed at once by a discharge all the more powerful, and so is an emotion that seems to be no sport, but dead earnest in the affairs of the imagination. Hence charms are repugnant to it; and since the mind is not simply attracted by the object, but is also alternatively repelled thereby, the delight in the sublime does not so much involve positive pleasure as admiration or respect.[5]

Here, Kant's language seems unintentionally to challenge his commitment to lofty detachment; and many feminists have pointed out that gendered distinctions have remained at the heart of aesthetics and art history.

The Danish philosopher Soren Kierkegaard took the debate further and in a rather different direction when he set the aesthetic against the ethical and religious dimensions of life. It may be an oversimplification to understand his discussion of these spheres as a Hegelian theory of stages, progressions towards a higher state, but Kierkegaard does seem to have identified the aesthetic with the surface of life, with the immediate. The aesthete searches for the next thing, the newest excitement, and there is nothing more than surface. The aesthetic life involves the pursuit of the evanescent and going with the flow along the surface of life, possibly also an inability to discriminate. There is no sense that spirituality or deep emotion can be expressed aesthetically. Harvie Ferguson suggests that irony is the typical mood of Kierkegaard's understanding of the aesthetic, since irony refuses to take up a moral stand; its main preoccupation to expose the arbitrariness inherent in the apparently fixed order of everyday life.[6]

Kierkegaard was critical of the Romantic Movement, which elevated art and the passions – and often-extreme experience – into a source, or even *the* source of meaning in life. This was one response to the shattering of the cosmic order as it had been understood before the Enlightenment and which Shakespeare had expressed in *Troilus and Cressida*:

The heavens themselves, the planets, and this centre
Observe degree, priority, and place ...
And therefore is the glorious planet Sol
In noble eminence enthron'd and sphere'd ...

but when the planets
In evil mixture to disorder wander,
What plagues, and what portents, what mutiny ...
Divert and crack, rend and deracinate
The unity and married calm of states
Quite from their fixture! Oh! When degree is shaked
Which is the ladder to all high designs,
The enterprise is sick ...
Take but degree away, untune that string,
And hark! What discord follows ...
Then every thing includes itself in power,
Power into will, will into appetite;
And appetite, a universal wolf ...
Must make perforce a universal prey
And last eat up himself.

This world picture, which had given an orderly meaning to the relationship between the individual self, the state and the universe, could not withstand the onslaught of the scientific work of the astronomers and scientists of the late eighteenth century. Chaos replaced the order of the cosmos as hitherto understood and, argues Ferguson, 'was ... powerless to reconstruct a meaningful totality from the fragments in which it had cast reality'. The work, for example, of the astronomer William Herschel (who discovered the planet Uranus) threw into doubt the above picture of a cosmos limited in size and only a few thousand years old, whose fixed stars were relatively close to the earth (which accounted for their astrological influence). A vast 'deep space', the Milky Way, the possibility of the existence of thousands of suns and worlds, made the certainties of Christianity seem inadequate in the face of a universe so vast and a world so small and insignificant. Few astronomers of the time would have accepted that they were atheists, but

> the growing sense of the sheer scale of the universe, and the possibility
> that it had evolved over unimaginable time, and was in a process of
> continuous creation, did slowly give pause for thought ... [and] ... put the
> Creator at an increasingly shadowy distance.[7]

The Romantic Movement responded by suggesting that art alone could offer

> to the bewildered observer of modern life a form-giving structure into which its chaotic but finite content could be poured. Art, as Friedrich Schiller and other German and English Romantics insisted, provided a new mode of unification for modern experience. The aesthetic provided ... an 'immediate' unity through which life could be grasped and shaped.

The aesthetic is, in part, a grasping of this immediacy.[8]

The importance of art seemed to grow and the role of the artist was magnified by ideas of genius as his role changed. Art increasingly challenged the status quo. Artworks differentiated themselves from vulgar, philistine bourgeois taste by not only exploring forbidden subject matter, but by flouting the rules of beauty and elegance. In the twentieth century, art itself became less orderly with the development of schools of modernism and movements such as Dada and Surrealism, which privileged unintentional and absurdist juxtapositions and discovered meaning in accidental 'found objects'. Yet although these might seem to have emphasised the arbitrary, Surrealism was not ironic, since for André Breton, for example, the apparently unintentional did have a hidden meaning. Meanwhile, in music, harmony was overturned and the fine arts rejected realism in favour of abstraction. Much of this work was a deliberate refusal of the pleasure traditionally expected from cultural works.

In the 1950s this modernism – the work, for example, of Jackson Pollock – became the poster for the individualism of the 'free world'; that is, the United States and Western Europe challenging the conformity of the Communist bloc. Unknowingly, artists who had thought of themselves as radical (in the 1930s, Jackson Pollock had been close to the Communist Party and involved in the New Deal artistic projects) were incorporated into a massive CIA propaganda project.[9] In following decades, art became politicised in a different way with the rise of the New Left, the anti-racist struggles, the movement against the Vietnam War and women's liberation.

This period, the 1960s and 1970s, gave rise to a new intellectual project that sought to theorise the burgeoning political movements.

Developing out of, but then moving away from, Marxism, philosophers who came to be known as structuralists and post-structuralists developed the body of theory that eventually attracted the label of postmodernism. Among these, Roland Barthes, the influential French semiotician, returned to the issue of pleasure and he was able more usefully to distinguish between the moderate, 'steady state' pleasure advocated by the Epicureans, and the intense pleasure sought by the Romantics and which was closer to those sentiments Kant had considered sublime.

For this second kind of pleasure Barthes used the French term *jouissance*.[10] *Jouissance* tends in French to be used in relation to the moment of orgasm; it is a climactic, explosive moment. Richard Miller translated *jouissance* as 'bliss', but this doesn't adequately convey the violence of the event. Barthes insists that *jouissance* is something striven towards but not predictable, not to be counted upon. It is the search for a space where there is 'the possibility of a dialectic of desire, or an unpredictable *jouissance*: the knowledge that the dice have not [yet] been thrown, that there is the possibility of a game'. *Jouissance*, in other words, is an unpredictable, fleeting moment (and is very much the sort of 'pleasure' experienced by a fan when watching 'his' team). It is a gamble. The search for it involves risk and, for Barthes, seemingly, the forbidden, for he uses the metaphor of what is usually thought of as a deviant as well as a dangerous form of solitary sexual pleasure, *jouissance* being like 'that untenable, impossible, purely romantic moment, experienced by the libertine at the culmination of a daring arrangement whereby he cuts the cord by which he is hanging at the moment of orgasm'. In distinguishing pleasure from '*jouissance*', Barthes not only acknowledges that the word 'pleasure' covers too wide a range of experience and that a more differentiated vocabulary is required; he also focuses on the emotions and feelings of the pleasure seeker (audience), and rejects both connoisseurship and social analysis as adequate if used exclusively as tools in the understanding of art and its effects.

The political project of postmodern cultural studies to rehabilitate popular forms took a particular feminist turn when women researchers deliberately focused on despised 'feminine' forms of work such as embroidery and other crafts and on popular

forms that, it was assumed, particularly appealed to women, such as television soap operas and romantic fiction. There were tensions. To be a feminist was necessarily to take a political view of culture and to assess positively only those cultural experiences that advanced or seemed to advance the position of women. To do this, however, was ironically, like Adorno and Horkheimer, to judge culture in terms of its political effects; and this could easily fall into the trap of elitism, feminists guilty of suggesting that other women, who enjoyed popular culture, were suffering from false consciousness.

An example was Ien Ang's critique of an influential defence of romantic fiction, Janice Radway's *Reading the Romance*. Radway presented herself as an enthusiastic reader of romantic fiction, who used ethnographic interviews to investigate its meanings for its consumers. But the aim of Radway's book, argued Ang, 'is directed at raising the consciousness of romance reading women, its method is that of persuasion, coercion even'. 'Real' social change can only be brought about, Radway seems to believe, if romance readers would stop reading romances and become feminist activists instead.

Ien Ang objects to the absence of 'any careful account of the *pleasureableness* of the pleasure of romance reading ... of pleasure as pleasure'. She agrees that 'the ideological consequences of [romance fiction] and its consumption should be a continuing object of reflection and critique',[11] yet her argument implies that 'pleasure as pleasure' is a sufficient criterion by which to judge a work. This certainly refuses to see pleasure as problematic, but if pleasure is taken as the sole and only touchstone of experience it becomes difficult to condemn murder, torture and cannibalism, since these give pleasure to at least some of their perpetrators. So pleasure cannot be a guarantee of the acceptable and we are back with the problem that has dogged the whole of Western culture.

In the last decades of the twentieth century Kant's sublime seemed to resonate with the aesthetic of ugliness that was not only an aspect of modernism and the avant-garde, but also of mass culture with its violence, excess and, often, deliberate rejection of any traditional notion of beauty. Indeed, traditional beauty became inescapably kitsch as it was massified and

vulgarised by Hollywood, advertising and the cosmetics industry into standardised and banal forms.

On the other hand, the way in which mass culture was appreciated went wholly against the Kantian idea of detachment, as researchers, by identifying the sources of identification and idealisation that mass cultural forms provided, justified the passions of audiences and fans for particular music, television, film and sport. The belief in an objective set of aesthetic criteria, whereby cultural works could be judged in relation to one another and placed in some kind of hierarchy, had by now long been abandoned by critics, although not by the population at large, who seemingly unaware that they are committing sins of elitism or cultural universalism, continue to judge entertainments in terms of good or bad, better or worse.

In this world of cultural relativism those who enjoy, say, classical music, have become little more than another niche interest group. They do not call themselves fans; that term is for 'middle' and 'low' brow culture. Instead they are 'aficionadas', 'cognoscenti' or 'connoisseurs', foreign terms that reclaim their disinterested and contemplative enjoyment for respectability. Yet these enthusiasts turn out to be as emotionally involved in the art they love as the most shameless 'Trekkies' or football fans:

When BBC Radio Three played the complete works of Bach (the 'Bachathon'), readers wrote of being addicted to [the composer], and of physical withdrawal and emotional dependency... Bach enthusiasts on the [BBC] message board confessed to their total immersion in the text, the merging of fantasy with reality, the delusional behaviour that the ... critics of popular culture have so often deplored.

Fans took sides; comparing Bach with Beethoven to the latter's detriment or trashing the 'frivolity' of Mozart as against the grandeur of the master of Leipzig.[12]

Scholarly research is even itself a kind of fandom. But this 'must be disavowed, because passionate attachments ... pleasure in mere assertions of value and arguments that primarily justify emotional investments are not phenomena that can typically be tolerated in academic spaces'.[13]

Artistic culture is a source of knowledge as well as a source both of pleasure and of '*jouissance*'. The emphasis in scholarly – and also more popular – approaches may have shifted from the quality of the work to the response of audiences, but both are necessary. Neither is likely to diminish the controversial nature of what gives us pleasure, what thrills and moves us. These passions remain suspect because they are not, or are not wholly, within state or religious control. Even if commercial interests ultimately control them, they may partially escape the cage of mediated society.

Much of culture is transient. Today's brilliant best-seller may be a dusty period piece in 50 – or five – years' time. On the other hand, cultural artefacts that have survived down the centuries, relics of the past that we still cherish, constitute the only form of eternal life we know. Their relative durability, their survival itself, is a source of faith in the human spirit. Emotional involvement should show us that the aesthetic contemplation of these concrete objects and our emotional involvement in them is far from being a shallow and 'merely' hedonistic search for pleasure.

In a mysterious entry in his *The Arcades Project*, Walter Benjamin wrote: 'the eternal ... is far more the ruffle on a dress than some idea'.[14] This is part of a fragment in which Benjamin also remarks that 'truth' is not just 'a contingent function of knowing'. Truth, in other words, is not abstract and cerebral. It is by implication imagistic and concrete (although that is not exactly what Benjamin says). And it is *because* art is concrete, visceral, *aesthetic*, that it reaches beyond the immediate and superficial.

3 Looking Backwards: Nostalgia Mode[1]

> Nostalgia is to memory as kitsch is to art.
>
> CHARLES MAIER

Like so many other pleasures, nostalgia is suspect. In a culture in which the whole movement is forever forward, we not surprisingly take it for granted that to look backwards is a sin. Nostalgia is something in which the pleasure seeker 'wallows' and wallowing implies self-indulgence and moral weakness. To replay the past is to take shelter in a sentimental 'comfort zone', sentimental because we feel that nostalgia falsifies the past. Sentimentality is, after all, the manufacture of ersatz and insincere feeling, in which the interest is in the feeling itself rather than in its cause. Nostalgia, it is assumed, always creates a saccharine past. We glamorise retrospectively a past that was, when lived, painful. The longing nostalgia expresses becomes a kind of aesthetic masochism. Yet the idea of pain, as the opposite of pleasure, is integral to the definition of pleasure itself and the sadness or longing of nostalgia has a glamour or a sweetness of its own.

It was a Swiss doctor, Johannes Hofe, who in 1688 coined the term nostalgia to describe the longing for home experienced by soldiers on active service in foreign lands. It therefore arose as a spatial, geographical category, expressing a sense of being in a different place from where one should be or would like to be; a form of homesickness.

It came to be associated with more general symptoms of psychological unease and pathology, with melancholy and depression,

and later no longer used as a psychiatric diagnosis, migrated into other areas of cultural criticism and political conservatism. In the process it became irreversibly associated with the past, with looking backwards and therefore with history.

For the philosophers of the Enlightenment, history was a narrative of progress.[2] Immanuel Kant described the Enlightenment as the movement from servitude to the freedom of independent thought. Reason and progress would usher in a new and utopian world. The challenge this presented might result, at least for a time, in longing for the older, simpler world, but the benefits of enlightenment and reason would eventually triumph.

The forward march of progress took on a political complexion with Karl Marx. He was as hostile to those who cling to the past as the philosophers who preceded him. For them, nostalgia had meant the wish for a return to the past of superstition, religious intolerance, monarchical despotism and the divine right of kings. For Marx, to look backwards also acted as a brake on the possibility of moving forward to the future of justice and equality for which Communists fought. He attacked utopian socialists and their 'prefigurative' communities based on an imagined medieval past, because they were, he argued, trying to 'roll back the wheel of history' and were in thrall to an illusion, since it was in any case impossible to repeat the past. The utopian socialists were critical of existing society and desired progressive change, yet they rejected the political struggle necessary as a means of achieving this. 'They ... dream of experimental realisation of their social Utopias, of founding isolated *phalanstères*, of establishing "Home Colonies", of setting up a "Little Icaria" ... castles in the air', he wrote in *The Communist Manifesto*. They sentimentalised medieval society and lost themselves in dreams instead of fighting for the future.

Abandoned by psychiatrists, nostalgia continued to have pathological associations and came to be seen as a cultural illness, instead of a disease of individuals. To long for and to try to dwell in the past is to refuse to confront the present reality. It is to resist the inevitability of change. Nostalgia leads to stagnation, because it sets itself against progress. The only healthy existence is one that embraces the present, because the present leads forward.

Paradoxically, the left has shared the idea of history as progress with the staunchest supporters of capitalism and the status quo, both capitalist societies and the socialist societies of the twentieth century being equally committed to continual movement 'forward'. By the twenty-first century, however, progress was interpreted in exclusively economic terms. The idea of 'progress', having lost all its progressive radicalism, amounts to no more than an acknowledgement that capitalism must continually expand in order to survive. There is no compelling alternative to global capitalism. At the same time there could be little further development of democracy, which was said to have reached its apogee. In reality, deprived of further growth, democracy was moving towards entropy, as the wider political values of the Enlightenment were gradually abandoned.

But to succumb to nostalgia is to reject progress. In particular, any yearning for 'socialism' or something approximating to it has itself become a form of nostalgia. In this world of economic determinism 'backwardness' is still to be overcome and nostalgia continues to be seen as a form of false consciousness. It is still a failure to embrace modernity with all its benefits of advanced dentistry, instant communication and 'fast fashion'.

Nostalgia is an expression of the unsatisfactory nature of the contemporary, the present. For the left it is morally wrong because we should be struggling in the *present* for a better *future:* for the committed capitalist nostalgia is bad because it rejects the *good* present in favour of a bad *past*. Only at the political extremes, in the West, is a longing for the past endorsed; by the American Tea Party movement with its longing for a non-existent past free from the State, and by those sections of the Green movement that argue for a return to artisanal crafts and village communities.

It may seem strange that, with Western societies at least wholly integrated into modernity, their citizens should still be looking backward. But as if to offset the demands of modernity, cultural nostalgia has constructed a whole ideology of backwardness, whose critics denounce its negative and reactionary effects.

Socialist historians of the late twentieth century were especially hostile to nostalgia. As the progressive movements of the 1970s faltered and right-wing governments took power in both Britain

and the United States, these historians argued that nostalgia was part of the conservative turn. As historians they particularly objected to what they saw as its misrepresentation of history. An imagined past had been constructed, they argued, which 'tells us about the present through its falsification of the past'. Comfortable and reassuring images of the past, especially as purveyed by popular culture, contributed to an invented nationalistic tradition, a glorification of Britain or an American past that masked injustice and racism: collective false memory syndrome.

For one of its fiercest critics, David Lowenthal, 'nostalgia today engulfs the whole past'. Nostalgia 'tells it like it wasn't', he insists and he cites Christopher Lasch, who wrote that 'the victim of nostalgia is worse than a reactionary; he is an incurable sentimentalist afraid of the future, he is also afraid to face the truth about the past', and those suffering from nostalgia are temperamentally incapable of confronting the 'rough and tumble, the complexity and turmoil of modern life'.[3] In this radical tradition nostalgia expresses a deep dissatisfaction with contemporary society, but poses the wrong solution to that dissatisfaction.

Its critics have been especially hostile to the cultural and commercial dimensions of nostalgia. They condemn the 'heritage industry' as a major culprit in creating a false representation of the past. The audience watching *Upstairs, Downstairs*, *Downton Abbey* or *Gosford Park* or the visitors to a National Trust stately home are, they argue, lulled into a version of country house living 100 years ago that manages to be simultaneously nostalgic and reassuring. These days such entertainments foreground the lives of servants as much as their masters, while seducing visitors or audiences with all the details of period dress, interiors and customs, so that the pleasure for spectators lies in enjoyment of the quaint, coupled with a self-congratulatory sense that we have overcome this hierarchical past. Britain (and the United States) may actually be even more unequal than they were 100 years ago and are certainly more unequal than they were 50 years ago, but the below stairs past of a country house allows us to congratulate ourselves on the end of deference and to dwell on the inequalities of yesteryear, and at the same time reassuringly to avoid confronting the inequalities of the contemporary scene. Similarly, urban and suburban dwellers 100

years ago invested romantically in a reconstituted suburban idyll of thatched cottages and rural bliss, blind to the squalor of nineteenth-century agricultural workers in their hovels without sanitation or running water, starvation wages and tyrannical landowners.

Historian and Labour MP Tristram Hunt saw another danger in these recreations. History was once about the lives of great men, he argued in the *Observer* newspaper, who were presented as an inspiration to the public, but 'increasingly the public spurned the lives of great men to trace their personal lineages through local archives [and] ... genealogy websites ... the quest for identity and empathy has taken over: explanation has become less desirable; understanding has assumed centre-stage'. The 'retreat into the warm, fuzzy embrace of the past' risks becoming 'history as entertainment, without the capacity to teach about the past or shed light on the present'. It risks becoming history as narcissism, the individual's family background becoming merely a prop to a sense of identity in danger of being eroded by the rapidity and uncertainty of contemporary life.

Postmodernist theorists in the 1980s and 1990s identified a different form of cultural nostalgia. As part of their onslaught against the 'elitism' of 'high culture', cultural critics targeted the high priests of 'high art', Theodor Adorno and Max Horkheimer, for their condemnation of mass culture in *The Dialectic of Enlightenment*. George Stauth and Bryan S. Turner, for example, asserted that this elitist critique was essentially nostalgic, based as it was on an assumption of 'the availability of some general or absolute values from which a position of critique can be sustained'. In contemporary society, however, 'the underlying communal reality of values has been shattered, there can be no clear position of values in order to establish a critique of mass culture'. For them, the virtue of postmodern cultural pluralism was that it exposed the 'privileged claims of high culture to be the criterion of aesthetic supremacy' as nothing more than backward-looking snobbery.

From this perspective it follows that when Adorno and Horkheimer attacked American mass culture they were merely expressing their grief at the loss of cultural power and authority, which had rested on their privileged position as 'professional intellectuals', a position attained only after years of 'discipline and

asceticism which can only be acquired ... through withdrawal from everyday labour and everyday realities'. Mandarins in their ivory tower, these Jewish exiles, confronted with the horrors of California and Tin Pan Alley, were necessarily 'anti modernists' suffering a double nostalgia: for their lost artistic culture and also for their lost urban world of cafés and cities. They were typical of a 'moribund intellectual elite, adrift from its traditional culture and institutional setting'.[4] We should, however, note the implicit self-hatred in this critique, since Stauth and Turner, as salaried university teachers, were themselves part of a later lost generation of unanchored intellectuals.

Stauth and Turner also revived the psychological dimension of nostalgia. They portrayed the intellectual who defends 'high culture' against the vulgarity of mass taste as necessarily a melancholic, withdrawn from contemporary culture. In other words, Adorno and Horkheimer were not merely cultural elitists, they were mentally ill. To embrace modern culture in all its (mass) forms suggests, by contrast, that the 'people' are wholly in tune with the present and furthermore have 'a positive view of consumption, as a real reward for the deprivations of production'. This extraordinary comment patronisingly reduces popular culture to a kind of bread and circuses for the toiling proletariat. (It should be noted that this critique of nostalgia is at odds with that of the historians. They were dismayed by populist heritage industry versions of history, although these are certainly popular with a mass audience.)

The very proliferation of cultural forms and new ways of disseminating cultural works and the enormous expansion of mass culture itself opens the way to increased nostalgia for lost cultural experiences. Andreas Huyssen pointed this out, when he wrote: 'The more memory we store on data banks, the more the past is sucked into the orbit of the present, ready to be called up on the screen.'[5] What are tribute bands but an expression of nostalgia? Young adults reminisce nostalgically of the television programmes they watched as kids. The soap, *Brookside*, and the more upmarket 1990s soap, *This Life*, about post-Thatcherite thrusting and hedonistic young lawyers, are remembered with a sense of loss and lost possibility. So ubiquitous are cultural experiences that there is so much more to be nostalgic about. This leads to revivals or

reworkings of formerly popular music and television; for example, *Sherlock Holmes* in modern dress, a new version of the classic, late-1940s film of *Brighton Rock*, updated to the 1960s, or the creation of new works that rely on nostalgia such as *Life on Mars*, a detective series that recreated the 1970s with all its accompanying smoking, sexism and police corruption.

It may be, as Linda Hutcheon[6] has suggested, that nostalgia and irony are closely related. Irony is more likely to be viewed as an alternative to nostalgia, but *Life on Mars* certainly played on the ambivalence of the way in which the social crimes of the past – chain smoking, sexist contempt for women – could be enjoyed guiltlessly precisely because they were located in the past. Viewers could vicariously enjoy the thrill of these crimes against political correctness without the guilt of actually committing them. In this case irony took the longing out of nostalgia. Yet who is to say that that enjoyment did not for some viewers include a nostalgia for a past in which certain forms of behaviour were not so heavily policed. And perhaps subtly, almost unconsciously, the series condoned them: nostalgia as a way of having your cake and eating it.

The virtual world may seem to strip away the past, but, as Huyssen noted, it continually re-presents it to us. We live in a hyper-aestheticised society and so mass culture inevitably and necessarily presents it to us in visual forms. Anything from old pre-war railway posters to the 1960s' fashions made glamorous in the American fictional series about the 1960s' Madison Avenue advertising industry, *Mad Men*, incites audiences to this nostalgia-lite. Another dimension of nostalgia for the (almost) contemporary is the way in which technology, including many small items of daily use, rapidly becomes out of date and redundant. So users can feel nostalgic about cassette tapes, about vinyl records and about clunky old telephones, and it is predicted that soon email and iPods will be on the sick list.

The Surrealists were already on to this nearly 100 years ago. Louis Aragon's *Paris Peasant* was a literary tribute to the lost corners of cities, especially the Paris arcades with their dusty shops selling outmoded items nobody wanted. They were, he said, 'the true sanctuaries of a cult of the ephemeral, the ghostly

landscape of damnable pleasures and professions. Places that were incomprehensible yesterday and that tomorrow will never know.'[7]

The critics of nostalgia have not had it all their own way. Since the 1980s a rehabilitation of nostalgia has been made possible by a change of name. Nostalgia has become memory. Memory is innocent of the negative emotion and falsity surrounding nostalgia. We all have memories, individual and collective. Much of the academic work on memory also gains gravitas and respectability because it has focused on collective political memory of trauma: the Nazi legacy, the conflicts in former Yugoslavia, the collapse of the Soviet Union, the disappearance of the German Democratic Republic and genocide in Rwanda. What is at stake here is mourning and the recognition of the injustices and indeed horrors that were perpetrated. If nostalgia is a failure to confront the present reality, then memory is the challenge to confront the past. Not to engage in the work of memory would be the abdication from this necessary task.

This is not to argue that there was a direct translation of nostalgia into memory. To recognise the importance of memory is, nonetheless, to make possible a reinterpretation of nostalgia. The exploration of memory acknowledges that there is a truth to be known and certainly some things are truer than others. Yet if memory is a film or a slide show inside one's head, is it – like a film viewed a second or third time – always different?

Critics such as Fiske have been rightly insistent on the experience of culture as an interactive process between audience and object/ spectacle. Time also plays a role in this, for individual and collective audiences alike. The first encounter with a given work will be different from all subsequent ones. The passage of time changes the audience and perhaps even the work itself.

Experiences are stored in the formaldehyde of memory, but the embalming fluid changes that which it preserves. In fact, memories are not dead objects or mummified, so it may make more sense to think of memory as an element like water, which softens and dissolves. Water, undulating, blurs the edges of things, clarifies, distorts, cleans and muddies. Or is water more like the passage of time itself, or do time and memory melt together? How is it

possible – is it possible – to separate out the passage of time from the memory itself?

Memory studies have emphasised the work of memory in coming to terms with mourning and loss. Nostalgia is an expression of loss and mourning too; of lost selves, lost objects of desire; lost landscapes, lost streets. What is wrong with the heritage industry recreations so detested by the critics of nostalgia is that they do *not* express a sense of the passage of time. The past is reduced to the quaint or at best the picturesque. In fact, the effect of the more serious attempts to recreate the past, such as the television series *The Victorian Farm*, does not play on or evoke nostalgia. *The Victorian Farm* was educational in showing how even as recently as the late nineteenth century, domestic, agricultural and industrial production processes required an enormous amount of physical toil. Hours of dirty and sometimes dangerous labour were needed to make something that today is acquired by purchasing it in a shop. The effect was to render contemporary living somehow transient and also disembodied as if dwellers in today's technologically advanced world suffer from 'the unbearable lightness of being', with toil and the possession of objects stripped of solidity to become ephemeral and thus less meaningful. The light-headedness of the consumerist society may at times arouse nostalgia, but it can also be a form of forgetfulness.

Svetlana Boym has suggested that nostalgia could be 'restorative', but that ironic nostalgia restores nothing. She writes in particular of forms of nostalgia for no longer existing socialist culture in Russia and former Yugoslavia, describing, for example, the Nostalgija café in Belgrade. This café, she says,

restores nothing. There was never such a café in the former Yugoslavia. There is no longer such a country, so Yugoslav popular culture can turn into self-conscious style and a memory field trip. The place exudes the air of Central European café culture and the new dandyism of the younger generation that [simultaneously] enjoys Tito-style gadgets and Wired magazine. This is a new kind of space that plays with the past and the present. The bar gently mocks the dream of greater patria while appealing to shared frameworks of memory of the last Yugoslav generation. It makes no pretence of depth of commemoration and

offers only a transient urban adventure with excellent pastries and other screen memories.[8]

(A screen memory is the Freudian concept of something remembered that occludes a deeper, unconscious memory.) On the other hand, 'the past for the restorative nostalgic', she writes, 'is a value for the present; the past is not a duration but a perfect snapshot ... the past has to remain eternally young'.[9] This is perhaps the way in which a moment of the past can leap out into the present, can be relived or re-vivified in the way Proust suggested a concrete physical memory can 'conquer time' and restore the past into the present. The past is not just a memory; it can *mean* something in the present.

There is also, says Boym, reflective nostalgia: 'The focus here is not on recovery of what is perceived to be an absolute truth, but on the meditation on history and passage of time.' This is nostalgia as an acknowledgement of a simple, irrevocable, inexorable passage of time. It is a legitimate sadness. Nostalgia displaces onto lost objects, places and experiences the longing for what is really lost: time. It is not even a longing for lost youth so much as a protest against the irreversibility of time.

That is what Roland Barthes found unbearable about old photographs and about which he wrote in *Camera Lucida*. The images testified that 'this really happened; this actually *was*', but that it no longer is makes it unbearable. Barthes stares at the photograph of his mother. There she is; when that photograph was taken she was alive. Now she is dead; and it is the impossibility of crossing that gap between present and past that is experienced as unendurable.

In a brief essay, 'On Transience', Freud expressed a surprisingly upbeat view of that sense of the loss of the past. In a few short paragraphs he described going for a walk with a young poet and a young woman (believed to have been respectively Rainer Maria Rilke and Lou Andreas Salome, formerly Nietzsche's lover and herself a psychoanalyst). The poet looked tragically round at all the beauty of the natural landscape through which they were walking and said that he could not enjoy what he saw because it was transient and would, like everything, disappear. This walk

took place during the First World War, so Freud's optimism seems all the more surprising. This tragic sense of transience, he said, was similar to the process of mourning. The process of grief is a gradual but necessary process of detachment from a loved being or object. If this proceeds in a normal fashion, in the course of time the detachment will have been achieved, after which the individual can find new joys and new forms of attachment. Clearly this is psychologically desirable (although not always possible) as a means of emotional survival in the face of the death of loved individuals, yet leaves unresolved the protest against the relentless march of time and the inevitability of death – or perhaps recommends a Lucretian detachment from it.

The emphasis of nostalgia's critics on its comfortable and cosily deceitful certainties misunderstands nostalgia, which in truth is far from reassuring. It is a painful form of longing that can never be assuaged. It is not even just a longing for a lost past, or even longing for the lost object of desire to which Freudians believe we are all attached; it is surely as utopian as the Enlightenment. It is the loss of the road not taken, is the longing for the perfect moment that could not be sustained, a longing for that happy place without contradictions (which is what a utopia is) – is almost longing for longing itself.

Laura Miller experienced this longing and describes it in her book on what it meant to be a fan of C. S. Lewis's *The Chronicles of Narnia*. As a child, she wished, 'with every bit of myself, for two things. First, I want a place I've read about in a book to really exist, and second, I want to be able to go there. I want this so much I'm pretty sure the misery of not getting it will kill me.'[10]

Later, I shall return to *Narnia* and the relationship of nostalgia to the fan and fandom; in the meantime it seems to me that this longing for Narnia, the non-existent yet (in a sense utopian, but simultaneously dystopian) imaginatively real place, is closer to nostalgia than one would ever have thought. It follows that the disapproving historians were wrong to criticise historical nostalgia on the grounds that it *misrepresented* the past; for even if there were a 'true' representation, it would not help. It would not undo the fact that not only is the past another country, but it is that 'undiscovered country *to* whose bourne no traveller returns'.

As a coda, I think of the ambivalent feelings aroused in old films set in the London of the 1940s and 1950s, for those old enough to remember the city as it then was. To watch one of those British post-war black and white films is to step into a Britain and a London that is unrecognisable. Like a dream, a ghostly post-war past unreels: the shabby, bomb site, weary streets of London in the 1940s and 1950s, a monochrome cityscape, in which both buildings and trudging armies of workers and housewives inhabit a world of crumbling walls, rain-swept alleyways, bomb sites and broken dreams.

The sub-noir frames open up the infinite regress of the corridor of memory into a world whose melancholy constitutes its promise. In the London of 60 years ago, it seems, you could cross invisible frontiers between the safe, middle-class worlds of, say, Kensington and Knightsbridge into uncertain territories where similar, but shabbier, Victorian terraces bled into something vaguer and more ambiguous. To wander about the streets must have been to penetrate what Iris Murdoch in her first novel, *Under the Net*, called the interstices of existence, the gaps in the net of existence, labyrinths, on the edge of which 'the web of the urban tissue was astonishingly slack',[11] as Claude Lévi-Strauss put it when describing his wanderings in 1940s' Manhattan. In the faded celluloid, images of lost London streets stretched endlessly away in all directions, magnifying the sense of nameless potential in a city whose recovery from war had scarcely begun to take the shape of the bombastic office blocks and towering council estates that would later appear. Things seemed more provisional. London was barely in recovery, supine like the mangy old lions that lay in torpid resignation behind the bars of their narrow cages at the zoo.

Yet it was just this negative capability that created a sense of potential. The very dreariness, the existence of ruined buildings, cracked pavements and spaces in between, invoked the expectation of finding some secret garden at the end of an alley, or a magical shop behind a forgotten courtyard. The very poverty of the urban surfaces, the unrestored façades and unplanned side streets exuded a sense of the enduringness of London – almost the more so because of the bomb damage.

Meanwhile, the strangers treading the pavements dressed drably enough in their class uniforms. Men wore hats in those days; bowler hats, homburg hats, trilby hats, the latter when worn with suede shoes suggesting something a little more daring, a refugee from the racecourse, an ex-RAF officer, a conman perhaps. Women in headscarves and shapeless coats shuffled along the street markets in worn-out shoes to buy vegetables from costermongers in flat caps and white scarves. The younger women were still wearing strict wartime suit jackets, often over printed frocks, with bare legs and socks set off precociously with platform or wedge shoes. It is easy to assume that all this had changed by the 1960s. Yet a 1967 film, *The London Nobody Knows*, showed older women, at least, still dressed in the same headscarves and coats, still trawling the street market stalls for second-hand clothes, so that this documentary constitutes a reminder that memories are always false memories. There was more to 'the swinging sixties' than Twiggy in a miniskirt and young blades tearing around on scooters; and film, rather than necessarily reinforcing the clichéd images of media memory, can also memorialise the persistence of the old in the midst of the new.

New youth fashions were found not in the 'young trend' or 'Junior Miss' sections of department stores with their acres of space and huge fitting rooms, but in the jazz clubs where styles that had somehow wafted from across the Channel were to be seen. Young women modelling themselves on Existentialists and the Left Bank wore Black Watch tartan trousers of the kind made fashionable by Juliette Gréco, existentialist chanteuse. Grandmothers' black lisle stockings could be rejuvenated as an 'arty' mode. A black polo neck sweater, a 'peasant' dirndl skirt, an embroidered Magyar blouse (these harking back to a vaguely remembered period when the Soviet Union was still an ally, before the Cold War was declared) and a duffle coat completed the outfit.

Meanwhile, near the 100 Club in Oxford Street where Humphrey Lyttleton's trad jazz band played, the Soho tarts stood on every corner still wearing the fashions of a decade earlier: platform shoes with ankle straps and suits with military shoulder pads, whether because they were too poor to afford new clothes or because it was an informal prostitutes' uniform, to show off legs at a time

when most women's pins were muffled in voluminous 'New Look' skirts.

The streetwalkers offered a reminder that other worlds through the looking glass might be dangerous as well as alluring. But that was part of London's strangeness, or perhaps it is the strangeness of any big city, that every pedestrian could be an incognito refugee from any of the hidden social worlds that lay beneath the uncompromising façades and dour panorama of the endless streets.

When the noise of traffic faded as the wandering pedestrian found him or herself in some backwater, some road or square that became uncanny simply by being uninhabited, the consciousness of hidden lives intensified, and perhaps this sense of hidden worlds was stronger in London when there were so few cafés or public spaces, when life was lived beyond closed doors, in private places. Because London seemed a secretive place, dress played an important role. It gave off signals of adherence to imagined worlds; it played an essential part in the panorama. But sometimes the signals themselves were so covert as to be invisible to all but the already initiated. The uniforms of those who were then beyond the pale – gay men, for example – had to be almost as hidden as the circles to which they gestured.

The lead singer of the 1960s' band, The Kinks, Ray Davies, wrote in his autobiography of his wanderings round London's West End in search of 'real life', searching for the hidden world that perhaps did not exist outside the adolescent imagination, or was perhaps really nothing more than the future adulthood that would inevitably arrive, when simply by growing older the youth would get to be given the key to the door, even if it was not the door he or she had hoped to open.

There is a frustration in watching those ancient post-war films – The Fallen Idol, Hue and Cry, or one of Robert Hamer's masterpieces of cynicism, thwarted passion and lost hopes – at the impossibility of penetrating the screen, of actually *being there*, not just to remember – or imagine – but actually to experience what it was like. Tired of the excess of consumer society at the millennium, there is a longing to know again the poverty of that time, the visual austerity, above all the unfinished, untidy London of 60 years ago.

In the new millennium the future is fast fashion with styles in such quick succession that one can get caught in a hamster wheel of change spinning so fast that it seems to be stationary, while the reconstruction of the East End to host the Olympic Games threatens to destroy all those unfinished, disregarded, interstitial wildernesses, the spaces between, indeterminate spaces with no name.

In the light of this, the gaze backwards into the past is less a sentimental longing than the appalled stare of Walter Benjamin's angel of history; the backward gaze of the subject being blasted forward by the winds of history: 'This storm irresistibly propels him into the future to which his back is turned, while the pile of debris before him grows skyward. This storm is what we call progress.'

Nostalgia then becomes the recognition that we have been whirled away far ahead of ourselves into a landscape of estrangement. At the same time, though, beware. The familiar past we recreate so lovingly in memory, when it was the real, lacked the certainty we retrospectively endow it with. If nostalgia were sentimental it would be a lie or at best a gross distortion of the past. But nostalgia is, as I discussed above, an act of mourning. Just as, eventually, the pain that accompanies the loss of a loved person at least partly fades into loving memory, so nostalgia dissolves the pain of the past in a memory of its beauty. But if one were to enter the celluloid dream and find oneself back in the grey streets of the 1950s, one would only long, of course, to get away.

PART TWO

Fashion

Fashion must be the intoxicating release from the banality of the world.
DIANA VREELAND

Anyone who has spent time, as I have, studying, discussing and writing about fashionable dress, will know that to argue for its importance and worth is to invite disbelief and disagreement, sometimes bordering on contempt. Fashionable dress is considered unworthy of serious study, a superficial subject that only superficial persons find interesting.

This disdain can easily descend to furious argument and public debate concerning items of dress that seem to arouse not merely disapproval, but quite violent antagonism. Over the past 50 years, Teddy Boy suits, Punk, miniskirts, low-slung trousers and the niqab are but a few of the garments to have aroused passions that contradict the idea of dress as unimportant and trivial. At the same time, the intensity of the rage with which certain items of dress are attacked seems as irrational as the idea that fashion is not important at all.

Dress is dismissed as unworthy of serious attention because it is preoccupied with the body and the appearance, the outward rather than the inward. When we are thinking about dress we are not thinking about 'higher things'. Yet it expresses all sorts of moral, political and religious meanings to which we respond

emotionally. Onlookers and critics do recognise that the Islamic veil is controversial because it symbolises a particular way of understanding sexuality and relations between the sexes, beliefs about gender relations and appropriate roles of men and women, which inevitably confer on it secular as well as religious meanings. They know that Punks or Teddy Boys – or members of other subcultures – are expressing rebellion and youthful dissidence in the way they choose to dress. But those who attack the niqab, the Mohican or the drape suit attack the messenger rather than the message. Taste in dress is also, of course, a function of class and other differences and acts as a lightning conductor for prejudices we hesitate openly to express.

These inconsistencies reveal the problem posed by dress. If it really were trivial, no one would get steamed up about it. Dress disturbs and preoccupies, not only because it speaks sexuality and rebellion, but also because of its very nature, which is to be visual and (if possible) pleasurable. Dress is concrete; clothes are objects. They are part of the aesthetics of daily life and the aesthetic dimension of life is about pleasure and beauty. This aesthetic dimension of life extends to all cultural activities, to the arts, sport and entertainment, and the aura of ambivalence and bad faith that hangs over fashion extends to these activities too – although to some more than others.

Clothing and adornment of the body are universal human, cultural activities of great symbolic importance, while economically, ideologically and aesthetically, fashion/dress is central to global culture. Dress also contributes importantly to the aesthetic dimension of life, and this is perhaps the source of the greatest ambiguity. It is concerned with pleasure and beauty. This is the aspect of fashion that seems hardest to accept. It turns out to be easier to discuss the morals of dress and fashion than to acknowledge the pleasures of dressing. It may be acceptable to say 'I take great pride in my appearance', because that suggests respectability and conformity to norms of cleanliness and neatness, but to say 'I take great *pleasure* in my appearance' is surely self-indulgent, an expression of vanity and narcissism. Yet the pleasures of dress are in fact not just about one's own appearance. Clothing is also about its own aesthetic effect. Yet it is considered not quite

right to revel in the perfect redness of one's varnished nails, in the way a well-cut suit caresses the body, or the way the beautifully embroidered silk of a gown rustles and gleams.

The acceptable parameters of pleasure are generally wider in societies that claim to be liberal and democratic, but all societies have placed limits on what forms of pleasure are acceptable. Within Christendom, until the Enlightenment, the morals of pleasure were adjudicated by the Church. Pleasure was a religious matter. The fashionable, worldly individual, particularly a fashionable woman, was denounced, her pleasures doubly sinful because they both expressed her own vanity and were intended as sexual seduction, to lure men into sin.

Perhaps surprisingly, fashion was not released from disapproval with the ascendancy of rationalism and science. It was simply that attacks on fashion moved onto different ground. Then fashionable dress was criticised for being unhygienic, unhealthy and produced in conditions of economic exploitation. Clerics no longer thundered against fashion from the pulpit; instead, doctors and dress reformers deplored 'errors' in dress and argued for clothing that was 'healthy and rational'; that is, which didn't impede women's main function, which was to breed. Today, sweatshops are still condemned, but otherwise the argument has shifted again, with the emphasis on the environmental damage sustained by the planet as the result of 'fast' mass fashion. At the same time, in relation to Islam there is also a return to concerns with modesty and sexual temptation, while many deplore the way the fashion industry sexually objectifies women, and doctors and politicians blame fashion for promoting anorexia and drug addiction.

Finally, fashion is one of many forbidden pleasures in which consumer society invites us to indulge. And in our disavowal is reflected the deep hypocrisy of our society. But perhaps there is something more: that fashion is ultimately disturbing, pertaining not just to display but also to hidden desires and dreams, even to magic.

4 Magic Fashion[1]

The finding of an object serves exactly the same purpose as the dream,
in the sense that it frees the individual.

ANDRÉ BRETON

There is more to fashion than meets the eye. The Surrealists under-
stood its uncanniness and in *Fashion and Surrealism*, the late Richard
Martin explored their ability to penetrate beneath its surface. His
starting point was Lautréamont's famous definition of beauty as
'the chance encounter of a sewing machine and an umbrella on a
dissecting table', illustrated by Martin with two Surrealist images of
a woman being actually sewn, actually created by a sewing machine.
These are disturbing images that seem to endorse common
objections to fashion: that it distorts and actually physically harms
women, for example. But Martin's comment is subtler. A garment,
a dress for example, he suggests, is *not* the woman who inhabits it,
yet *references* her, and is a memory of her body.[2]

Each of the female bodies in the images, a painting by Oscar
Dominguez and a collage by Joseph Cornell, appear passive
and unmoved as she is fashioned by the machine. Such eerie
detachment is a facet of that uncanny quality that, says Hal Foster,
'is central to Surrealism'. The Surrealist Uncanny consists in part
of a 'confusion between the animate and the inanimate'.[3] This is
central to the relationship between garment and wearer. Normally,
in our interactions with others, we see not bodies but clothing;
clothing stands in for the body. It is, as Martin suggests, an intimate
and even mysterious relationship. In the works by Dominguez **55**

and Cornell, the female figures are both living and inanimate, in suspended animation at least. They purvey serenity rather than a sense of constriction. Yet they also recall Simone de Beauvoir's denunciation of fashion and beauty culture as the reduction of the living woman to a thing:

> Routine makes a drudgery of beauty care and the upkeep of the wardrobe. Horror at the depreciation that all living growth entails will arouse in certain frigid or frustrated women a horror of life itself; they endeavour to preserve themselves as others preserve furniture or canned food. This negative obstinacy makes them enemies of their own existence ... good meals spoil the figure, wine injures the complexion, too much smiling brings wrinkles, the sun damages the skin, sleep makes one dull, work wears one out, love puts rings under the eyes, kisses redden the cheeks, caresses deform the breasts, embraces wither the flesh, maternity disfigures face and body ... spots, tears, botched dressmaking, bad hair-dos are catastrophes still more serious than a burnt roast or a broken vase, for not only does the woman of fashion project herself into things, she has chosen to make herself a thing.[4]

Walter Benjamin echoed this thought in his ambiguous notes on fashion in *The Arcades Project*, perceiving a sinister side to fashion: 'Every fashion stands in opposition to the organic. Every fashion couples the living body to the inorganic world. To the living, fashion defends the rights of the corpse. The fetishism that succumbs to the sex appeal of the inorganic is its vital nerve.'[5]

To the confusion between the animate and the inanimate, the Surrealists added the confusion between the natural and the artificial. Fashion lives this out, for garment and body are inseparable, neither complete without the other. The naked body may be biologically complete in itself, but is not socially and culturally complete without adornment. And certainly the garment is a mere shadow of itself until it is inhabited. Théophile Gautier observed:

> In the modern age clothing has become man's second skin, from which he will under no pretext separate himself and which belongs to him like an animal's coat, so that nowadays the real form of the body has been quite forgotten.[6]

This may be less true today than it was in 1860, but it is still clothes that make the body culturally visible and, conversely, the clothes themselves are only complete when animated by a body. As the Surrealist-influenced designer Elsa Schiaparelli put it: 'A dress cannot just hang like a painting on the wall or like a book remain intact and live a long and sheltered life. A dress has no life of its own unless it is worn.'

We initially tend to assume that fashion is intended to improve our appearance and make us look more beautiful, but Richard Martin underlines the ambivalence of this close relationship between fashion and body, something well understood also by the Surrealists. For them, he argues, fashion offered a 'compelling friction between the ordinary and the extraordinary, between disfigurement and embellishment, body and concept, artifice and the real'.[7]

By aligning fashion with art, Richard Martin asserts fashion's cultural importance. If fashion is a form of art then it becomes more than a soothing consumer product aimed at making life more pleasant. Art offers an 'insurrection to daily life'. Art is subversive, challenging our assumptions.

On the other hand, Surrealist artists, such as Salvador Dali, Jean Cocteau and Cecil Beaton, forged in the 1930s a close relationship between fashion, popular media and commerce. Surrealism provided a fertile source of inspiration for fashion magazines, advertisements and window displays as much as film and photography, which were transformed by the movement. Many in the art world argued that in engaging with fashion and advertising, Surrealism was cheapened; that Surrealism proved amenable to the purposes of consumption, proved its superficiality and lack of integrity and disbarred it from being considered as art. (Psychoanalysis, of course, was similarly used in PR and marketing, yet has escaped criticism on that account.) It was also in its use of psychoanalytic ideas that Surrealism, as used, say in advertising, linked consumer objects with the unconscious desires of the public.

Yet it is possible to overemphasise the showmanship and playfulness of artists such as Dali at the expense of a different, literary tradition in Surrealism, dominated by André Breton, the difficult patriarch of the movement. Breton disliked Dali, whom he nicknamed Avida Dollars, alluding to Dali's thirst for fame and

celebrity; whereas he himself was rigorously intellectual and his work in many ways courted obscurity.

Both were nevertheless intensely preoccupied with the nature of the unconscious: but where – as so many argued, even at the time – Dali's efforts to introduce psychoanalytic symbolism and concepts into his art resulted in an all too conscious and knowing intellectual vulgarity, Breton pursued his sense of the Marvellous by journeying into 'an uncharted conceptual terrain', using the 'disorientating signposts' of somnambulism, hypnotism and the occult 'on a "voyage to the end of the Unknown to find the new!"'[8] In Breton's world, objects acquire an obscure and often disturbing significance, very different from the consciously witty and subversive garments of, for example, Schiaparelli.

Breton was a resolutely avant-garde and intellectual writer. At the same time his interest in fortune-telling, clairvoyance, hypnotism and the tarot connected him to a mass popular audience. Breton, unlike many intellectuals, did not approach such beliefs with a sense of irony. Otherwise rational individuals read horoscopes, perhaps even consult astrologers, refer to their own personal characteristics in astrological terms ('I'm a typical Leo') and enjoy tarot readings. But there is more often than not an element of disavowal in this, an ironical self, distancing from anything resembling total, unquestioning belief. In approaching 'superstitions' naively, as it were, Breton both acknowledged the role of 'fate' in human life, which is the extent to which we do not control our own destinies, and equally the persistence of human efforts to reach beyond the surface of life to find underlying meaning.

Garments play a significant role in the shadowy realms of superstition, fate and the occult. Sportspersons and actors seem particularly prone to superstition, no doubt because of the emotional and physical risks any performer takes in testing their skill in front of an audience. Billie Jean King, for example, a multiple Wimbledon champion in the 1960s, had a favourite dress she had to wear for every match, Bjorn Borg did not allow himself to shave for the duration of a tournament and Goran Ivanisevic, unlikely winner of Wimbledon in 2001, celebrated each successive unexpected match victory by stripping off his shirt and tossing it into the crowd, as a mascot or fetish for the lucky spectator who caught it.[9]

It is not surprising that dress should be involved in personal superstition, nor are such superstitions confined to performers. Certainly for many individuals, articles of clothing not only affect mood and self-perception, but also acquire quasi-magical properties and meanings.

The British psychoanalyst, Donald Winnicott, noted how many small children have a special object, often a blanket or shawl, or sometimes a scarf or even part of the mother's dress, which they have to have with them at all times. Winnicott's name for this 'security blanket' was the 'transitional object'. He believed it symbolised the mother and the mother's body. The infant clings to this symbol or metaphor of the mother as it gradually separates physically and emotionally from this first symbiotic relationship, which begins for many as a kind of merging. The piece of material or garment stands in for the mother during the transition from complete dependence to relative autonomy.

Walter Benjamin implied a similar association between clothing and the mother/child relationship when he wrote of 'what the child ... discovers in the pleats of the old material to which it clings while trailing at its mother's skirts'. Garments, once they have been worn, come to have a residue. They take on qualities of the wearer and of the occasions on which they were worn. Their feel and smell come to represent memories, conscious and unconscious. They are far from being simply functional adjuncts to the body, or even a language of communication, but take on symbolic meanings of which we are not always aware.

In their superstitious behaviour, tennis players exposed a central feature of magical beliefs when focused on an object. The idea of 'luck' is intimately related to the idea of 'chance'. A 'lucky' outcome imbues the object that is believed to have contributed to it with an element of fate, converting chance into its opposite. On the first occasion a garment worn for a match that was won had been chosen by chance, but retrospectively is imbued with the fortunate outcome so that now the choice of that garment rather than any other seems to show the 'hand of God'. In this way a chance object becomes a fetish object and therefore highly magical.

Fetish takes its own specific form in consumer society. A different ritual holds sway and it is fashion that 'prescribes the

ritual according to which the commodity fetish demands to be worshipped'.[10] The society of the commodity demands the novelty of the continually changing. It follows that the rapidly changing fashion cycle is particularly resonant in the society of capitalist consumption, since it symbolises the way in which the fixed and stable class and social relationships of earlier epochs are dissolved. Therefore, where commodities once signalled established rank, they now increasingly operate as signifiers of identity, social place, make believe and value – and also of desire. The idea of fashion as symbolic is often taken to mean simply that designer clothes and 'labels' become straightforward status symbols, operating purely on a conscious level of emulation and display; but there is much more to it than that. Garments, like other objects, take on imagined and/or subjectively experienced properties that go far beyond the flaunting of wealth or refined taste. It is *because* we live in a society dominated by capital and consumption that we commandeer material goods for the symbolic expression of values remote from materialism. Superstition, magic and spirituality are expressed through secular fetishes – as we shall see later in relation to 'fans'.

Magic, witchcraft, paganism and superstitious practices are the residues of older religions crushed by monotheism – although Christianity itself incorporated various features of pagan belief. But in any case, until the late sixteenth or early seventeenth century in Britain, magic and science were similar, and beliefs that today seem fanciful or magical, such as astrology, were part of the educated person's picture of the universe and its workings.[11]

A similar mingling and confusion between Christianity and paganism is to be found in the history of the fetish. Very briefly, the idea of the fetish arose in 'a mercantile intercultural space created by the ... trade between cultures so radically different as to be mutually incomprehensible, that is the European slave trade with West Africa'. It is a hybrid, belonging to neither culture. The term originates from the Portuguese and from the period when Portuguese traders were active along the West African coast. These Roman Catholics brought ideas of witchcraft, superstition and idolatry to the objects and practices they encountered. In the seventeenth century, Dutch protestants ousted the Portuguese, and for them the fetish and related phenomenon represented a 'chaotic irrationalism'. This

complex cultural encounter eventually led to the Enlightenment view of the fetish as an example of false values and superstitious delusions. These blocked reason and were misunderstood as miraculous events whose origins lay in the natural world.[12]

The fetish therefore arises in the same period as the commodity form. It became an important rhetorical and theoretical idea in the writings of the foremost theorist of commoditisation, Karl Marx. For him, Capital itself was a kind of fetish and political economy; an 'a-theological religion of everyday life' in a secular society that remains fundamentally irrational. Marx developed the concept of commodity fetishism to describe and explain the way in which, as in a religion, an inanimate human product acquires a life of its own. The difference is that whereas in anthropological fetishism the fetish bestows power (whether real or imaginary) on the owner or wearer, in Marx the fetishisation of the commodity involves the disempowerment and alienation of the human actors.

Marx wrote of the fetishism of the *production* process, but objects of *consumption*, including of course garments, are also fetishised, taking on a meaning far beyond their use – or exchange – value. They therefore become like figures of speech or metaphors. Above all, the fetish involves a form of 'disavowal'. A fetish object takes on, for its owner, metaphorical and symbolic meanings which make disavowal possible, disavowal being the idea that 'I know this cannot be true *but yet* I believe...'.

The fetishism of articles of clothing and body parts is most usually discussed in relation to sexual fetishism, and for the Surrealists the conjuncture of dress and the body could certainly become intensely erotic, as the artist Hans Bellmer indicated:

> I wonder if I will wear the tight seamless trousers made of your legs ... and do you think I will, without swooning prematurely, button over my chest the heavy and trembling waistcoat of your breasts? As soon as I am immobilised beneath the pleated skirt of all your fingers ... you will breathe in me your perfume and your fever.[13]

Sexual fetishism is important, but the fetish, including fetish garments, may also stand in for other, more nebulous desires: for power, for social affirmation, for spiritual certainty, as well as, of

course, as Marx demonstrated, representing the machinery of capitalism.

Theodor Adorno, analysing astrology and occultism, saw popular superstitious practices as alienated, yet, like neurotic symptoms, having their own rationality; they perform a function of compromise between situations in which individuals are powerless, yet desire to feel they have some control. The still pervasive, classical liberal view of the unfettered individual and his freedom is incompatible with the paranoid, bureaucratised world we live in, Adorno argues, but quasi-magical beliefs provide some kind of defence in this world. At the same time he notes the irony and disavowal characteristic of our attitude towards astrology and similar beliefs, an intellectual attitude he describes as one of 'disoriented agnosticism'. Yet alienated forms of belief nevertheless express real and genuine yearnings, for something beyond the organised sciences which, as Adorno says, 'do not cover the universality of existence'.[14]

This was also Breton's view, but he went further than Adorno, since he rejected the view that the fetish was only an aspect of false consciousness or alienation, albeit one with a defensive function. The fetish, he believed, related to the Surrealist concept of the Marvellous. The Marvellous came about as the marriage of what the Surrealists called 'convulsive beauty' and 'objective chance'. Chance encounters, unexpected places and found objects all exemplified the Marvellous. Their accidental occurrence or the unexpected manner in which the Surrealist became conscious of them invested them with the same sort of magical meaning as had been attributed to the fetish. He believed in the special importance of what he called 'found objects'; objects he chanced upon and in which there seemed to inhere some obscure but portentous meaning. Found objects were, in fact, Breton's take on the fetish. In L'Amour Fou, Breton defined chance as 'the form making manifest the exterior necessity which traces its path in the human unconscious'. Engaged in an attempt to formulate a 'modern materialism', a form of Surrealist Marxism that would dissolve the distinction between the material and the ideal, he searched for an obscure third realm underlying both. Chance encounters and found objects were, he believed, portents of or keys to this realm in which human subjectivity and external reality might be resolved and reconciled, their contradictions abolished.

The found object contains repressed energies, but at the same time has the power to undo repression. As a piece of the object world it connects that world with the psychic world of the individual.

Breton looked to psychoanalysis to bring a new dimension to Marxism, since one of its strengths is its insistence on the power of the irrational. Unlike Freud he did not seek to reduce the sway of the irrational. On the contrary: 'it is only by making evident the intimate relation linking the two terms real and imaginary that I hope to break down the distinction, which seems to me less and less well founded, between the subjective and the objective'. This, of course, was a utopian aspiration.

There was an uncanny aspect for the Surrealists to the dreams, chance encounters and psychic states they privileged, in which dream/reality and animate/inanimate were blurred or confused. The relationship of dress to body is especially appropriate as a site of this blurring.

For the Surrealists, the memories and associations stored in the folds of garments constituted something more than alienation. Dress in modernity acts as a vehicle for the enchantment that Max Weber felt had been leached out of the world by the imperatives of bureaucratic rationalism. Dress became a largely unacknowledged conduit for the communication and symbolisation of inchoate impulses and desires. Elsa Schiaparelli's designs from the 1930s, playful enough at first glance, exploring the ambiguously blurred boundary between body and garment, hinted at something darker and more uncanny. Far from forfeiting all claim to artistic seriousness by succumbing to the seduction of consumption and becoming part of the seduction process, her Surrealist-inspired engagement with fashion rendered it more serious, rather than being frivolous.[15]

Jean Baudrillard, writing 50 years later, challenged the very idea that seduction was something to be rejected. In contrast to Breton, he rejected psychoanalysis as anti-magical, because it wanted to restore unconscious impulses to the realm of reason through interpretation. He argued in favour of seduction as an anti-rationalist opposition to attempts to explain and to orthodox approaches. Seduction was 'malefice and artifice, a black magic for the deviation of all truths, a game with arbitrary rules and elusive rituals ... to seduce is to die as reality and reconstitute oneself as

an illusion'. This he defended as an aesthetic rather than a moral approach to life, and 'it is what remains of a magical, fateful world'. He suggested that fashion, which is 'a passion for the artificial', is a 'kind of fetish, an increasing excess of communication'.[16]

Similarly, for Breton the magically found object really can unleash new energy and unchain our desires. The fetish can act as a catalyst in transforming the individual's relationship to the world. It acts to redeem the non-sentient world and re-energise our relationship to it: as Richard Martin believed fashion could do because of its power of memory and its latent subversive quality.

Any attempt to explore the magical properties of dress may seem a puny and even trivial commentary on the unnerving world of consumption, with its illusory and disorienting powers of enchantment. There is, of course, a powerful element of disavowal in the stereotypical popular dismissal of fashion as inherently trivial: disavowal because alongside the dismissal of fashion we see crowds flocking to fashion exhibitions and devouring fashion magazines and newspaper columns.

Surrealism helps us to understand something of the reasons for our fascination with fashion and our uneasiness about it. We strive to invest our lives with something of the magical, to access 'the dream energy of society', which Walter Benjamin felt had accumulated within fashion, while being drained from so much of the cultural fabric of his time.

It is the very irrationality of fashion – its most frequently criticised aspect – that gives it significance. It bears witness that the magical is more than just the refuse, the useless rubbish of the rational Enlightenment world. Like Surrealism, fashion affirms the autonomy and mystery of human desire, its irreducibility, at a time when not only our bodies but also our very desires are in danger of being wholly colonised by consumer lifestyle.

Fashion, the epitome of consumerism, is also its stealthiest critic, and in its obsession with what Freud referred to as 'the refuse of the phenomenal world', of the disregarded, the marginal and the every day – of the tiny details rather than the grand narratives of life – suggests that there are still gaps in the apparent seamlessness of consumer culture through which we can escape into enchanted worlds.

5 Glamour: The Secret Behind the Sheen[1]

Glamour is ... about the persistence of longing.
ROBERT C. MORGAN[1]

That elusive concept, glamour, is closely associated with fashionable dress. It is also linked to performance. At the turn of the twentieth century, glamour was located in theatre and music hall; by the 1930s it was part of the thrill of Hollywood. Films disseminated one particular idea of what glamour was, and studio portraits of the stars relied on what they wore as much as on the actors themselves – indeed, with the use of lighting and make-up, they created images that really did become (to use a hackneyed and often inaccurately deployed word) icons.

Yet originally glamour meant something more than airbrushed perfection, both word and concept drawn from ancient Celtic culture. It is thought to be a corruption of 'grammar' and thus associated with knowledge. In turn, 'grammar' was related to 'gramarye', which meant occult learning or magic. The OED cites an early eighteenth-century use: 'when devils, wizards or jugglers deceive the sight, they are said to cast a glamour over the eye of the spectator'. The word continued to have the sense of casting a sheen, that is to say dazzling or blinding the spectator. This in turn suggested something false, a trick in which the surface deceives what is really going on underneath. A different meaning, but one also related to the idea of 'sheen', was that glamour came to be associated in some degree with a sense of a shiny and thus a hard surface.

The Scottish Romantic novelist, Sir Walter Scott, is credited with having introduced the word to modern English at the turn of the eighteenth and nineteenth centuries, but the lure of the gothic and exotic in literature actually arose earlier, for Horace Walpole inaugurated the vogue for 'gothic' fiction with *The Castle of Otranto*, published in 1764, and this was followed by Ann Radcliffe's best-seller, *The Mysteries of Udolpho*, published 30 years later. Terry Castle argues that the rise of gothic fiction and, more widely, a gothic sensibility should be seen as the 'Other' of the Enlightenment; that is to say, it expresses the irrational, supernatural and ineffable expelled by the reason, deism and scientific cast of thought of official eighteenth-century culture.

Scott's historical best-sellers presented an idealised vision of a wild, pre-modern Gaelic culture full of heroism, the supernatural and the picturesque, evoking the imaginative power of a culture distant in time (as did John Keats in his poem *La Belle Dame Sans Merci* and later Tennyson in his Arthurian poems). Other Romantic writers applied the sheen of glamour to geographically distant cultures; Byron, for example, being particularly enamoured of the near East. These narratives, especially Byron's, linked beauty and emotional power with an element of the sinister or at least the doomed or damned – the 'fallen woman and the fatal man' being key figures. Costume played an important role in these literary romances, which exploited the thrill of the exotic 'Other' (there is a famous portrait of Byron himself in Greek national dress). In the nineteenth century fashion played with historical fashions; while Turkish costume influenced utopian dress.

In the field of the fine arts, the Pre-Raphaelites were devoted to their vision of the medieval and gothic, but the sinister was downplayed in favour of, for example, the idealised, glossy and otherworldly beauty of Dante Gabriel Rossetti's portraits of his lovers. G. F. Watts brought this glamour to his society portraits, depicting his beautifully dressed female sitters as ever pensive beauties, often standing against a mysterious and timeless garden landscape. In these paintings the sheen and gloss of glamour enhances the personality of well-known individuals.

Why should the concept of 'glamour' have emerged at the dawn of the industrial age? The French Revolution had put a final end to

belief in the divine right of kings, even as the eternal cycle of rural life was destroyed by the coming of the factory and the great new cities. As Karl Marx famously put it, 'all that is solid melts into air', to create an unprecedented world of hitherto unimagined sensation, uncertainty and uprootedness. In this new world, political authority would increasingly adhere to leaders who gained ascendancy by force of personality – charisma – rather than by inheritance. Often this power would be gained by illegitimate means; the weakness of the democratic procedures that developed in nineteenth-century Europe, at least, providing avenues for their own usurpation by the unscrupulous and the dazzling. The gradual decay of organised religion in the West resulted in a displacement of religious sentiment onto politics, so that heroes such as Garibaldi and (much later) Chairman Mao became iconic figures, the supreme example being, of course, Adolf Hitler.

Along with the revolutionary upheavals and the rise of the Romantic Movement there emerged a figure seemingly indifferent to industrialisation and equally distant from romanticism: the dandy. George 'Beau' Brummell, while he did not single-handedly invent the new regime of masculine dress, condensed it in his person and imposed it on society so successfully that its aesthetic protocols have lasted until the present time (the demise of the modern man's suit, periodically announced, never actually occurring).

Glamour, then, starting as magic, then developed into a very specific form of individualism via Byron and the dandies of the Regency period. With the dandies it took the form of personal charisma. The individual imposes himself upon society by means not of power but of self-presentation and personality, unanchored and divorced from traditional social relations. The dandy, in other words, is a performance and, individual that he is, paradoxically anticipates the rise of spectacular mass culture – for eventually 'stars' replace aristocrats and royalty as figures of glamour. 'Beau' Brummell was a middle-class upstart. The new masculinity he constructed became the template for the nineteenth-century bourgeois businessman, but dandyism itself was more subversive. Beau Brummell appears to have been a heterosexual womaniser, but dandyism came to be associated with eroticism outside the conventions of marriage, homosexuality or a narcissistic asexuality.

Dandyism developed into a defiant – nihilistic – political posture in France, and was succinctly theorised by the poet Charles Baudelaire in a short essay on the subject.

The dandy aesthetic was one of exquisite restraint, refinement, cleanliness and renunciation, certainly in Britain, although perhaps less so in France. According to George Walden, the dandy continues today in new forms. He argues that the aesthetic of the dandy is basically an attitude, confined neither to a historical period nor to the minimalism of neutral colours and unostentatious yet perfect cut and textiles.[2] Above all, however, it creates a seamless protection, as impenetrable as the carapace of a beetle and indicative of secretiveness, ambiguity and an opaque personality.

The secret at its heart was due to the originality of Brummell: he fused the wearer and the dress. The dandy was not just a style of dressing, nor was it just a certain kind of person; it was the combination of the two, united in a stance of combined disdain, provocation and indifference towards the world. The dandy is therefore the quintessentially glamorous individual. He entered the cultural stage with a conscious or unconscious understanding that the new economic world order was destined to promote an individualism expressed in diverse forms of consumption.

Yet glamour is not about consumption in the consumer society. Nor is it simply about luxury. The sociologist Georg Simmel saw how fashionable dressing sought to extend the 'force field' of the individual's personal aura, making it wider and more striking; fashion as an adjunct to power. Dress, however, did not simply indicate power in the obvious sense of a class uniform; nor was it about mere wealth. More subtly it brought the combination of person and clothing to a pitch at which that person created glamour by means of daring departures from the conventionally well-dressed, combined with an aura of defiance. Yet at the same time, this method of art as life, or one's self as a work of art, was nihilistic. What was it *for*? Personal advancement must have been a motive; yet Brummell in the end – from boredom or self-destructiveness? – undid all the personal power he had acquired, ruined by debt and his quarrel with the Prince Regent. Some of the courtesans who also traded on their glamour, notably during the Second Empire period in France, were also brought down when their lives spiralled

out of control, whether from greed or promiscuity. In some sense they prefigured the celebrities of the late twentieth century.

Glamour is an essentially secular concept precisely because it usurps certain religious or spiritual features. A dandy might well think of himself as a martyr to his dress, and Baudelaire discussed this aspect of dandyism, but the only spiritual or supernatural element that enters into glamour is the extent to which it can provide a home (albeit of a kind that might seem trivial to many) for a displaced search for perfection. The religiously devout continually castigate themselves for their failures to achieve a state of grace; and the same struggles are played out on the surface of the body by those who are dedicated to the cruel arts of fashion.

Glamour crept into the English language at the same time as industrialism provoked the reaction of the Romantic Movement with its love of gothic, because these changes were connected. The gothic served as the opposite of Enlightenment rationality, but it was also pressed into use as a critique of the iron necessities of the new world of work and the factory cities, now longing for an authenticity that seemed to have been lost in commerce and business. As we saw earlier, the Aesthetic Movement was a later reaction to the need for beauty and the search for glamour.

Secular as it was, the lingering meaning of spells and witchcraft continued to be found in the idea of glamour as the dangerous secret of those outside respectable society; the femme fatale of the decadence and the *fin de siècle* was a manifestation of this, sometimes literally diseased and deathly, or hideously supernatural as in Bram Stoker's idea of the vampire. His *Dracula* popularised in a covert way all the fears about dangerous sexuality, syphilis and fatal women that swirled around in a society in which traditional restraints were becoming more difficult to maintain. The torrent of vampire fictions, and, above all, the vampire films that have poured from the factories of mass culture throughout the twentieth century and into the twenty-first, have proved that there is an enduring, perilous fascination in this marriage of death and sex. The forbidden and the dangerous were always saturated in glamour.[3]

Almost until the mid century, glamour continued to have *louche*, at time even sordid undertones. The 'vamp' of the silent cinema (vamp was, significantly, short for vampire) was a dangerous and

destructive figure, preying on men. (And 'glamour' was, well into the 1940s and 1950s, routinely used as a euphemism for soft porn, the 'glamour model' or 'glamour photo' being essentially a 'scantily clad' pin-up, or her image.)[4] In the 1930s the vamp ceded to subtler representations, the two most transcendent icons of glamour in the period being Greta Garbo and Marlene Dietrich. That both were of European, non-English speaking origin was part of their allure, signifying them as 'other' from the beginning. Each also had a beauty far removed from the sultriness of Jean Harlow, the perky charm of Virginia Mayo or the sportiness of Katharine Hepburn. Garbo and Dietrich were neither the girl next door nor the 'other woman', but the strange planar sculpture of those extraordinary faces had that 'mysterious blend of accessibility and distance ... neither transparent nor opaque ... [but] translucent', as Virginia Postrel eloquently puts it.[5] Both were also, ironically, lesbian or bisexual – which perhaps attests to the untouchable quality of glamour.

Hollywood made glamour into a mass commodity. The image was increasingly crucial to the amplification of glamour – Hitler was as much aware of this as Louis Mayer, using his own photographed image and the films of Leni Riefenstahl to promote his ideology – but did not this irreversibly change, or destroy glamour in the long run? To begin with, after all, glamour was a kind of cottage industry, a self-produced effort; its endless reproduction reduced once shocking and alluring styles to banality. How wise of Garbo to retire to her solitude.

For glamour is elitist. The emotions associated with glamour include desire, fear, deviance, loss and an acknowledgement of death. Glamour carries with it a whiff of the tragic; many are those who achieved glamour through suffering: Byron is one possible example.

Paradoxically, glamour is also the result of work and effort – artfully concealed, of course. Whether it be Beau Brummell spending hours to tie the perfect cravat, or Garbo creating not only an acting style but, more importantly, a total persona, there is no such thing as instant glamour. Glamour depends on what is withheld, on secrecy, hints and the hidden. In periods when sexual preferences and behaviour were less openly discussed than they are today, this glamour of mystery created an aura of danger, and dangerous fascination.

The elitism of glamour sends a message that we cannot all be glamorous. We can aspire to, but will never reach, the stars. The Star is there precisely to remind us of this fact, while beckoning us forward in the hope that we can somehow aspire to the pantheon s/he inhabits: glamour presents itself – disingenuously or not – as divorced from and beyond commerce. It takes itself seriously, is even humourless. And, like fashion, its whole point is its pointlessness.

From one point of view, glamour could be said to have reached its fashion zenith with Christian Dior's New Look and Balenciaga's sculptural gowns in the 1950s. The latter in particular expressed a modernist, minimalist glamour, akin to that of the dandies, creating a perfect body, smoothly encased in its shell.

Yet it was also in the 1950s, at its height, that glamour began its retreat in the face of celebrity. As consumerism revived after the deprivations of first the great depression, then war and the years of austerity, figures such as, in Britain, Princess Margaret, younger sister of the British queen, and in the United States the entertainer Liberace, aspired to glamour but perhaps achieved celebrity. At the end of the decade the Kennedys reasserted glamour as an adjunct to power, and the 1960s were more glamorous years than those that had preceded them. The youth music and drug culture had plenty of glamour and tragedy. In Britain the 'Moors murderers', Ian Brady and Myra Hindley, equally aspired to the glamour of evil – Jeff Nuttall, in his account of the decade's counterculture, *Bomb Culture*, certainly saw them as expressing the darkest aspect of the 1960s' mood, arguing that they fell (only just) 'the wrong side' of the excess of the period and its fascination with 'going too far'.

In contemporary discourse there seems to have arisen an automatic assumption that glamour relates to and resides in luxury and celebrity, but already in the 1950s glamour was beginning to be eaten away by vulgarity. For a time it had a symbiotic relationship with the mass media, but eventually the mass media invented celebrity as its democratic alternative.

Today, 'glamour and celebrity' are routinely yoked together, as though they meant the same thing. Yet actually they are polar opposites. Celebrity is all about touch; glamour is untouchable.

Celebrity is open, shameless, vulgar, in-your-face, nouveau riche. The feelings elicited by celebrity have more to do with envy, malice,

greed and *Schadenfreude* than with longing, admiration or aspiration. Glamour might elicit hero worship or sadness; celebrity is about horror and excitement – more infantile, primitive responses. A celebrity may be someone such as the actor Hugh Grant, whose talent and good looks were tainted by the sordid, yet somehow ridiculous, scandal of his encounter with a prostitute, thus revealing him to have feet (or perhaps nether regions) of clay. Indeed, some celebrities are *all* feet of clay. And celebrity does contain an element of Rabelaisian humour, while glamour is humourless. Celebrity is *Hello!* to glamour's *Vogue* as it used to be (for today *Vogue* too has become a celebrity magazine). It depends on total exposure – shameless self-exposure, which divests even quite grotesque acts and 'perversions' of any element of genuine danger.

The self-exposure of the celebrity can be seen as an example of Julia Kristeva's theory of abjection. The abject consists of aspects of our earliest and most primitive emotions, and as the infant grows these must be cast away as unacceptable – impossible to assimilate into the maturing ego. However, residues of these early, primitive impulses remain; the abject can never be wholly erased, but remains as 'above all the ambiguous, the in-between, that which defies boundaries [and represents] ... disorder, it is a resistance to unity ... and is fundamentally what disturbs identity, system and order'.[6] In revealing their 'seamy side', their infantilism and mess, celebrities display a kind of collective 'abject'.

Alexander Warwick and Dani Cavallaro used 'abjection' to discuss dress as a putative boundary between body and outside world, but note that fashion continually breaches this boundary, creating an ambivalence and ambiguity about what is seen and what is concealed. The partnership between body and dress is 'baffling' and: 'if the body itself is only uncertainly defined, dress reinforces the fluidity of its frame by raising the ... question: where does the body end and dress begin?' The porousness of this boundary creates an unease at what might be able to leak out. The perfection of the dandy or the New Look was an attempt utterly to banish the abject.

Rebecca Arnold approached the displacement of glamour and perfection by abjection fashion when she commented on the decadence, 'heroin chic', underwear as outerwear and the cult of brutality and excess at the end of the twentieth century. She points

out that fashion has abandoned its quest for seamless glamour, and instead now encompasses references to death and decay, uncertainty and yearning, in its allusions to the detritus of the city, illuminating the shifting moralities of contemporary existence.[7]

A similar move might be seen in the work of Cindy Sherman, from her earlier 'Untitled' pastiche film stills with young women clad in uncluttered early 1960s' chic, to later images of broken bodies lapped in filth and decay. Tracey Emin's art is a further example of the aesthetic of the self-revealing abject.

It was the late Princess Diana who precipitated the final transformation of glamour into celebrity. She appeared at the start of the 1980s as the very spirit of distant glamour, while at the same time representing the conspicuous consumption of that decade, when the rich grew richer and the poor more desperate. To right-wing triumphalism was added the emergence of the Aids pandemic, an apocalyptic scenario in which gay men – who had so recently emerged from their closet to create a raucously sexual subculture of hedonism and disco – were immediately struck down by what seemed like an Old Testament revenge. 'Inconspicuous consumption' was not yet even a gleam in the eye of the future; the 1980s was an age of extravagant display.

Along with these rather traditional forms of consumer madness, a different underground culture emerged. Gay culture – enamoured of celebrity in one version – also took glamour to the wilder edges of danger. In the 1960s, Andy Warhol and his friends had invented new definitions of glamour and consumption at the Factory in Manhattan. This counterculture displayed not the madness of untrammelled wealth, but the glamour of madness itself. Drag queens on acid, debutantes, outcasts and artists manqué, or not so manqué, dared one another to see how far over the edge they could go. Incandescent moments of crystal meth individualism were worth the price of suicide and psychosis. In any case, perhaps the ultimate drug was simply that: unbridled individualism, swallowed neat. And the attention of an audience: the Factory merged audience and actor to create the sublime experience of a self without boundaries, an ultimate freedom, filmed in movies that lasted for eight hours and in which nothing happened except the spiralling display of excess personality. The shimmering powder of

glamour transformed the marginalised and rejected into stars in a parallel universe.

By 1980 the Factory was long gone. But on the Lower East Side the sublime glamour of the outcast continued. A new generation of the lost and self-destructive was being memorialised by Nan Goldin in her throbbingly coloured photographs, all bleeding red, engorged pink and bruised purple and blue. Her subjects, who were her friends, like the Factory crowd, were women and men for whom the cruel, yawning gap between artistic aspiration and fame was more often than not filled with addiction and sexual transgression, to which was now added disease: now 1980s glamour *became* that very abject of which it had once been the opposite. Goldin recorded the semen stains of exhausted sex and her own face bruised by a violent lover. Glamour was becoming infected by self-exposure. These were the martyrs of consumer culture, gorily displaying their wounds, but tragic as their destinies might be, Goldin transforms their suffering into art. Their wounds – and hers – are as clearly made into an aesthetic spectacle as the religious painting of medieval times and the Renaissance, in which Saint Sebastian elegantly endures his arrows or Saint Catherine is beautifully broken on the wheel.

In 1980s' Britain, meanwhile, the club culture of the New Romantics provided an ambiance for similar displays of life as art. Boy George, John Galliano, Steve Strange, Marilyn and, above all, Leigh Bowery, the culture's high priest, costumed their (then) poverty in costumes that defied nature and biology to create a wholly artificial self. Bowery, a massive Australian, went far beyond gender, let alone mere drag, to transform his being into a parody of glamour that astonished with its effrontery.

At first glance the aesthetic confrontations of the 1980s might seem to have little to do with Princess Diana. She inhabited a rarefied realm of haute couture and royal visitations. Of course, this performance of royalty was (and is) as much a spectacle as Leigh Bowery and Boy George, but the association of Princess Diana's elegance with the British royal family gave it a special aura, and placed it slightly apart. Ironically, the Princess was to play a major part in the partial dismantling of that special royal family aura (now re-established, it would seem, by the arrival of Kate Middleton, Duchess

of Cambridge). Yet in the first years of her marriage, in her initial role as (almost) reigning beauty and ultimate icon of conventional 'glamour', Princess Diana lived a life far removed from the Lower East Side or the Camden Town, London, squats of the New Romantics. In 1985, when she took the Reaganocracy by storm on her visit with Princes Charles to the United States, she seemed wholly at one with the glitz of the period. There was nothing, then, to link the Princess with the demi-monde of a rebellious avant-garde on either side of the Atlantic. She was a vision of remote perfection, heightened by the fluctuating mystique of the British royal family, who are always viewed through the double lens of the ordinary/extraordinary. She made the other royals look dowdy, yet the fact that she was royal herself added to the glamour in which herself was arrayed.

From the beginning, however, there were signs that she might transgress the boundaries that guarded her special status, particularly when in the early years of her marriage she made a gesture that was to bring her closer, symbolically at least, to that other society of outcasts and deviants. On a visit to the Aids ward of a London hospital, she shook hands with an infected patient *without wearing gloves*. Ironically, this gesture, so personal and democratic, also evoked echoes of the ancient magical belief that the monarch's touch can cure incurable illness. This gave her gesture – albeit subliminally – a special significance and almost divine quality, yet at the same time it was a departure from the rigidities of royal protocol and gave notice that she was not going to conform. Hers was the same compassion that Nan Goldin's audience saw in the Lower East Side photographs, a genuine love for the suffering and afflicted, an immersion in their reality. This single gesture might be said to have marked the moment at which the suggestion of magic – with the divine touch – brought her glamour to its highest point; and yet simultaneously the moment at which the shock of the gesture – and its empathy with suffering – tipped her towards celebrity.

As her marriage disintegrated, Princess Diana's transformation from icon of glamour to suffering celebrity gathered pace. In true celebrity style she revealed the details of her 'crowded' marriage – containing three persons – in a famous television interview; there were stories of bulimia, of bizarre relationships, of the unkindness of her in-laws. This fulfilled all the requirements of the celebrity

life: that every scrap of dirty linen be washed in public, that the celebrity is a figure to be knocked off her pedestal, and that it is impossible to disentangle genuine trauma, mistakes and misfortune in celebrity suffering from self-obsession and hysterical addiction to drama. The celebrity is above all a spectacle.

The role played by fashion in celebrity culture is very different from its role in the creation of glamour. In celebrity culture, conspicuous consumption rules. Fashion departs finally from any pretension towards art or even beauty, and becomes largely a matter of branding, money, megaphoned sex appeal and labels. This moves 'glamour' so far from its original meaning as to become meaningless. Alexander McQueen's catwalk shows in the last years of the twentieth century may have resurrected a different, truer meaning for glamour, but in general celebrity has more to do with competitive conformity than individualism. Everyone must join the queue for a Birkin bag, and if you cannot afford an original, there will be plenty of copies at every price range.

The avant-garde designer Hussein Chalayan has bemoaned the symbiosis of fashion and celebrity, saying that it should not be like that. Unfortunately, as he acknowledged, it is. However, he is right that celebrity has essentially nothing to do either with fashion or with glamour. Celebrity itself can be mass manufactured, whereas Brummell had no stylists or PR personnel to promote his 'image'. It was for this reason that it was original and that he was able to create a fashion that, with rather minor changes, has lasted for two centuries.

Glamour is primarily an attribute of an individual. It is an *appearance*, including the supernatural, magical sense of that word – as in apparition. The appearance of glamour resides, though, or is created in combination with dress, hair, scent and even *mise en scène*. Its end result is the sheen, the mask of perfection, the untouchability and numinous power of the *icon*.

Celebrity deconstructs all this, displays everything in bits, the inside, the mess, the clothes apart from the person, the naked greed, the genuine suffering, the painful excess. The celebrity is desperate for our attention. That is why she can never be glamorous. For true glamour is expressed in Garbo's pose of icy indifference, so let her have the last word: 'I want to be alone.'

6 Dressed to Kill[1]

We seldom think of fashion in relation to literature, still less to crime fiction. Yet, from Little Red Riding Hood's cloak to Scarlett O'Hara's gown made from green velvet drawing room curtains in *Gone with the Wind*, dress is inescapably important in the telling of any story. If anything, it is even more crucial in crime fiction.

At its most prosaic (and perhaps least interesting), clothes can function as forensic clues. In Paul Willetts' *North Soho 999*, for example, an abandoned raincoat is the item that eventually nails the murderers – an archival photo of a member of the forensic science team using 'a modified vacuum cleaner to collect dust and fibres from a jacket' illustrates the point.

More usually, dress functions to add realism to the setting. Ruth Rendell excels at suggesting period through details of dress – for example, in *A Dark-Adapted Eye*, where the 1940s are succinctly pinned down with 'Vera in a dress made out of two dresses, brown sleeves set into brown and orange-spotted bodice, surely in 1941 the prototype of such a fashion', but in 1986, when the book was published (under the pen name of Barbara Vine), an unthinkable colour combination. Dress provides a reality effect, whether the setting is past or present.

More than that, it represents social codes and indicates class, group subdivisions, regional difference and individual personality. Agatha Christie uses dress, often unsubtly, as a shorthand method of indicating character. In *Taken at the Flood* (1946), when a new client visits Hercule Poirot, he asks his manservant to describe her:

She would be aged between forty and fifty, I should say, sir. Untidy and somewhat artistic in appearance. Good walking shoes, brogues. A tweed

coat and skirt – but a lace blouse. Some questionable Egyptian beads and a blue chiffon scarf.

This tells us much of what we need to know about the woman in question: that she is upper-middle class, and addicted to spiritualism. The get-up may be stereotyped, but it works.

Alison Light has commented that there is a 'significant ambivalence' in Christie's use of types or 'cardboard characters'. Often criticised, these stock characters actually, suggests Light, subvert the stereotypes Christie has set up. They ought 'to represent known and fixed qualities'. Yet although 'her stories are indeed peopled with instantly recognisable types – the "acidulated" spinster, the mild-mannered doctor, the dyspeptic colonel', in practice, far from being embodiments of unchanging virtue or villainy, they challenge assumptions based on surface appearances. They no longer carry any reliable moral cargo, but signify the possible untrustworthiness of values rather than their security. Christie is here as clearly 'post realist' as any other modernist, deliberately playing with the assumptions of an earlier literary form and working in pastiche. The spinster may turn out to be a blackmailer, the doctor a mass murderer. Their clothes and persona, therefore, act as mask and disguise rather than revelation of personality.[2]

Dress plays an indispensable role in the creation of a stereotype. Clothing makes visible social assumptions, social codes and collective understandings. It can also 'speak' for the individual, as in *A Dark-Adapted Eye*, in which Jamie, the boy whose life has been ruined by the murder of which he was the cause, in adult life dresses 20 years too young for his age. And here the detail *is* subtle; an unexplained and mysterious indicator of how psychic trauma can work its way through to the surface of the individual.

So dress can stand in for character, straightforwardly or deceptively. It can also draw on a culturally understood system of signs – when white represents purity and innocence, for example (at least in Western societies).

Yet Claire Hughes, in her study of dress in literary fiction, tells us that, at least in the nineteenth-century fiction of her study, dress is seldom described in detail, or directly. This surprises me. My memory seems cluttered with fragments from all sorts of nineteenth- and

twentieth-century novels of dress described and Marcel Proust was certainly lavish in his sartorial description, devoting pages, for example, to an analysis of the Duchesse de Guermantes' Fortuny gowns. For Proust, dress also provides a moral compass, as when the Duc de Guermantes is more preoccupied with his wife's sartorial crime of wearing black shoes with a red dress than with the fact that their old friend Charles Swann has just informed the Duke that he is dying.

Whether or not literary fiction operates through suggestion rather than direct description, films necessarily differ, since when we watch a film we *have* to see the clothes. This might be an advantage, but might also take away the subtler possibilities of suggestion and inference. In a film, what you see is what you get.

It is therefore no surprise that dress in film and television has been studied more than dress in fiction, for no one can deny that costume is a central component of the whole cinematic or televisual experience. One reason for the popularity of television dramatisations of nineteenth-century classics of fiction − Jane Austen, Charles Dickens, Elizabeth Gaskell − is probably the pure pleasure experienced in the rich detail of the costumes. Clad in the sober, casual and, it must be said, dreary uniform of early twenty-first-century quasi-sportswear, we can revel vicariously in corsets, bustles, crinolines, top hats, and cravats high and tight enough to choke you: so uncomfortable but so glamorous, so vulgar but so exuberant, so different from our own inhibited, restricted minimalism.

The minutely detailed realism of today's productions contrasts, for the most part, with some of the earlier Hollywood − and French − efforts; films in which, rather poignantly, Danielle Darrieux and Bette Davis were dressed in the fashions of the 1790s or 1830s, but made up more in the style of the 1940s, with antennae-pencilled eyebrows and cupid's bow lips; and although Anne Hollander, in her study of the relationship of clothes to art, *Seeing Through Clothes*, concedes that even before the Second World War historical costume in Hollywood film was often accurate, she maintains that a whole fake history of costume also grew up, functioning primarily as a series of signals − powdered hair and silk breeches signifying the eighteenth century or a ruff the Elizabethan period.

A twenty-first-century series of Agatha Christie adaptations of the *Miss Marple* novels for British television seemed nevertheless to signal a move away from meticulous realism once more. Whereas the series filmed in the 1980s had produced painstaking reproductions of the 1930s, 1940s and 1950s, audiences were treated in 2006 and 2007 to a 'postmodern' version in which not only were the plots reworked and a romance for Miss Marple invented, but the period dress became parodic – two respectable spinsters whose lesbianism is clear, but never actually spelled out in so many words in the original *A Murder is Announced* (1950), becoming in the new version a youthful butch femme dyke couple straight out of *Diva* magazine. On the other hand, the recent crime series set in wartime Britain, *Foyle's War* (Anthony Horowitz, 2002–10), maintained the tradition of hyperrealist accuracy, with crepe frocks, red lipstick, permed hair, peasant blouses and tweed 'slacks' in satisfactory profusion, not to mention the period interiors. These seemed genuinely 'realistic', representing the austerities and shortages of war as they were. On the other hand, productions of Christie's Poirot classics have usually overdone the period accuracy, so that all the characters in, say, 1935, wear 1935 fashions (which would certainly not have been the case) and have furnished their houses and flats with perfect Art Deco furniture, furniture that in real life would have been scorned by anyone but the *nouveaux riches*; the well born, after all, did not buy but inherited their antique furniture. Curiously, almost all such productions (here *Foyle's War* is once more a shining exception) fail to reproduce the language of the period, so that characters in perfect period dress utter slang from a much later period.

If not all period films in the 1940s were strictly accurate when it came to dress, some were. *The Man in Grey* (directed by Leslie Arliss in 1943), starring Margaret Lockwood, Phyllis Calvert, James Mason and Stewart Granger, the first of the Gainsborough Studios period productions, was produced in austere conditions during the Second World War. Location shooting was banned and the whole film was produced on a shoestring. Yet the costumes managed to look both lavish and accurate, with the transition from 1790s' fashions to the full flowering of the Regency style carefully reproduced.

The significance of dress is not confined to spectacle. In the opening and closing scenes of The Man in Grey the wicked Hester (Margaret Lockwood) wears black, which, overtly a sign of poverty at the beginning and of mourning at the end, symbolically represents her villainy. In film noir too, the evil woman is almost always signalled by her manner of dressing. In the famous opening scene of Double Indemnity (directed by Billy Wilder in 1944), when the hapless insurance salesman (Fred MacMurray) meets his doom in the shape of Barbara Stanwyck, she first appears wrapped only in a towel. As she gazes down at him from the first-floor landing, her power over him is already visually in place, and his nervous, joking innuendo cannot undermine her dominance. Later, dressed, as she descends the stairs from the landing the camera focuses on her legs, anklet and high-heeled shoes – the fatal approach of the phallic woman.

The enjoyment of dress on screen, like the enjoyment of its description in literature, may link seductively with a taste for crime fiction, for both involve an encounter with the forbidden. Even today, to take too much pleasure in dress is transgressive, and one reason for the contempt heaped on celebrities may be their excessive and blatant enjoyment of self-adornment and expensive clothes. Likewise, one reason for the way in which crime fiction is often dismissed as an inferior genre may be that the reader's enjoyment in the unlawful and usually lethal is also illicit. This is not to deny that celebrity culture is tedious and vacuous, nor that crime fiction can be written with clumsy plots and crude characterisation. The fascination notwithstanding testifies to the existence of the secret pleasures to be derived from them.

It is easy to see why historic and retro fashions are more readily drawn into this conspiracy of forbidden desire than the utilitarian fashions of the early twenty-first century. What film today could be compared, for example, with Michelangelo Antonioni's Story of a Love Affair (Cronaca di un amore, 1950), in which romantic passion, murder and haute couture mix to make an intoxicating cocktail?

Filmed in the empty, rain-sodden streets of Milan in winter, at a time when automobiles were only for the rich, Antonioni's first feature film tells the story of Paola and Guido. In their youth, in Ferrara, Guido was engaged to Paola's best friend, Giovanna, who mysteriously fell to her death in a lift shaft two days before their

wedding. Some years later, a private investigator appears on the scene and we discover that Paola has married a rich industrialist, Enrico. Warned by an old acquaintance from Ferrara that the case is being re-investigated, Guido renews contact with Paola and their passion reignites. We learn that both were in some sense guilty for Giovanna's death, since they knew the lift was defective, but allowed Giovanna to step into it. Now, Paola seems still to be consumed with desire for her lover, whereas Guido's motives and feelings are ambiguous. More in love, she is also more imprisoned, since she cannot imagine renouncing her husband's wealth. Her solution is to persuade Guido to murder Enrico, but the event of his death mirrors Giovanna's, in that Enrico is killed in a car accident at the very moment that Guido is loitering by the roadside and preparing to shoot him. For the second time, Paola and Guido have not exactly committed a murder, yet they are again both united and separated by the guilt of their intentions.

Paola's wardrobe is fabulous. She totters across the wet streets in sumptuously sculptured furs, prowls the bourgeois bars and salons in body-hugging dresses and fantastic hats (a phallic leopard skin hat and huge matching muff are particularly outrageous), and in the last scenes, flees panic-stricken through the night in an evening dress composed of multiple layers of organza ruching – a kind of dying swan in the drab, post-war city. Her fashionable dress functions on the surface to denote the icy world of bourgeois wealth she inhabits; on a more subtle level, it suggests the frozen quality of the passion between the lovers, so that to her lover, who is a mere car salesman, she will always be slightly unreal, spiritually imprisoned by the jealous Enrico (who initiated the investigation that propels the plot), but equally by her strangling skirts and preposterous headgear.

Later, Alain Resnais' *Last Year in Marienbad* (1961) again linked the frigid perfection of haute couture to psychological imprisonment and deathliness. In *Marienbad*, Resnais paid homage to Alfred Hitchcock's *Vertigo* (1958), and there can be no mystery film in which dress plays a more crucial role than in the latter.

In *Vertigo*, Scottie, a detective, has retired from the police force after his vertigo led to a colleague's death. He is nevertheless hired by an old friend, Gavin Elstir, to follow Elstir's wife Madeleine, who has been behaving strangely and might be suicidal. As Scottie

follows Madeleine in her wanderings through 1950s' San Francisco, he becomes obsessed with her and they seem to be falling in love; but his vertigo again leads to death – he fails to prevent her throwing herself off a bell tower.

This event bisects the film. In the second half, Scottie finds Judy, Madeleine's double. At this point, Hitchcock prematurely reveals what, in a straightforward thriller, should have been the denouement of the mystery: Judy actually *is* Madeleine, and her masquerade was part of a plot to conceal the murder of the 'real' Madeleine. Elstir, having used her, has dumped her. Scottie, still obsessed, forces Judy to become the dead woman once more, by transforming the way she dresses and by bleaching her hair, so that she becomes the fetishised, petrified object of his gaze. With her platinum blonde French pleat and pale grey post-New Look suit, she exemplifies the death by dress described by Simone de Beauvoir: 'She is, like the picture or statue ... an agent through which is suggested someone who is not there ... this identification with something unreal, fixed, perfect.'

That Hitchcock gives away the plot in the middle of the movie suggests that the real subject of *Vertigo* is not the mystery, but rather the oppressive possession of women by men and the lethal nature of the 'male gaze'. In a curious early scene, Scottie visits 'Midge', a commercial artist and former girlfriend who is still hopelessly in love with him. Her glasses, neat twinsets and pencil skirts position her as the 'plain' foil to the beauty of Madeleine. As she chats with Scottie, she sketches a brassiere. When Scottie comments on it, she tells him it works without straps; it was designed by an aeronautics engineer 'in his spare time' and its principle is the same as that of a cantilevered bridge. Hitchcock here slyly prefigures in comedy the tragedy that will unfurl, by referencing the fetish garment through which men create an 'idealised' version of womanhood.

By contrast with Midge's practical clothing, Madeleine appears in luxurious yards of fabric: a black dress with rivers of emerald green in the form of a satin stole; a voluminous white coat; a perfect pale grey suit to underline her ethereal, ghostly existence. But although in the first half of the film her look seems ravishing, exquisite and precious, when Judy is forced by Scottie to re-inhabit it, the audience sees the sinister twist whereby the woman is created

by a man in love with an unreal image; her very appearance no longer belongs to her and, as de Beauvoir suggested, she has been objectified and turned to stone by the basilisk male stare.

The feminist critic Tania Modleski takes a more nuanced view, arguing from a psychoanalytical point of view that in *Vertigo*, femininity is a masquerade without essence. In his obsession with not merely possessing, but actually *creating* 'Madeleine', Scottie reveals not his strength but his own nothingness, for without this foil his own masculinity would not exist. *Vertigo* clearly bears witness to the idea that appearance – women's appearance in particular – is artificial, a cultural creation that has nothing to do with the natural. Fashionable dress – and the structured, stiff, elaborate post-New Look fashions of the 1950s are perfect for this – represents this idea. There is also the further disturbing idea that fashion's obsession with change is a kind of death wish in its desire to preserve the fleeting moment eternally, or a defence against the human reality of the changing body. Paradoxically, its manic obsession with change is the very thing that protects us against the recognition of change in the shape of ageing and mortality – another reason for its potency when linked to the idea of crime, for crime too occurs when individuals refuse to face reality.

Yet there may also be a redemptive, utopian aspect to fashion's attempt to stop time and shore up the human body against its decay. There are resemblances to the legend of Orpheus and Eurydice in *Vertigo*. The attempt by Orpheus to bring his lover back from the dead – an assertion of hope in the face of the inevitable – is imagined in the scene in which Judy finally 'becomes' Madeleine, appearing to Scottie bathed in ghostly light and as if through a mist.

And if, in focusing on the link between fashion and crime, I have necessarily emphasised its dark potential, and even if the endless, repetitive search for the lost object of desire is doomed to failure, there remains a ray of hope in the continual renewal offered by fashion. In fashion, tomorrow is always another day and the quest for the beauty of perfection is eternal.

For that reason the greatest crime films force us to side with the criminal; for the criminal pursues his or her dream and flies in the face of the reality principle. Which in its own way is heroic, as is the tragic farce of fashion.

7 Camouflage and its Vicissitudes[1]

... to 'get made up', to put on cosmetics and costumes in order to play a theatrical role – or to be deceptive ... to disguise oneself for illicit purposes.

ROY R. BEHRENS

In a peaceful corner, cut out of the torrent of traffic that swirls through the Elephant and Castle in London, stands the Imperial War Museum in its own small park. Plane trees shade the grass in the September sunshine, so that the neo-classical building appears less like a museum than a church set in a graveyard without headstones. Only the enormous guns parked on the forecourt, and the tanks like dinosaurs towering above the visitors in the entrance hall, shockingly remind the visitor that this is not just a museum, but a museum dedicated to *war* – and an *Imperial* one at that. Inside, the political correctness of disability access, educational provision and the Holocaust exhibition make an attempt at disavowal of the museum's central subject, and since it is primarily a museum of the First and above all the Second World War, this disavowal is intensified as death, war and killing are subtly transformed into a memorial of Britain's finest hours. Indeed, a notice urges the visitor to make a voluntary contribution, so that 'your history' may be preserved, while the shop sells a rather magnificent selection of 'Warstalgie' items to remind visitors of rationing, blackout and the Home Front. This is not to deny that it is an excellent museum, but the experience it offers is shot through with what seems like unintentional irony.

The same might be said of the camouflage exhibition held in 2007. This covered all aspects of the subject: camouflaged ships, fake camouflage trees erected as cover for combatants, art using camouflage patterns and faked burning buildings to divert the enemy, but the item that first greeted the visitor at the entrance was Yohji Yamamoto's elaborate 2006 two-piece in shades of brown camouflage: a many-layered, voluminous skirt and a complicated, wide-collared jacket with nipped-in waist, all reminiscent of the late 1940s' New Look. For 'Camouflage' included camouflage in fashion, an irony in itself you might think, and it ended as it began, with haute couture: a strapless, huge skirted evening gown by Jean Paul Gaultier from 2000. In this, as in the Yamamoto, the sombre, dingy colours worked against glamour. The skirts of the Gaultier gown, made out of tufts and ever-deepening frills of a dull, muslin-like material, unpleasantly resembled a mop or a rag rug, so that the garment aroused unease and dissonance.

In recent decades, fashion designers have appropriated camouflage as though it were ripe for glamorising, at the same time as camouflage has swamped the armed forces. The hellish desert, dust and ochre monochrome landscapes of combat footage from Iraq and Afghanistan are peopled with soldiers in strange mottled outfits reminiscent of toddlers' playsuits, a far remove from the stiff khaki of the Second World War. Even generals have substituted these shapeless overalls for the military tailoring of a former era. The casualisation of dress has thus reached the last redoubt of authority and discipline.

Yet it appears that even these trips to hell can be glamorised. Khaki, war, sex and glamour came together in a fashion shoot by Steven Meisel for *Vogue* (Italia), September 2007, in which semi-clad models posed as prostitutes for tattooed squaddies in an Iraq army camp.

The khaki army clothing on show in the exhibition was, however, mostly from an earlier period. A First World War cape with a hood like a burka – with just two slits for eyes – was truly sinister. An officer's jacket remained conventional apart from the paint applied to camouflage it – paint that looked like spots of dried blood. A garment from the Vietnamese National Liberation Army had grey, black and brown blotches like a leopard's pelt or crazy paving,

while a Rhodesian T-shirt could have come straight from Urban Outfitters. There was even a camouflage maternity outfit for the female soldier, and what I took for a punky 1980s' jumpsuit turned out to be a naval frog suit in a colourful jigsaw pattern with a black zip up the front.

The exhibition explored the way in which camouflage has infiltrated fashion in the last 40 years. Under the heading of 'Rebellion' was displayed the old uniform of a Vietnam Vet; many Vets, it seems, customised their army clothing with badges and slogans to reinforce their anti-war message. No exact date was given, but it was also in the 1960s that the international 'alternative' society of youth culture discovered combat trousers and army uniforms – in London from the now (sadly) defunct army surplus shop, Laurence Corner in Hampstead Road. In the early 1970s it was *de rigueur* if you were in the 'alternative' left, a 'Libertarian', feminist, anarchist or general revolutionary to own an army, air force or naval greatcoat. My own khaki overcoat was in some ways the best garment I ever owned, my absolute favourite. It was extremely warm, because it was made of thick, stiff wool and lined with Viyella (a wool and cotton mixture), and its tailored shape fitted like a glove. It felt empowering and I thought I looked wonderful in it with my straggling hennaed curls and Cuban-heeled boots (although when, in 2011, I discussed this assessment of my then appearance with an old friend she gave me a very satirical look, so perhaps I did not appear to others as I did to myself). Better still, the older generation hated it. My girlfriend's mother clicked her tongue vociferously whenever I turned up in it. But when I visited my mother in the King Edward VII Hospital in London (the one used by royalty, and to which she gained entry because her father had been a naval officer) I became belatedly aware that she was utterly mortified by my outlandish appearance and that I should have worn my best 'normal' outfit.

It took no time at all for fashion designers to grab the trend. As early as 1967, Jean-Charles de Castelbajac had found a roll of camouflage material in a flea market and used it to make a garment signifying protest against the Vietnam War. On display was his 2000 camouflage short evening dress, ornamented with a wide diagonal sash in the rainbow colours of the peace movement. Also displayed

was a recycled camouflage jacket by the British label Maharishi, appliquéd with red and pink letters that spelled out 'all you need is love'.

In the 1970s and early 1980s, Punk popularised the trend for camouflage combat trousers; the exhibition displayed a pair worn by Joe Strummer for The Clash's 1982 Combat Tour. In that decade camouflage still carried traces of dissent and the notion of urban guerrillas. It could also be used to convey a counter-intuitive message.

By the 1990s, however, rebellion had dissolved into the mainstream. Camouflage became just another pattern, its countercultural past a dim 'ur-memory', if that, as it itself became camouflaged in the general mish-mash of casualised dress at the turn of the millennium. At the same time, new camouflage patterns incorporated images such as logos, so that instead of its role to 'conceal, deceive and distort', in the words of the exhibition, it aimed to 'advertise'.

The exhibition ended with a series of photographs of (non-rebellious) students wearing garments, making use of various kinds of camouflage. These days, it is just another 'choice'. Meanwhile, on the battlefield too, camouflage is losing its purpose, as new scientific techniques of thermal imaging are used to snuffle out hiding combat troops.

What appears to be a much-enlarged version of the Camouflage exhibition was held at the Canadian War Museum in Ottawa in 2009–10. Julia Pine, who reviewed it, wondered if the vogue for this military style had something to do with a general militarisation of society and also to do with the increased surveillance in societies today. She wonders if it reflects 'wider problems concerning conflict, power structures, issues of concealment and revelation in a culture of increasing surveillance'.[2]

It may have had more to do with the rebellious subcultures that first brought camouflage into countercultural fashion – the Che Guevara effect, if you like. This was at a period when there was recognition, however superficial, that to bring about revolutionary change was unlikely to be achieved without violence. Camouflage signalled the readiness of the revolutionary to take direct action, even armed insurrection. When such attempts failed miserably

(and were ill-conceived from the outset), revolt dwindled into style, just as in an earlier period, countercultural bohemian fashions were enthusiastically taken up commercially and became a superficial badge of 'lifestyle' rather than the uniform of a truly alternative way of life.

Camouflage seems to have derived from the French verb *camoufler*, whose original meaning had to do with joking and trickery. Its appeal is perennial because it still plays with the ideas of hiding/revealing and of danger/playfulness. It sends a contradictory and subversive message, balanced on the cusp of pleasure and danger.

A second 2007 exhibition, 'Sailor Chic', focused on nautical wear, was housed in the Maritime Museum in Greenwich, another building of grandeur even more imposing than the War Museum. 'Sailor Chic' demonstrated a sophisticated understanding of the relationship between uniforms (in this case naval ones) and fashion. The exhibition catalogue explored the ambivalent relationship between uniforms and subversion, pointing out that the sailor is a figure of particular importance to a naval nation such as Britain, and that it suggests 'obedience, order, bravery and loyalty, but also a freedom of spirit, independence and rebellion'.

It appears to have been the Victorian royal family who introduced naval styles into civilian garments, initially in the shape of sailor suits for children. With the growth of seaside holiday resorts and the growing belief in healthy exercise and sports, nautical styles were adapted for women's bathing wear, while in the 1920s, Coco Chanel loved the striped *matelots* and bell-bottom trousers worn by sailors in the Mediterranean and in Russia, using them to promote an androgynous high fashion image of female freedom and independence. Yet, *sportif*, naval fashions could also be adapted to urban chic, the clean lines of navy blazers, white pleated skirts and striped collars seeming particularly suited to spring by haute couturiers such as Yves St Laurent.

The sailor image was used subversively in pop culture. Glam Rock in the 1970s made use of its androgynous qualities and homoerotic aspect. The sailor, after all, is at once butch and masculine and yet also open to the lure of sex with men. In the 1990s, Jean Paul Gaultier brought the 'hello sailor' imagery into haute couture –

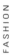

Figure 4: My mother in sailor dress *c.*1917. At this age she disliked wearing it, but her father was a naval officer and her mother insisted on it for this reason.

and reinforced the idea with his 1990s' scent bottle for Le Male, shaped like a sailor's torso. Sailor Chic also noted how fashion in wartime assumes a chameleon-like mimicry of military styles and references. In 1914, Marcel Proust had noted that immediately after the outbreak of the First World War women's fashions were reflecting the new reality:

> young women went about all day with tall cylindrical turbans on their heads … and … straight, dark-colored Egyptian tunics, very 'war', over very short skirts; on their feet they wore thong-laced boots … recalling those of our dear boys at the front … they wore rings and bracelets made out of shell fragments or the bands from seventy-five millimeter ammunition.[3]

The fashions of the Second World War equally drew on the aesthetic of uniforms and their bisexual glamour. At the 2005 launch party for Sarah Waters' novel *The Night Watch* (set in the Second World War), held in Winston Churchill's War Rooms in Whitehall, all the guests were dressed in period styles: Land Girls, RAF officers, WAAFs, glamour girls, Home Guard. And it was quite surprising how much sexier everyone looked in uniform. Something about these garments and their reference to discipline and restraint forces sex to ooze out of the split between the uniformity of the dress and the waywardness of the individual.

Yet while both exhibitions made much of the ambivalence of these two varieties of military dress and their ability to signify both conformity and rebellion, neither made as much as they might have of the deviant or forbidden quality of sex in uniform, and that dark relationship between the erotic in fashion and in war. Uniforms unite two axes of the erotic in dress: the forbidden; and erotic power.

8 Fashion and Memory

Clothes wear us and not we them; we may make them take the mould
of arm or breast, but they would mould our hearts, our brains, our
tongues to their liking.

VIRGINIA WOOLF

Fashion and photography have much in common. Each claims the status of art, yet remains at its margins. Photography was born as an industrial process, which produces the image en masse. Fashionable dress was originally artisanal, but it too has been wholly incorporated into and transformed by mass production. Both fashion and photography claim the status of art. Photography's claim to aesthetic status has achieved some recognition, yet photography-as-art constitutes only a small part of all photography.

Fashion's claim to artistic status remains contentious. Many writers interested themselves in fashion over the course of the twentieth century, but for most that interest was sociological, psychological or economic. In 1985, George B. Sproles, a behavioural scientist, pointed out that 'fashions are aesthetic products and any theory of fashion will necessarily include aesthetic components'.[1] This followed the 1983 Yves St Laurent retrospective at the Costume Institute of the Metropolitan Museum of Art. It was a groundbreaking departure for an art museum to hold an exhibition of fashions, but since that time there have been many and one could argue that this proves fashion's artistic status.

However, in an exploration of the question, Sung Bok Kim cites a number of writers, including the late Diana Vreeland, who had been

the doyenne of fashion in the 1950s and 1960s, editor of American *Vogue* and of *Harpers Bazaar*, who continued to insist that fashion and art were distinct and separate. For one art critic, Michael Boodro, cited by Sung Bok Kim, this was due to the commercial basis of fashion. The intervention of an industrial, mechanical process negated the possibility that an aesthetic product could be 'Art'. 'Art is eternal, while fashion designs are ephemeral', claimed Boodro.[2]

Art was long held sacred. It transcended commerce. It was difficult to align photography to this notion of the special status of art. The relationship of fashion to the body and its association with novelty and change, at a time when art was held to express the eternal, disqualified it. Vreeland believed that art was 'spiritual' in a way that fashion could never be.

The late Richard Martin disagreed. Art, he argued, has become a commodity as much as fashion, although there is a lot of denial in the art world about this. On the other hand, fashion is potentially every bit as expressive as other art forms. And even Boodro acknowledged that there were strong links, even a convergence between the two. After all, from time to time, artists such as Gustav Klimt had designed clothing, and couturiers such as Yves St Laurent, with his 1965 Mondrian dress, drew on art for inspiration. Nonetheless, Boodro still distinguished between art, 'typically private, the creation of an individual', and fashion, a public 'collaboration between designer, manufacturer and wearer and then between wearer and viewer'. But such a definition would also apply to film, which is considered a form of art. Indeed, the majority of art forms involve collaboration. The orchestra, the classical artist's studio and the theatre would be unable to produce art without it. Even the writer must work with editors and publishers if her work is to see the light of day.

Alison Gill interrogated the artistic status of dress in relation to the 'deconstruction' or '*mode destroy*' fashions of the 1990s: the work of Martin Margiela, Comme des Garçons, Ann Demeulemeester and Dries Van Noten. These could be interpreted as anti-fashion, a kind of dismantling or analysis of fashion or a form of avant-garde fashion.[3] These were as original and challenging as any artwork.

A decade later the idea of fashion as rebellion – anti-fashion – has less traction. The classical avant-garde shared the assumption of the dominant society against which it rebelled: that the culture moves continually forward in a series of moves and counter moves, with the future forever overcoming the past. Today this driving forward, whether evolutionary or revolutionary, has been thrown into doubt and the idea of the avant-garde has lost its potency.

At the present time, fashion styles are disseminated globally by means of the reproducible image, so that quite aside from the characteristics they share, fashion and photography are economically entwined. This economic symbiosis has a further dimension in that both mass fashion and the mass image have aestheticised the globe, massively contributing to the visual culture in which we now live.

Fashion and photography are also alike in that in contemporary society both function as potent visual representations of history; of the past. This does not just mean in terms of images in the press and other mass media; the rise of mass photography has meant that amateur photography – the snapshot – has become a major bearer of personal memories, just as images in the mass media become the archives of public memory.

One long-standing difference between photography and fashion has nevertheless persisted. Many still hold to the idea that fashion could never express any kind of truth about the world. It could never illuminate anything, but was destined always to be a sort of meretricious gloss on modern life and for moralists a kind of lie: concealing, from a left-wing perspective, the underlying ugliness of consumer capitalism; for the right, the sinfulness of the human body and inferiority of womanhood.

By contrast, photography was the bearer of truth. The camera could not lie. In fact, even before the advent of digital photography and the computer, which bring endless possibilities of altering the raw image, it had been realised that no photograph is neutral, but that the photographer always constructs the image. Nevertheless, photography continues to benefit from the idea that it bears witness, that it is objective. At the same time this supposed documentary objectivity distinguishes it from art. It is visual journalism rather than visual literature.

Alternatively, photography could claim artistic status by trying to be more like art, but Walter Benjamin disliked this kind of arty photography. He wrote:

> The more far-reaching the crisis of the present social order ... the more has the creative – in its deepest essence a sport, by contradiction out of imitation – become a fetish, whose lineaments live only in the fitful illumination of changing fashion. The creative in photography is its capitulation to fashion. The world is beautiful – that is its watchword. Therein is unmasked the posture of a photography that can endow any soup can with cosmic significance but cannot grasp a single one of the human connexions in which it exists.[4]

Benjamin rejected the ideology of Art for Art's Sake (as would any good Marxist of his time) and realised that the kind of photography that is closest to painting renounces some of the distinctiveness and disavows some of the other possibilities of photography. To think of photographs in some abstract sense as art also tends to distance both from the realm of the everyday; when it is as reminders and memorials of the everyday that the hold of photographs is so potent. A meaningful photograph would be more like a found object than an oil painting.

One could make a similar argument for fashion: that it has become over-identified with celebrity glamour, when its real interest and meaning lies in the opposite: that it is quintessentially about the everyday; everyday life. Clothes are what we put on every day; even those who most strenuously insist that what they wear has nothing to do with fashion, and that they are not interested in fashion, are nevertheless wearing clothes as directed by fashion in one way or another. No one wore jeans to the office or to a party 50 years ago; men (let alone women) did not wear shorts in town. Men did not wear vests (i.e. a T-shirt) as an outer garment either. Women did not go about in what would once have been considered underwear, for example, a camisole in summer. The casualisation of dress, which has made it possible for many individuals to feel that they have opted out of fashion, is in fact a fashion in itself, even were it not that the jeans we wear today are subtly different from those of ten or 20 or 50 years ago. (To

say this is not to deny that there continues to be sartorial rules in many situations.)

Photographs preserve the past and therefore have nostalgia potential. This might seem to separate photography radically from fashion. We choose the clothes we wear every day in order to look right now – today. In that sense fashion is very much about the present. It is about fitting in, while, perhaps, remaining distinctive. It is to create an impression and to persuade others that *this* is who we are; this is what we are like. In that sense the everyday practice of fashion has nothing to do with the past or with memory. In fact, the wish is to efface the past, to erase any memory of our having been other than what we are or how we wish to appear today.

Fashion photography, which brings the two together, is effectively a specialised domain, which de-historicises fashion and, as Susan Sontag points out, idealises it. It aims to create a mood rather than to inform. Photographers such as Corinne Day and Juergen Teller aimed to extend their art beyond the narrow perimeters of the garment itself to address social concerns. Theirs is thus a creative and engaged form.

But although a strong case can be made for the importance of this kind of fashion photography, fashion photography offers something very different and much more self-conscious than the presentation of clothes in all those photographs that are *not* fashion photographs. For one thing, fashion photography creates an enclosed, self-sufficient world. Inevitably – proposing as it does the right way to look *now* – it effaces the past, or at least creates a strange disjuncture from it. Even when it references the past it creates a stylistic pastiche of pastness that bears little relation to any actual past. This is consistent, of course, with the *present day-ness* of our fashion practice. On the other hand, photographers such as Teller and Corinne Day share the concerns of non-fashion photographers such as Nan Goldin – and thus with other art forms – in proposing what was once the new aesthetic of the dark, the deviant, the disturbing, a reaction against the formalist notion of timeless beauty; but unlike Nan Goldin they do not capture and memorialise an actual subculture, they simply recreate it as pastiche.

This means that fashion photography could be less interesting than, say, amateur snapshots, photographic images of fashion in

everyday life that memorialise the ephemeral. A fleeting moment is captured on a piece of paper or celluloid, or, today, on a chip. Snapshots, photo-journalism and news pictures capture people wearing clothes in the situations in which they actually wear them, in the street, at home, at parties, in demonstrations or in crowds at sports events – clothes *in use*, rather than the presentation of an ideal of fashionable dress which is what fashion photography is. Even the contrast between the fashion pages and the gossip spreads at the back of *Vogue* or similar magazines – and the celebrities on these pages are normally expensively dressed with an eye to being photographed – presents a telling difference between the ideal and the actual. It does not necessarily follow that snapshots are more authentic than art or fashion photography, but certainly their relationship to both past and present is different and distinct. The former, as Benjamin suggests, captures the moment in a unique way. 'The most precise technology', he writes,

> *can give its products a magical value, such as a painted picture can never again have for us. No matter how artful the photographer ... the beholder feels an irresistible urge to search such a picture for the tiny spark of contingency, of the Here and Now, with which reality has, so to speak, seared the subject, to find the inconspicuous spot where in the immediacy of that long forgotten moment the future subsists so eloquently that we, looking back, may rediscover it.*[5]

Roland Barthes dwelled, like Susan Sontag, on the melancholy estrangement of the photograph in his *Camera Lucida*, a meditation on photographs of his recently dead mother. Along with Benjamin, he insisted on the magical quality of photographs. Photographs differ from paintings in that what they show us *really was*. These persons actually lived; these streets did exist. But they are stuck in the past and we cannot reach them. The photograph can never become Alice's looking glass, which dissolved so that she could move into the alternative world within or behind the glass. As we stare at a photograph we remain locked out of its reality. For Sontag, a photograph is a message from the past, with all the pathos that that entails. The persons caught on camera are ghosts from the past, testifying to the relentless passage of time. The clothes they

wear as they stare out at us form an integral part of the image and of their ghostliness and these comical *démodé* outfits, of which they as often as not seem so proud, contribute to the pathos of these figures. In this way fashion and photography are central to a presentation of the past and of transience. It is essentially their fashionable dress, or dress of its time, that now underlines the transience of these lives.

Yet we are as likely to mock these images of the past as to find them poignant. How could they, our forebears, have put up with these fashions! How ridiculous they are. How could we ourselves have worn those dreadful clothes! This is a form of protective disavowal that seals off the sadness we might otherwise experience at seeing our much younger self with long hair and silly sideburns or with enormous 1980s' shoulder pads.

This suggests that there may possibly be a protective aspect to the fashion cycle. It could perhaps be that the changes that take place in fashion, with its continual and recurring incitement to find beauty in the new, represent a beneficial impulse. Far from signifying a trivial and superficial attitude to life and to the world, perhaps fashion's cycle testifies to resilience and optimism, to overcoming, as Freud suggested, the mourning and pain occasioned by our recognition of transience. One could argue that many, indeed most, societies did not have a fashion cycle at all in the sense in which we understand it. But clothing *rituals* have existed in all societies, and perhaps one should see modernity's fashion cycle as the ritual of a dynamic and hectically innovative society in adjusting to the force and pace of change and helping us to live with it.

9 Urbane Fashion

The streets belong to everybody ... in the crowded street the Duchess
... mingled with the public life of the world moments of her secret life,
showing herself in all her mystery to everyone.

MARCEL PROUST

The industrial revolution in Europe overturned the rural ways of life that had endured for centuries. Urban life was hardly new, but industrialisation drew more and more citizens into the towns and cities, and speeded the process that became known as modernity. Nineteenth-century sociologists such as Georg Simmel and Max Weber believed that modernity represented a decisive break with the past. They developed the contrast – which must indeed have been startling to the agricultural workers flocking to the new industrial cities in the nineteenth century – between rural life, tradition and stagnation (what Marx unkindly referred to as 'the idiocy of rural life'), and urban change, fragmentation and mobility. Modernity has come to act as the label for the complex changes they observed, when life speeded up with the coming of rapid transport systems and rapid communications, when all aspects of life, including leisure, were increasingly institutionalised, bureaucratised and subjected to the market, and when continual change and experimentation replaced traditional ways.

Among the many other changes they observed was the widening sway of fashionable dress. It is not hard to see how fashion systems came to represent these processes and how the life of cities provided a culture ideally suited to the expansion of fashion. **99**

Georg Simmel and others who followed him understood the curious feature of fashion: that it embodies a contradiction – that is, that in dressing fashionably we aim simultaneously to stand out from and blend in with the crowd – and understood also that the urban *audience* is necessary for fashion to flourish. True, there had always been audiences for fashion or elaborate dress generally, aristocratic courts in particular, but it was the rapidly growing cities of the nineteenth and twentieth centuries that provided the ideal ecology for fashion as for the first time it began to be industrially produced and so could spread beyond the aristocracy and wealthy classes. Over time, increased mobility, both physical and social, the development of mass production and mass markets, and the growth of a fully monetised and commodified social formation, enabled fashion to become less expensive and extravagant and for fashions to change much more rapidly.

The great city became a huge experimental laboratory, in which adventurous women as well as men could challenge tradition. In the urban culture of the Renaissance, erotic experience could change along with everything else, and part of this, Lynn Hunt has argued, was the development of erotic and pornographic literature. 'Pornography was closely linked with political and religious subversion', she suggests. Long before de Sade, erotic literature offered a critique of conventional morality and religious orthodoxy, the church and aristocracy, and it therefore had a democratic dimension. It was part of a more mobile society in which not only men but also some women were travelling more freely and independently; and even if most of the female characters in pornographic narratives were prostitutes, they are 'most often portrayed as independent, determined, financially successful and scornful of the new ideals of female virtue and domesticity'.[1] It was only with the reordering and reinforcement of gender difference at the close of the eighteenth century, Hunt argues, that sadomasochism and the victimisation of women came to be dominant features of pornographic literature.

Seen thus, pornography becomes a dimension of the experimental freedom of urban life, in which the streets are thronged with strangers with whom erotic encounters can invite adventure. The city becomes a locus of desire, of transgression and

of the exploration of the body. It is to be expected that fashion and adornment will achieve great importance in such a situation. Dress will signify the erotic dimension of life as well as social status and economic calling. Women, and men too, will use clothing to call attention to their charms and individualise themselves.

It does also seem likely that, then and later, urban life offered some possibilities, however restricted, to women in terms of emancipation from the family and possibilities for independence. This was in fact the basis for much of the criticism of city life and of the ambivalence of many writers towards it. The contrast between rural virtue and urban worldliness theorised by Simmel and Weber did not originate with them. Bunyan's *The Pilgrim's Progress* presented a powerful picture – an antidote to the pornographic literature, if you like – of 'Vanity Fair', the wicked city full of temptations to vice of all kinds. The eighteenth century saw the development of the idea of the peaceful rural life as closer to godliness than the city, so that by the nineteenth century the city was increasingly depicted as a dangerous labyrinth, a jungle, a cess pit, a source of vice, crime and disease. There were, of course, many Victorians who celebrated the cities they were building, but the fear of vice and crime was never far away.

Today, economic globalisation has transformed relationships both between country and town and between nation states. The contrast between town and country may have lost some of its force in Western societies, as the suburbs encroach ever further, but the contrast as an *idea* has retained its salience, and nineteenth-century *images* of the urban remain resistant to change. Journalism reworks the idea of the cutting edge, bohemian inner city, and similar ideas continue to be reproduced in popular music, in fashion and in film. In the 1980s a whole sub-genre of 'yuppie nightmare' films, in which, typically, a hapless young yuppie underwent the hell of a night in lower Manhattan, menaced by drug dealers, gangsters and the mentally ill, reworked the image of the dangerous city; a light-hearted version was Madonna's *Desperately Seeking Susan*, in which, perhaps significantly, a garment, the Madonna character's funky leather jacket, stood in for, or represented, urban cool in general. In the world of fashion, the youth-directed cosmetics range, Urban Decay, with its 'edgy'

names for lipsticks and eye shadows and the fashion chain, Urban Outfitters, neatly sum up the idea that pleasure and danger in the city are intimately linked, and that precisely the charm and magic of urban life lies in its proximity to disintegration. Given the choice, Europeans may migrate to Cotswold villages or Provence, but they evidently still also wish to consume this romantic image of the city of dreadful but alluring night.

This picture of an exciting urban lifestyle is at odds with another, which mourns the loss of what loved cities used to be. Iain Sinclair has polemicised against the destruction of the old East End and Hackney,[2] and there has come to be a perception – whether accurate or not – that as city centres have been gentrified they have lost their authenticity and edge. Journalists and academics have described how city centres – Manhattan, Dublin, Glasgow – have become what François Maspero, writing of Paris in his *Roissy Express*, called 'Disneyfied' cities. His book charted a journey on the RER train service from north of the periphery to its southern edge and as he meandered from one stop to the next he was saddened by the way central Paris and its famous landmarks had been repackaged for tourists, but he found the real life of the city has moved elsewhere, in this case to the tower blocks and dismal estates beyond the *péripherique*.

Maspero had little to say about fashion, but Christopher Breward in *Fashioning London* mapped a historical trajectory of the production *and* consumption of dress on to specific changing districts of London – Covent Garden and the Strand at the end of the nineteenth century, Chelsea in the 1960s and Camden Lock in the 1980s, when the market there was the locus of all that was streetwise and edgy. But that street style, too, had declined by the millennium, by which time Camden Lock had become largely the hunting ground of tourists, with endless stalls of cheap T-shirts, fast food outlets and where only the covens of Goths clung doggedly on to some remnant of authenticity.

It was, in fact, an *unchanging* feature of cities that their bohemian and chic districts were continually mobile. Familiar streets and architecture, which one would intuitively expect to be the most enduring aspects of daily life, disappeared from one day to the next under the imperative of the developer, thus generating bohemian

nostalgia. Even those districts of which the actual fabric remained intact might completely change their usage and ambience, as the cool and fashionable migrate like flocks of birds in the direction of the latest hot spot. Urban space itself comes under the dominion of fashion.

Such perceptions might be in part due to sentimental nostalgia, a grim or at least banal present contrasted with some lost golden era of authenticity. Yet it is pertinent to ask the question: what is happening to cities? Where are the new places? More specifically, what is the contemporary relationship of the urban and fashion? Is urbanity still urbane? Is fashion still fashionable? Can fashionable dress play the same role in these contemporary city centres that it is alleged once to have played in the nineteenth-century city?

Indeed, what was the role of fashion in the great metropolis? In the Regency period in Britain the assembly rooms at Bath, Covent Garden and Vauxhall Gardens were all spaces of personal display. In the 1860s, American writers described the *passeggiata* up and down Broadway. Even right down to the 1980s there were clubs and venues where, in London, the New Romantics theatricalised their lives, and where, on the Lower East Side, the circles memorialised in the photography of Nan Goldin dressed up and flaunted their deviance. And these were all examples of Simmel's fluctuating dynamic, whereby fashion oscillates between, or rather combines, the opposites of uniformity and outrage.

It may be that as urban centres have become reprogrammed for tourists, their role as a theatre of display has diminished. Tourist dress, which has been little researched, is hardly distinguished by its elegance and fashionability and also tends to be even more distanced from formality than other kinds of urban day wear, the general casualisation of dress notwithstanding.

If we accept that modernity is ongoing and continual change shapes our lives, this must have effects for the nature of urban life and the city fabric (in all senses of the word). Are we too reliant on outworn conceptions of the urban, such as those elaborated by Weber and Simmel?

In 1990s' London, Phil Baker tells us, 'psychogeography' and the writings of psychogeographers such as Iain Sinclair were fashionable. Psychogeography was a development of the thought

of Situationists – Guy Debord and others – in the 1950s and 1960s. 'The idea of different ambiences is central to psychogeography', says Baker:

> The zones and quarters of a city are made up of distinct psychic micro-climates; places attract and repel us, or feel psychically warmer or colder, in a way that can be mapped. This emotional effect of place can be extended to single buildings ... In different hands it can be supernatural ... something like haunting, or entirely materialistic.[3]

Do, or did, the psychogeographers tell a more contemporary and relevant story of urban life, or are they, too, locked into an essentially romantic vision derived from Charles Baudelaire and Walter Benjamin? Theorists of dress, and of the city, have certainly continued to draw on Benjamin's vision as a key to the understanding of modernity and its relationship to the city, attracted to the often gnomic fragments in his *Arcades Project*.

To ask a rather different question: what is the way to dress for city life today? And does it matter? Andrew Hill has suggested that everyone now dresses badly, that the vaguely sports-derived sartorial efforts of the urban crowds are utilitarian and uniform; streetwear can be divided into casual wear and office dress, both equally dreary. 'There is little or nothing that stands out as distinct ... you could swap people's clothes around and it would not make much difference – they would look virtually the same',[4] observes Andrew Hill. In February 2012, after British fashion had enjoyed a spectacularly successful week of catwalk shows, the avant-garde couturier, Vivienne Westwood, made a similar observation, criticising the young for their clone-like adoption of cheap styles. Anecdotally, this observation tends to be confirmed when the observer walks through central London, Paris or New York. But it is working adults rather than teenagers who appear to have adopted a dreary uniform, influenced by the dull protocols of sportswear. Perhaps now that so many women are in paid employment women's day wear is approximating more closely to the relative stability and uniformity of men's business and casual wear. It may also be that actually – and perhaps counter-intuitively – we are living in an increasingly conformist society. Ethnically

different dress may be increasingly visible on city streets, which is a topic in itself, but Western dress and customs seem in some ways to be increasingly circumscribed. There is but a single uniform for most ages and both genders: tight jeans, leggings or dark trousers paired with windcheaters, cagoules, Puffa jackets or parkas, often accessorised with trainers and baseball cap, as citizens dress for a trip to the shops as though they were about to attempt the ascent of the Matterhorn. Someone has been exaggerating the hazards of Oxford Street.

The dominant political discourse is about choice and individuality, yet the strange paradox of consumer society seems to turn out to be that the more our desires are commercialised and differentiated, somehow the more the parameters of acceptable behaviour and appearance are narrowed rather than widened, even as our

Figures 5 & 6: Clone dressing.

choices seem to contract rather than expand, certainly in what is regarded as attractive or beautiful. Teeth, for example, must be straightened and whitened; women's underarm hair has become an obscenity.

The high street itself as a retail venue has become increasingly uniform. It is sometimes difficult to remember whether one is in Oxford or Oxford Street, Stafford or Stanford, California, for the same chain stores are everywhere to be seen, and for that matter Nanjing Road more closely resembles Bond Street or Fifth Avenue than it resembles Shanghai in the 1930s, let alone in the 1970s.

This is not simply a national but a global development. Simona Segre Reinach has demonstrated how important the global fashion industry is and how it affects the appearance of men and women on city streets all over the world. The production and consumption of fashion are still an urban phenomenon, although actual production may also take place in the countryside. She describes the collaboration between Chinese clothing producers and Italian firms and how this, she suggests, has led to a new fashion culture emerging. On the one hand: 'to refer to the Shanghai lifestyle implies evoking the spirit of the new and distinctive type of capitalism that characterizes communist China, one aspect of which is an attitude towards copying that differs from the western attitude'. This is part of the new emerging fashion culture,

> the culture of instant or fast fashion, born of the globalization of trends, of a global concept of production and domestic marketing; quick and easy brands capable of answering the needs of a new consumer who is fickle and changeable, and quite different from those desires prompted by life-styles and the democratization of luxury.

This new fashion system is contrasted with the two previous systems: of haute couture – exclusivity – which represented high bourgeois taste; and the post-1945 system of prêt-à-porter – the good style of the diffusion line. Both systems, the second in particular, catered to a world in which, superficially at least, conceptions of 'lifestyles' were beginning to replace the more rigid divisions of class. Both haute couture and prêt-à-porter nevertheless paid obeisance to quality and the desire for clothes that would 'last'.

Today, no one wants clothes that 'last' any more. As recently as a generation ago there were still young men who boasted that they were wearing the bespoke suits their fathers had had made for them in the 1940s. Now, it is difficult for the great Jermyn Street firms even to recruit the bespoke tailors of tomorrow.

Instead, Segre suggests, we inhabit very temporary identities and 'fast fashion' caters to these. She also says a great deal more about the many complex relationships of Sino-Italian fashion production. She describes a new fashion world in which fake brands and the real thing are hardly distinguishable (and what does that mean anyway?), in which Italian firms export 'market stall' fashions to China and Chinese brands are produced and made 'as if in Italy'; where unknown, new, small brands arise as an antidote to the blandness of the Gap model and where the new retailers, such as H&M and Urban Outfitters, offer a huge variety of fast fashion styles. She concludes by questioning the assumptions of the theorists of high modernity: the Weberian belief in privileged links between modernity and the West, particularly the Western city. We should be looking at the new huge cities of the Pacific rim for a view of the future and the future of fashion, cities that are in some respects very different from the classic Western metropolis.[5]

Chris Breward's *Fashioning London* places the relationship of urban fabric and (literally as well as metaphorically) fashion fabric at the centre of fashion systems. I have tried here to reprise some of the ways in which this relationship was configured in the classic sociology of modernity. The relationship between urban life and fashion does not provide an exact parallel or analogy. However, just as at an earlier period of cultural studies the exploration of youth cultures inaugurated a fruitful period and an exponential growth in the field – with the work done on teddy boys, mods and rockers – so now, in a different way, it is to be hoped that a heightened awareness of the fashion/city symbiosis will be the spur for another leap forward in understanding. This will mean that the generalities of classical sociology are surpassed, while work continues to build on Simmel's refined and subtle aesthetic insights.

PART THREE

The Future We Have Lost

10 Austerity in Retrospect: The Glamour of Masochism[1]

*I wanted to throw the dried egg out of the window, burn my shabby
curtains and wear a Paris hat again. The Amazons, the women in
trousers, the good comrades had had their glorious day. But it was over.
Gracious living beckoned once again.*

ANNE SCOTT-JAMES

In June 2007 restaurant critic Matthew Norman noticed how
suddenly, and for no obvious reason, Britain had been overtaken
by nostalgia for the 'Austerity Years'. The publication of David
Kynaston's *Austerity Britain*, greeted with rave reviews, and the
first instalment of Andrew Marr's BBC television series, *History of
Modern Britain*, screened shortly after the publication of Kynaston's
book and also massively popular, seemed proof that those years
of deprivation and rationing suddenly seemed seductive. Everyone
was once more switching off the lights to conserve energy,
buying second-hand clothes and saving every scrap of paper.
Environmental anxieties partly explain this resurrection of the
past. Plastic bags are replaced with carriers made of jute or string;
we are continually urged, as Norman notes, to use less fuel of all
kinds, and in August 2007 the *Guardian* noted that:

*Life was a beach for Tony Blair. Or a villa. Or a luxury yacht. But
perma-tanned politicians must holiday more carefully under Gordon
Brown. The prime minister is ushering in a new austerity for summer
vacation'*

This mood had developed before the credit crunch and the banking crisis of 2008. Environmentalism and economic crisis must partly account for the new interest in austerity, although perhaps there may have been some other premonition in the air, an uneasy deep-down feeling that the bubble could not last forever, but the rapturous reception accorded *Austerity Britain* suggests that it also keyed into enduring myths about the national past and their relationship to 'what really happened' or how it seemed at the time. There is also the question of the meaning of twenty-first-century nostalgia and whether it acts as a substitute for taking control of the present.

David Kynaston believed that his book offered a new interpretation of the 1940s. He asserted that the British look back on the decade with misty-eyed nostalgia for the spirit of the Blitz and the Labour landslide. As such, more than half a century later, his aim was to demythologise it. Certainly the period of the Second World War itself is still remembered as glorious. (The 2011 film, *The King's Speech*, winner of many Oscars, is one example of this.) The abiding popularity of television programmes like *Dad's Army*, *'Allo 'Allo!* and *Foyle's War* (which did show the seamy side of the home front at war) also testifies to the continuing importance to the British of this hard won victory and the myths surrounding it. But austerity gloom is hardly forgotten. Well over a decade ago, for example, the fashion writer Colin McDowell made a television programme on Dior's New Look, which used the familiar footage of Harold Wilson begging women not to lower their hems; this was also used in another television series on fashion in the early 1990s, *Through the Looking Glass*. The symbolism of the New Look as a potent, if backward-looking, representation of longed-for luxury is better known than you would think from reading Kynaston and his reviewers.

Austerity Britain is a substantial work. John Charmley, in the *Guardian* (19 May 2007), described, apparently with admiration, its method – of placing descriptions of events, lavishly backed up with long quotations from 'ordinary people' – as resulting in 'a plum duff of a book', which, unintentionally perhaps, accurately captures the rather indigestible quality of the accumulation of facts. Kynaston does, however, have a central thesis. As D. J. Taylor

in the *Independent* put it (4 May 2007): 'Kynaston's theme [is] the imposition on the British people, throughout a six-year period of quasi-socialist government of ideas, policies and decisions which they did not want or to which they were at best indifferent'; and in the *Sunday Times* (6 May 2007), John Carey described the picture of unalloyed misery he found in *Austerity Britain*, and warmed to Kynaston's populist interpretation whereby the Labour government was full of high-minded socialist ideas that they were undemocratically determined to foist on a resentful, conservatively minded public. Several reviewers mentioned the notorious occasion (which, incidentally, featured in the independent television series *The Making of Modern London* over 20 years ago) when the Minister of Town and Country Planning, Lewis Silkin, was almost lynched as he forced the government's proposal for a new town in Stevenage down the throats of the existing population of 6,000. He was greeted with shouts of 'gestapo' and 'dictator', the tyres of his car were punctured and sand poured into the petrol tank.

Whether this really proves that there was hostility across the board to the reforms of the Atlee government is unproven. This Stevenage protest seems little different from the long-standing protests today by local residents against the expansion, for example, of Stansted airport. It is hardly surprising if the inhabitants of picturesque villages have never welcomed their destruction. It is true that the Byzantine structure of controls and planning regulations after the war were hugely cumbersome and much disliked by the large variety of groups affected by them; but this is not the same as saying that the totality of post-war welfare reforms were rejected.

Kynaston, in fact, tends to reinforce the belief that post-war planning and housing policy was dominated from the word go by the Le Corbusian vision of high-rise living and the separation of pedestrian from vehicular traffic. His reviewers certainly read him in this way and it is true that after the war modernism was the dominant trend in the English architectural community. The influential *Architectural Review* was wholly committed to it; though in 1946 its editor, J. M. Richards, had published *The Castles on the Ground*, a nostalgic tribute to the English suburb, written when he

113

was still on active service in the African desert. His plea for the beauty and romance of the suburbs was atypical, for town planners in general loathed the way 'suburban sprawl' ate up precious land; this was one reason for the later adoption of high-rise flats.

Significantly, though, the earliest post-war housing estates in the East End of London were high-density but low-rise. Moreover, the high-rise block was not the only ideal for post-war British planners. Ebenezer Howard's Garden City ideas were equally influential. Patrick Abercrombie, architect of the post-war plan for Greater London, wanted at least 1 million Londoners to be decanted to new towns (one of which, of course, was to be Stevenage). The new town as a garden city was to end the vast incoherence of the twentieth-century urban agglomeration. Garden cities would be of manageable size and would therefore create better regulated and more harmonious communities (community being, as always, a buzzword beloved by planners and politicians).

Kynaston deals fully with these issues, but his method, with its welter of detail, obscures the outlines of these controversies, which are simplified to the elitism of highfalutin planners versus the wishes (or indifference) of 'ordinary people'. True, the redevelopment of partially bombed city centres such as Plymouth or Exeter was disastrous and the support of the new, combined with hostility to Victorian architecture and conservation, resulted in fearful acts of vandalism. This was not, though, entirely due to some kind of elitism on the part of the Atlee government and its henchmen, but is rather a story which has continued through to the present day. Writing in the *Guardian* in November 2007, Simon Jenkins celebrated the unlikely saving of St Pancras Hotel (in contrast to the Victorian Euston station, which was demolished) and pointed out that the same battle was now having to be fought over Smithfield market. And even though he cited Spitalfields as a success story for conservation, the reality is that a formerly interesting market has been decimated and partly replaced by yet another anonymous high street/outdoor mall-type development, complete with all the usual banal chain stores.

It was Lionel Esher who pointed out that the real failure of post-war planning was not the mismatch between elitism and the popular will, but the uneven contest between the local planning

authorities and the private property developers, who were always one step ahead, picking up 'plum sites on the cheap'. The developers gambled on population pressures 'long before governments had finalised their regional plans ... they picked up all the plums of urban renewal, leaving the local authorities to do the unremunerative chores'.[2] Nor was it *only* the planners who wanted Victorian squalor swept away. Housing shortages were never resolved, but the extensive local authority housing projects – which continued under the Tories in the 1950s – constituted a major advance and were welcomed by tenants. Even tower blocks were initially popular, as the researchers Miles Glendinning and Stefan Muthesius have exhaustively demonstrated in their monumental tome on the subject, *Tower Block*, published in 1994.

Kynaston is also mistaken in suggesting that the special experiences of women after the Second World War have never been addressed, as a number of feminist studies were written in the 1980s and 1990s. Yet this collective effort to puncture the many myths circulating about women's experience in the second half of the century seems to have failed, for worn out stereotypes resurface. John Carey, for example, deduces from Kynaston that 'most women did not have jobs'. This is simply not true. A desperate need for labour contradicted the assumption that married women would retire from the labour force after hostilities had ceased. The Royal Commission on Equal Pay, which reported in 1946, gave a very guarded welcome to the idea of married women working, and the economist Roy Harrod blurted out the underlying fear about equal pay when he stated that the most important thing was 'to secure that motherhood as a vocation is not too unattractive compared with work in the professions, industry or trade'. There were efforts to foster the idea of 'home making as a career' across all classes. Yet many women, who had experienced radically different and more challenging kinds of employment during the war, now rejected the idea that marriage and career were alternatives. They wanted both. Conservative ideology persisted, but women did not go back to the home. The employment of married women, even if mostly in part-time work, continued to rise after the war, and certainly during the late 1940s there were voices that argued for an end to all laws and customs impeding women's participation

in the labour force. In 1946 an International Labour Organisation study reported: 'A sound and scientific basis for the employment of women is being increasingly advocated as serving the cause of democracy and as promoting the general welfare'; and the Economic Survey for 1947 initiated a campaign for the recruitment of women to the labour force, although in restricted terms:

> Women are urgently needed in many factories, in many services and in agriculture ... [the Government] was not asking women to do jobs usually done by men, as had been the case during the war ... the labour shortage was temporary and women were being asked to take a job only for whatever length of time they could spare, whether full time or part time.[3]

This is one interesting aspect of the immediate post-war years, that conservative attitudes and ideologies continued under their own momentum, yet to some extent were parting company with economic trends.

The most interesting aspect, therefore, of the success of Austerity Britain is the question raised by Matthew Norman: why now? At first I attributed this enthusiasm to a prevailing cultural mood in which anything even faintly resembling socialist reform, the state and the command economy is assumed to be at best mistaken, at worst sinister. But the first programme in Andrew Marr's television series, which presented a more nuanced and largely positive picture of the late 1940s, was also well received. The praise heaped on Kynaston's vision of a surly, fuck-off populace uninterested in having its cultural or any other sights raised beyond material comfort nevertheless depressed me, yet I would interpret the post-war mood rather differently. It is hardly surprising that the British, exhausted by six years of war, having achieved victory against the odds, and then finding themselves faced with smaller rations, appalling weather, in hock to the United States, their empire disappearing and their role in the world diminished, should have reacted with sullen apathy: 'We won the war – why is everything so much worse?' No wonder the mood was mean-spirited and carping and the cultural climate so downbeat. Yet Kynaston does seem to overstate the popular resentment (and is, in any case, not the first to comment on it[4]). Until 1950 the Labour party had not

suffered a by-election defeat in five years (and there were more of them at that time as the male lifespan was shorter – more MPs died in harness than is the case today), and Donald Thomas speculates that it was not austerity and rationing but the Sidney Stanley corruption scandal (Stanley was a rather shady businessman who bribed or attempted to bribe a government minister) that turned the tide.[5] Kynaston also, rather strangely, given his desire to speak for ordinary people, which must mean primarily working-class people, downplays the strength and significance of the ferocious opposition by sections of the middle-class to the Atlee reforms, to which the even then largely right-wing press added powerful ammunition, waging continual ideological campaigns against nationalisations, petty bureaucracy and rationing.

This was a period of recovery after the massive trauma of war; an aftermath, a psychic hangover. The bloody mindedness of post-war Britons could be seen as a way of getting through the bitter disappointment that was this society in the first years of peace, when many people did not yet feel the benefits of the policies brought in by the Labour government.

There was another, more intimate, cause for the sour mood. Reviewers of *Austerity Britain* seemed fascinated by the sexual repression expressed by Mass Observation interviewees and diarists, and the situations in which so many found themselves after the cessation of hostilities must have contributed to the wider disillusionment. Victorian puritanism and hypocrisy had lingered on right through the 1930s; but during the war this changed abruptly. Love affairs, adultery and homosexuality became briefly more acceptable because lovers might be killed tomorrow or never meet again; there were more opportunities for forbidden and fleeting loves to flourish.[6] With the coming of peace, husbands returned home, families had to be put together again, 'living in sin' or having a child out of wedlock became unthinkable once more, there was soon a massive witch-hunt against homosexuals, and an attempt was made to put the lid on promiscuity, divorce and venereal disease and to return to pre-war morality. Even if psychoanalysis was influential at this time – and it was – and led to the promotion of the view that men and women should be helped to enjoy more fulfilling erotic lives, this was to be strictly within the confines of

marriage; the Freudians and Kleinians were every bit as down on queers as the police, even if their methods were not quite so draconian (and they also deplored working mothers).

This sense of erotic frustration and doom was played out in the art, literature and film of the period. John Piper painted dark, gothic landscapes; the verse plays of T. S. Eliot and Christopher Fry were in vogue; and although 'Scandinavian' soon became code in interior decoration for modern furniture with spare lines, there was also the fashion for Regency wallpaper and Victorian tat, while in fashion the New Look offered a wholesale return to the *Belle Époque*.

But it was in films that the dark atmosphere found its truest expression. Needless to say many of these were comedies, from the Ealing stable in particular. And while *Passport to Pimlico* was in part an attack on rationing, petty regulations and controls, the earlier *Hue and Cry*, released in 1946 as one of the earliest of the Ealing productions, was a stirring account of how a group of kids running free through the lavishly photographed bomb sites of the capital, managed to foil a gang of thieves. This was the optimistic view of austerity Britain, with its belief in the *collective* resourcefulness and responsibility of the rising generation and with footage of the new buildings rising out of the ruins of the old.

Still, the dominant mood captured on celluloid was gothic. In American cinema, film noir was in the ascendancy, a strange amalgam of thriller, melodrama and the expressionism directors such as Fritz Lang had brought with them from Germany. Jules Dassin's *Night and the City* (1950) was one of the few set in an atmospheric London and explored a gloomy underworld of wrestling promoters and drinking clubs. Robert Hamer's films, *The Long Memory* (1952) and *Pink String and Sealing Wax* (1945) (the latter set in the Victorian period, but still essentially noir), similarly touched on ideas of thwarted love, betrayal and men on the run, while *They Made Me a Fugitive* (1947) was a tale of gangsterism that also drew a savage picture of masculine attitudes to women. The theme was typically the 'little' man, lost in the urban labyrinth, betrayed and betraying, crushed by the cruel anonymity of the metropolis. Behind this theme, though, doomed romance perhaps best expressed the great post-war disappointment: no more

snatched affairs, just family life once more and for women, even if they had jobs, a return to housework unshared by husbands.

It is always tempting to look back on the past as a way of persuading ourselves that we are different. The vision of a put-upon nation harried by controls and grandiose plans may resonate less today when the contemporary world is so utterly different from the late 1940s, so far as daily life is concerned. We live in an ultra-consumerist society, whereas the immediate post-war past was dominated by extreme shortages. Old political allegiances have weakened. Even how to vote is for many a consumer choice, based on short-term considerations rather than long-term loyalty to a set of ideas. Yet 'choice', so often promoted as the touchstone of the good life, can lead to disorientation and be as depressing, if there is too much of it, as too little, especially when the choices are between goods that are essentially the same, as Barry Schwartz so clearly demonstrated in *The Paradox of Choice*.

Kynaston's negative assessment of those short yet endless years of austerity did not meet with universal agreement. John Carey's populism and dislike of 'elitism' – elitism in this case being the Fabian paternalism of planners who thought they knew best – leads him optimistically to think that 'we are infinitely more tolerant than our counterparts 50 years back', and that we have been saved by prosperity (again, writing before the banks crashed). By contrast, Christopher Hudson, writing in the *Daily Mail* (12 May 2007), believed that

> despite the devastation, Britain was in many ways more blessed back then ... for all the poverty and hardship people behaved towards each other with greater civility than they do today ... queues were orderly ... children did not insult their elders, and were liable to be ticked off in the streets by strangers if they misbehaved – but they could walk to school in safety. There was a pride in British history ...

Whether or not such different assessments reflect the possibly differing political positions of the writers, they do illustrate a contemporary ambivalence towards austerity. The extent of the housing crisis has begun to force a rethink about home ownership, reckless mortgage lending and public sector housing. The growing

awareness of the dangers of climate change, the fragile state of the environment and the growing inequalities in society – for example, the widening gap between rich and poor – has led to a reappraisal of the consumer society. But the revolt against consumerism has also an aesthetic and moral dimension and is not wholly pragmatic. The occasion of Matthew Norman's comments quoted at the beginning of this article was his visit to a new kind of restaurant. He tells us:

> As for the restaurant industry, though it would be stretching things to discern a towering tide of austerity, it becomes clearer by the week that the opulence and pretension of recent years is yielding to simplicity ... Heston Blumenthal and Gordon Ramsay have opened pubs serving ultra-traditional food ... and the march of cheap and previously dishonoured cuts of meat ... seems irresistible.

He goes on to describe a new City of London eatery, 'the genteel shabbiness of the room ... cheap repro antique light fittings, yellow ceiling adorned with the odd bit of cornicing ... and a succession of reasonably priced, splendidly simple and beautifully cooked dishes', and concludes:

> This wasn't a meal notable for austerity. But in spirit ... it paid tribute to a time long before truffle oil, aubergine caviar and the substitution of gravy with jus and spoke eloquently for a new generation of cooks who've bleeding had it with the ... Franco-eclectic poncery that has plagued restaurant food for so long. Had he saved up the five years' worth of ration books for such a lunch, dear old Clement Atlee would have loved it, and higher praise than that there cannot be.

And the fact is that today many people have 'bleeding had it' with the ever more bewildering varieties of choice in a world from which a wider secular social morality has been leached away.

Austerity, then, becomes a more bracing, more purposeful stance to life, and one in which objects are to be used and cared for rather than just consumed and thrown away. A *Guardian* journalist recently described how her father had always insisted on turning one light off before turning another on, had advocated unheated bedrooms and saved everything possible for re-use. She had judged this mean and

penny-pinching until taken to task by a friend who said that, on the contrary, he was an environmental hero and genius of conservation before his time. Another columnist in the same paper wrote of her mother's wonderful fry-ups made from scraps of leftover food, from which she aimed to get at least one free meal a week. Meanwhile, in the *Daily Mail*, an unnamed writer offered a recipe for rabbit broth and added:

> These economies had nothing to do with wartime shortages, it was the way we lived then. Not so much to do with poverty either. My mother spent her early years as a maid of all work in some of the biggest industrial barons' mansions in south Yorkshire, and all her stories were of thrift verging on stinginess. Stale bread could be made into rusks for the nursery, or rubbed through a sieve to make breadcrumbs for the mackerel au gratin. There wasn't a war on; it was just that her employers believed that if you looked after the pounds, the pennies will be looked after by the staff.

Meanwhile, Lydia Slater in the *Evening Standard* (9 November 2007) reported the rise of the new 'unlikely frugalettes' – fashion models and TV stars who practise austerity mode by seeking out cheap haircuts and buying second-hand clothes.

Such evidence is anecdotal, yet the reappearance of string bags, composting and the vogue for used clothes (although that is not in itself so recent) suggests that the 'Austerity Period' still has a deep appeal. This has little to do with the achievements or failures of a government in the late 1940s that thought of itself as socialist, but which has since been condemned both as too timid and as too 'statist'. The fascination of the period may reside rather in its being so contradictory: it was progressive and conservative, depressing and heroic. And its inconsistencies resulted in an atmosphere compellingly memorialised in the films produced at the time by the ailing British film industry.

It is tempting to enjoy the austerity years as a nostalgic trip down memory lane to smile at the horrors of tinned whale and spam fritters avoided, but perhaps the threat of climate change will forge a different, more generous reappraisal. Then perhaps it will be possible better to understand the generation of intellectual planners who insisted on deferred gratification for the sake of the

Figure 7: Charity shops reinvent themselves as fashion boutiques to entice the fashion 'frugalettes'.

general good and to bring the country back from bankruptcy, and that choice and consumption are more distractions than solutions. Unlike the 2010 Coalition government, the post-war Labour government, in a far worse economic position than today, used austerity to invest and expand the welfare state and to regrow the economy, not to privatise and destroy it. Whatever its faults and failures, it had hope in the future. That is the paradox of austerity: that it brought hope out of deprivation. Something that cannot be said today.

11 Post-war Perverts[1]

*The Lord Chamberlain, our stage censor, bans any mention of
homosexuality.*

TERENCE RATTIGAN

In summer 2010, I visited an exhibition, *A Dictionary of Dress*, held at
the unlikely venue of the Victoria and Albert Museum repository –
once the Post Office Savings Bank – near Shepherd's Bush. I turned
a corner and the repository loomed abruptly over a gentrified side
street, the artisans' cottages pastel painted and flanked by French
cafés and twee boutiques. The building must always have been
and still is a thundering, oppressive irruption into this once humble
neighbourhood of corner shops and modest lives. Astonishing in its
grandeur, it is a sublime monument both to the banking principle
and to the wearisome burden of small savings, poised somewhere
between prison, barracks and palace.

The theme of the exhibition, curated by Adam Phillips and Judith
Clark,[2] was the meanings of words in relation to dress. Clark's
surreal conceptual creations were thought-provoking installations
on words such as 'comfortable' and 'pretentious', 'diaphanous' and
'armoured', placed at strategic intervals through the endless rooms.
Yet what was primarily a meditation on words had to compete
with the repository itself as small groups of visitors were escorted
on a journey from the giddy heights of the lead roof down tiled
staircase after tiled staircase, through room after room of objects
assembled endlessly to what purpose, held in a perpetual limbo,
simply accumulated for the sake of accumulation, never seen. The

effect was of chaos barely held at bay, as if all the objects in the world had to be gathered up into this mountain of things, swords next to toys, vases, chairs, cellos, no longer arranged or belonging, disoriented and disorienting in a giddying void of surplus that almost negated the idea of objects as precious and meaningful.

My visit to the exhibition in West London was a journey back into childhood, because I went to school nearby in Brook Green and the school is still there, built in the same period as the repository – around 1900 – but in a more gracious style somewhere between Lutyens and neo-Georgian. I remembered borrowing a copy of *The Well of Loneliness*, Radclyffe Hall's lachrymose tale of blighted lesbian love, from Hammersmith Central Library, another imposing building from the beginning of the twentieth century, which still stands in Shepherd's Bush Road. (The book was on a restricted list, so would-be borrowers had to endure the embarrassment of asking for it specifically, one of many trials of growing up lesbian.) But while the 100-year-old buildings have survived, the Hammersmith Palais de Danse – a reminder of the cheerful side of the austerity years and its democratic mass pleasures – no longer faces the library across the road.

My brief stroll into the past coincided with a reading of Richard Hornsey's *The Spiv and the Architect*, an account of the collision between post-war queer London and the social democratic planning of the 1940s and 1950s.[3] At first I feared that Hornsey's critique of the post-war settlement might resemble Kynaston's. Hornsey is indeed critical of post-war planning, but his perspective is different and more interesting. He describes how the post-war functionalist vision of a stable society set out by planners such as Patrick Abercrombie came up against the Other of this vision: the post-war (male) homosexual, the deviant who, like the spiv, could not be contained. Lesbians do not feature in his account, but I think this is justifiable, for they played a role rather different from the feared figure of the gay man, were pathetic creatures who had missed out by not 'getting a man', rather than being perceived as dangerous.

Hornsey's account begins with a telling metaphor taken from evidence given to the Wolfenden Committee, set up in 1954 to make recommendations on male homosexuality and (heterosexual)

prostitution. In written evidence, Peter Wildeblood, a homosexual prominent because of a sensational trial which had resulted in prison sentences for several well-known upper-middle-class gays, including himself, likened homosexuality to colour blindness – in other words, a natural deviation in a minority of individuals, for which they should not be punished. Sir Jack Wolfenden, the chair of the committee, made a note in the margin, answering the question 'Is it logical to punish them?' with 'Yes, if colour-blindness results in them driving cars across traffic lights'. This note succinctly summarises the collision (I initially typed 'collusion', and perhaps there was also a peculiar collusion in the post-war discourse) between conflicting ideologies of desirable social behaviour, which is the subject of Hornsey's book.

Hornsey's first discussion is of Patrick Abercrombie's plan for post-war London, *The Greater London Plan* (1944). This blueprint was to be frustrated by the exigencies of post-war shortages and short-term pressures, but Hornsey regards it, along with the 1946 'Britain Can Make It' exhibition and the 1951 'Southbank Exhibition' at the Festival of Britain, as a crucial ideological statement. Not only was the dark Victorian city of slums, disease and crime contrasted with the modern world of pedestrian precincts, landscaped green spaces and functional zoning; the reconstruction of London (and this would apply to all major cities) was to be 'the formative crucible for a cybernetic mode of urban governance in which social order, stability and national cohesion were pursued through the fragmentation of the populace into mobile individuals and their insertion into different patterns of circulation'. The *Plan* did more than advocate the dispersal of a London population considered too large for its own good; it did more than seek to provide adequate housing and open spaces; it attempted to create a city 'outside historical time' where 'by discreetly spatialising daily activities and ordering these within prescribed routines ... conflict, change and social upheaval were perpetually kept at bay by an endless repetition'.

Hornsey links this to another key text of the period, T. H. Marshall's 1950 *Citizenship and Social Class*. Its argument (crudely summarised) was that if all members of society were and felt themselves to be 'citizens' (in today's parlance 'stakeholders') then this made the abolition of social class unnecessary. Indeed, class

distinctions could be part of a functionalist consensus in which everyone had their place in a stable and well-ordered society.

Hornsey argues that Abercrombie took this socially cohesive functionalism in a sinister direction, in that he was keen, indeed determined, to include in it every daily activity, even the most seemingly innocent. Leisure as well as work was to become yet another disciplinary function. 'Escapism' could lead to 'untidiness' if not properly organised, and the *Plan* was 'particularly attentive to those interstitial portions of the day in which the disciplinary imperatives of functional zoning were at their weakest' – times, it was implied, though not stated, when Satan might make work for idle hands (or other body parts) to do. The commute, for example, 'as a period of neither work, domesticity nor, properly, leisure ... [was] a site of anxiety – an unproductive time defined by no activity and thus haunted by the spectre of social instability. The weekday lunch hour was another such potentially disruptive moment.' Special areas of parkland were to be provided for this purpose, free, Hornsey suggests, from the dangers of 'metropolitan sexual disorder'.

For sexual disorder is the unspoken fear occluded by the busily intrusive functionalism of planning ideology. The word is never mentioned, but this is a surveillance society, a utopia in which nothing unplanned can possibly occur. Hornsey notes that even the routes through 'Britain Can Make It' and the 'South Bank Exhibition' were carefully prescribed, but this was how the planners wanted the whole of society to be, for, as *The Architectural Review* put it:

> There are many places where the town-planner needs to guide the pedestrian in one direction rather than another and prevent his feet straying where they shouldn't. Rather than rely on the solid wall or the forbidding high iron railing he can make use of many more imaginative means, generically known as 'hazards', which, instead of putting a solid barrier in the pedestrian's path, suggest a barrier by subtle psychological means ... the potential decorative value of these is illustrated in many parts of the exhibition.[4]

The 'South Bank Exhibition' was marked by the mid-century's continuing faith in technological and scientific advance (even as the

developments in nuclear armaments was beginning to undermine this faith). This was deployed to reinforce Abercrombie's highly conservative view of society as an organism in which each part is essential to the functioning of the whole – the false analogy of a society to a single body; the City of London, for example, is not the 'heart' of London, or Britain, in the way that a heart is essential to the functioning of a mammal. (This view, of course, has no place for the homosexual, who is unable to promote the functioning of the whole of society, since he is barren and sterile.) The optimistic belief in science was beginning to be undermined by the terrifying reality of the atom bomb and nuclear warfare, but here the atom was domesticated. Textile designs, for example, were based on the atom, and in the science exhibition the atom was presented as an eternal and stable structure.

Above all, the post-war planners focused on the needs of the family. Abercrombie's plan had local neighbourhoods at its heart, and these neighbourhoods were significantly planned around the local primary school. A specific type of family as much as a specific type of neighbourhood was promoted as ideal, for this was the brief heyday of the nuclear family: the breadwinner husband; the wife who was essentially a home-maker and housewife, although she might engage in part-time paid work; and the two or three children that were considered the ideal.

Just as Marshall's work was the ideological bible for class, so *Family and Kinship in East London* by Michael Young and Peter Willmott and Elizabeth Bott's *Family and Social Network* were key texts that promoted a particular sociological view of what family life was about. The research that underpinned Bott's book was based on interviews with a small number of families, so perhaps her findings should be treated with some reserve. They are nevertheless interesting, for what she found was a distinct difference in the attitudes of working-class and middle-class couples towards sex. For the former, sex seemed to be a disturbing irruption, but the attitude of the middle-class pairs may be aligned with the whole social engineering enterprise outlined by Hornsey, in that it reflected an ideology prevalent in liberal circles since before the Second World War, namely that sexuality was important and should be enjoyable and fulfilling, but only within carefully delineated boundaries that

included birth control and consequently a limit on the number of children in a family. This sexuality was still seen as essentially related to procreation. The childless couple, along with the homosexual, were condemned as sterile. The 'bachelor', once an unremarkable figure in British life throughout all classes, had become suspect. The spinster, of course, had long been an object of ridicule.

The working-class attitude allegedly uncovered by Bott hints at a reality different from the orderly enjoyment advocated by sexual reformers: at the disruptive force of passion, romantic obsession and sheer lust. Hornsey argues that just as the post-war spiv represented the destructive force of economic individualism and free enterprise, so the queer represented the parallel dangers of a sexual free-for-all in a post-war Britain in which the relatively relaxed, even frivolous attitude towards sex, found at least among the upper classes between the wars, had been replaced – rather curiously alongside a new democratic optimism – 'with a new pursed-lipped morality and Cold War chilliness' (as Miranda Carter described it in her biography of Anthony Blunt).

Hornsey argues that quite apart from the changing moral climate, a more practical reason for the crackdown on homosexual behaviour in public was a change in police practices. Surveillance of urinals and street corners was stepped up 'in response to a generally perceived increase in visible queer activity. The number of men appearing before the magistrates rose exponentially – from 106 in 1942 to 212 in 1947.' The result was the belief, pumped up by the tabloids, that homosexual activity itself was increasing and the country in the grip of an epidemic of unnatural vice. The sensational Montagu Pitt-Rivers trial in 1953 (in which Wildeblood had been a defendant) further confirmed this view. Such things could only happen in the old Victorian city of crime and vice that the post-war planners aimed to eliminate. In the wake of this trial – and of another, that of the actor John Gielgud for soliciting in a public lavatory – cafés, railway stations, parks and other indeterminate areas through which the populace was supposed to flow became suspect, since they made possible the loitering of the queer, the pervert out to seduce and corrupt the innocent and the weak.

Gay activity could not, however, be entirely suppressed. One of the most entertaining aspects of *The Spiv and the Architect*

resides in its analyses of popular culture. Hornsey uses a mixture of psychoanalytic and deconstruction theory to expose hidden queer meanings in films, posters, book covers and interiors of the period. For example, he reinvents *The Lavender Hill Mob* as a coded tale of queer male sexuality. On the surface it is the story of a bullion heist, but Hornsey makes a convincing case for a hidden subtext whereby the conspirators are engaged in 'a parody of heterosexual romance'. Within the safe space of the cinema auditorium 'the illicit pleasures of social transgression and urban disorder that were elsewhere being excised from the moral projection of the replanned metropolis could be legitimately, if momentarily, enjoyed ... the audience ... joyfully complicit in ... a very queer mode of reading, experiencing and negotiating the city'.

The Lavender Hill Mob was made in 1951, which was also the year in which Guy Burgess and Donald Maclean defected to the Soviet Union. Burgess was notoriously gay, and one aspect of the Cold War anti-Communist witch-hunts was the link made between treachery and homosexuality. The homosexual was a dissembler. The Montagu Pitt-Rivers trial exposed the ways in which gay men recognised one another, their secret language and gestures – although ironically, as Hornsey points out, the plainclothes 'pretty policemen', now responsible for spying on and cracking down on queer activity in public places, were just as ambiguous as the queers they were hunting down, for 'a similar disparity between appearance and motive ... legitimated [their] access to the illicit codes of queer communication'. At the same time, in an unintentionally parodic return to the playfulness of *The Lavender Hill Mob*, Burgess and Maclean made their escape from Britain on a cross-channel pleasure steamer, theatrically catching the boat only at the very last moment.

The anarchic pleasures of this Ealing comedy could not be tolerated in real life (and even the film had to end with the capture of the miscreant, played by Alec Guinness). Nevertheless, after the Montagu trial, a new and partly medicalised understanding of gay love – one that was equivalent in the psychological realm to the post-war planners' vision of a functionalist and stable society – gained traction. Peter Wildeblood himself made a distinction between the invert – a man (or in *The Well of Loneliness*, a woman)

who was born gay or became gay in early childhood, and whom it was therefore inappropriate to punish – and the pervert, a character of the lowest moral quality, who was either corrupted and happy to be so or rejoiced in his deviant sexuality, whether innate or acquired. The Wolfenden Report, published in 1957, promoted this analysis and hastened the emergence of a new type, the respectable homosexual. Here, an archetypal text was D. J. West's *Homosexuality*, published by Penguin in 1960. West (pen name of Gordon Westwood, who was himself gay) portrayed the 'good' gay as an upright citizen in control of his sexuality. His sexual being was rigorously confined to the private sphere; he would never hang about street corners or importune in 'cottages' and he was probably a middle-class professional man with a serious career. The class implications of the Montagu trial, with its trysts between working-class servicemen and upper-class toffs, were thus reworked in social psychological mode.

This was consistent with the dominant theme of the Wolfenden Report: a strengthening of the public/private divide. So far as prostitutes were concerned, the report wanted them off the street; it also recommended that homosexual activity between two consenting adults over 21 years of age *in private* should be partially decriminalised (this became law only in 1967, a decade later).

The public/private divide became an important focus for feminists in the 1970s and 1980s, since one of its implications was a reinforcement or at least an endorsement of the Victorian idea of the public sphere as the sphere of men, and the private sphere, the home, as the realm of the 'angel in the house'. In other words, public and private were highly gendered.

This divide was also part of the post-war concern with public order. This continues today but has possibly shifted to a concern about political activity, as demonstrations and direct action become ever more closely policed and prevented, while the more carnivalesque aspects of public activity (open air concerts and festivals, for example) are increasingly tolerated, or have simply become more common – just as regulations concerning correct ways of dressing have hugely relaxed in the public sphere of entertainment (a few still wear evening dress and many at least a suit or smart dress to the opera, but jeans are perfectly acceptable) and on the street,

while becoming more rigorous in many workplaces: a trend in tune with the mania for school uniforms as an agent of order, stability and obedience.

In the 1950s and 1960s the preservation of a sober public demeanour still seemed extremely important. People did not wear beach clothes (i.e. shorts and flip flops) on Oxford Street. The respectable homosexual, especially, was surely wearing a tie. Yet the integrity of the public and private divide was continually breached, and certainly could not be maintained in the sphere of reading. As Hornsey points out, no one could be certain that West's *Homosexuality* would be bought and read for the 'correct' reasons – might not readers purchase it less in search of enlightenment and understanding than in order to get an illicit thrill similar to that offered by the homosexual novels published at this period – many of which, despite their lurid covers, were actually serious explorations of the dilemmas of gay love? (And when I first borrowed a book whose title had attracted me – *Sodom and Gomorrah* – was it really that I wanted to read a great French classic, or because of the illicit knowledge Marcel Proust's novel seemed to offer?)

One of Hornsey's case histories from the period (along with a rather less convincing account of the queer possibilities of the photo booth, in particular as exploited by Francis Bacon) is another notorious 'crime': the defacing by the playwright Joe Orton and his lover Kenneth Halliwell of a series of library books from Islington and Hampstead branch libraries. The public library had been since the nineteenth century an important location of civic pride, the approved alternative to the public house or the gambling den. It was a temple of industrious self-improvement and a monument to the benefits of education. Orton and Halliwell subverted this noble enterprise with their mischievous alterations to books they borrowed or stole.

The report of the incident in the *Library Association Record* describes how the pair typed false blurbs onto inside covers, pasted alien images onto dust jackets and defaced and altered illustrations inside books. All these alterations served to create unexpected surreal and/or obscene meanings that the innocent borrower would eventually discover. It seems extraordinary today, but in 1962 the pranks of these culprits actually attracted a prison sentence.

Hornsey discusses the interior of the flat the two men shared in Noel Road, Islington, where the walls were completely covered with an enormous collage of pictures, many of nude men, taken from books and magazines. The couple, and the plays of Orton, which became a hugely popular expression of their queer deviance, are rightly seen as subversive by Hornsey, although the lovers were also tragic, paying a high price for their radicalism. (I lived a few streets away from Noel Road at the time, had come home one lunchtime to see the crowd round the flat, and soon afterwards heard the news on the radio: Halliwell had murdered Orton and then committed suicide. A few weeks later I visited a local junk shop with a [gay] friend. The owner gestured to a couch covered with a blanket and said with a dramatic flourish, 'that's *the* couch, you know'.)

Hornsey describes the Orton/Halliwell flat as a queer interior and this takes him to his final subject: the domestic interior as yet another environment policed and gendered by the stylistic conventions first promoted at the 'Britain Can Make It' exhibition and at the Festival of Britain – conventions of modernist, Scandinavian design with clean lines, cybernetic and ergonomic. A 2009 exhibition at the Victoria & Albert Museum, 'Cold War Modern: Design 1945–1970', explored the way in which this style fused with a utopian view of a scientific space-age future in post-war designs for the home as well as in town planning and, say, aeroplane design. Hornsey shows how the first viewers of this modernism – a style rapidly popularised as 'contemporary' and enthusiastically promoted by the Council of Industrial Design – not only disliked the interiors of the specimen rooms on show at 'Britain Can Make It', preferring traditional arrangements, but actually assigned a moral dimension to the contrasting decors. 'This is definitely a family room and ... morally we want to encourage family rooms', wrote one visitor, whereas the 'contemporary room' was 'very much for a rather immoral type of person – it's out to impress, it's not sincere'.

That interior decoration should be so heavily moralised now seems rather quaint, but Hornsey reminds us of the way in which interior design had been fraught with moral meanings at least since the aesthetic movement of the 1870s. In the 1920s the

masculine values of Corbusian rationality were contrasted with the fashionable 'amusing' style of neo rococo and whimsical clutter. Yet it was difficult for the gay man to steer a course between this and an over-masculine room that might seem to protest too much. Of course, the mere fact that he was living on his own or with another man, and therefore without the feminine touch to the interior provided by a wife, made him suspect, even without the added hurdle of solving the conundrum of arranging a room that did not somehow speak his deviance.

Hornsey does not exaggerate when he insists on the importance of interior design for morality and social engineering. Throughout the early post-war period state institutions and its representatives went on the rampage to educate the public into correct taste. John Newsom, a prominent educationalist, revealed the class and gender bias underlying this obsession when he wrote in 1948 in *The Education of Girls*:

> Our standards of design, and therefore our very continuance as a great commercial nation, will depend on our education of the consumer to the point where she rejects the functionally futile and aesthetically inept and demands what is fitting and beautiful ... Woman as purchaser holds the future standard of living of this country in her hands ... If she buys in ignorance then our national standards will degenerate.[5]

In the New Towns built during this period many residents disliked the layout of their houses. Instead of a front parlour with separate kitchen, they found open-plan design. Judith Attfield, in her study of Harlow, *A View from the Interior*, quotes a censorious account of 'mistakes' made by tenants:

> They fight shy of open plan living ... there is a strong tendency to shelter behind net curtains. Large windows are obscured by elaborate drapes and heavy pelmets, by dressing table mirrors and large settees. Corners are cut off by diagonally placed wardrobes and sideboards ... the open plan houses are being closed up again, light rooms are darkened and a feeling of spaciousness is reduced to cosy clutter ... in achieving cosiness they are completely at variance with the architects' achievements in giving them light and space.[6]

Hornsey cites the 1961 film *Victim* as a key moment in the passage of the homosexual from pervert and public menace to responsible citizen. Openly propagandist for a reform of the law, it deployed a variety of gay 'types' in its thriller format, which revolved, understandably, around blackmail – since this crime was a major spin-off from the illegality of male gay love. Here, as elsewhere, interiors speak the man. The unhappily married hero, ironically played by the always closeted Dirk Bogarde, is shown as living in a traditional house filled with bibelots, antique furniture and fussy figurines, while the well-adjusted gays of the tale are provided with the ideal contemporary home. 'Startlingly modern', their open-plan flat has walls covered with contrasting textures, and is furnished with lightweight 'Scandinavian-style' furniture and a few tasteful glass ornaments and floor rugs.

Hornsey includes the emergence of DIY in the later 1950s as an integral part of the new incorporation of the nuclear family into the domestic interior, but as with *The Lavender Hill Mob*, finds a subversive subtext. DIY was, naturally, highly gendered, but Hornsey has found some hilarious examples of unintended double entendres or possible queer meanings. For example, he reinterprets an advertisement designed in the shape of a strip cartoon. 'It began on the 8.14' is the strap line, and it charts the induction of one commuter by another (casually met on the train, of course) into the joys of DIY. Hornsey rereads the whole ad as a story of gay seduction, occurring in just one of those indeterminate spaces – the commute – that caused Abercrombie so much angst.

Both serious and entertaining, *The Spiv and the Architect* is an original approach to the cultural history of the early post-war period, especially in its juxtaposition of unexpected areas of 1950s' society. In conclusion, Hornsey suggests that the antics of Orton and Halliwell were taken forward by Gay Liberation as a strategy to be used in radical politics. Gay Liberation was indeed a carnivalesque moment, but it did not, as carnival is often alleged to do, merely act as a safety valve so that things could go on as normal for the rest of the time. On the contrary, it was a moment in the trajectory whereby today, in official discourse at least, the gay is a well-integrated and even cherished member of society. But this came about (and in fact the transformation is far from complete; homophobic attacks – at least

Figure 8: DIY ad re-imagined as gay seduction.Courtesy Richard Hornsey.

one resulting in murder – appear to have grown in number in recent years) not just as a result of subversive activity, but also because of the promotion of the idea of gays and lesbians as respectable and largely 'normal' – the reformist rather than the radical idea of gays. In privileging the disruptive and subversive nature of post-war queer culture, Hornsey is insufficiently critical of an outdated postmodern agenda. The postmodernists of the 1980s launched an attack on what they saw as the oppression of 'totalising' theories, which claimed to liberate and revolutionise, but only effectively promoted the preoccupations of the 'white, Western male'. They claimed that their deconstruction agenda would bring the marginalised to the fore and fragment, and thus destroy the status quo. What resulted was the opposite: the entrenchment of consumer capital as celebrities flaunted new and often fleeting identities and fetishised their choices of leisure activities.

In an influential article, 'Walking in the City', Michel de Certeau contrasted the all-seeing eye of the planner to the wanderings of the pedestrian in the interstices of the planned city, always seeking to subvert the planner's intentions. But he acknowledged that the pedestrian only ever has 'tactics' and can never rise to 'strategy'. He reacts rather than creates. The words 'subversion' and 'transgression', so popular in postmodern discourse, have always suggested their own limitations. In the end transgression became an end in itself, something fashionable rather than challenging. Queer theory ended up as merely the opposite of what went before, with the paradoxical effect that 'transgression' could come to mean erstwhile gays embracing heterosexuality even as former Marxists discovered their inner bourgeois.

Hornsey is in danger of following this path insofar as he positions the subversive life of the 1950s' queer as a valid critique of the conformist certainties of the Abercrombie way of life. It is indeed valid. At the same time, it is important not to lose sight of the fact that those lives were at times blighted by the harsh attitudes and laws of the time. The respectable homosexual may have been a restricted and dreary figure, and those who defied the laws were creative and life-affirming as well as brave, but attitudes could not have changed without both of them combining against prejudice and persecution.

12 Bethnal Green

I, the Builder of Churches, am no Puritan nor Cavaller, nor Reformed,
nor Cathollick nor Jew, but of the Older Faith.

PETER ACKROYD

In 2003 my daughter lived for a time in a student house on an East End council estate. Apart from a few other students almost all the residents were Bangladeshi. There was only one way into the estate by car. The arrangement had probably been made to give a sense of security, but the courtyards were eerily empty and the monolithic flats looked grim and bleak. On foot the estate was reached along an alleyway between a park and the railway arches. It was unlit and I worried to think of my daughter walking home late at night, the empty little park on one side, on the other the shadowy spaces straight from a Piranesi print. Worried, that is, until she told me about the thriving all-night Turkish bakery at its busiest at one or two in the morning and the baker who always greeted her and made sure she was safe.

I remembered the old East End shabbiness from a long gone period when I worked in the East End. Unlike the inner London further west where I lived, the Mile End Road with its jumbled architecture, ethnic shops and cafés and the little nineteenth-century cottages to the south seemed unreconstructed, refreshingly authentic after the groomed slickness and gleaming painted stucco of more gentrified areas, a step into a more Dickensian past.

In the 1970s the shrunken terraces had housed a squatting movement that had colonised whole streets. On the far side of the

Mile End Road terraces of shrunken nineteenth-century houses were unchanged, but now families had moved back into the cottages.

I wandered with a friend down Parfitt Street in search of a much-publicised exhibition sponsored by Artangel, 'The Schneider Family', created by the German artist, Gregor Schneider. This 2004 installation consisted of two adjacent houses, whose interiors had been recreated identically. The rules were explicit. The exhibition was to be visited in pairs, each entering one of the houses alone. Then the process was to be repeated in reverse.

The house was dimly lit and the walls were dull brown as if stained by decades of nicotine fumes. In the kitchen a woman endlessly washed up in a dreary kitchen, next to a claustrophobic sitting room, which contained a few books and an ashtray full of stubs. You, the visitor, were there, but not there. You were a ghost. The woman at the sink did not see you, never spoke.

Upstairs a man masturbated behind a transparent shower curtain. In the white, cheap bedroom with its padded satin headboard, shag pile carpet, gilded fitted cupboards and fan heater turned up to maximum, a figure in the corner with a black plastic sack over its head was less uncanny than the silence, which was only emphasised by the hum of the heater.

When you peered through the keyhole into the attic you could see violent sexual graffiti. But the only part of the house that really frightened me was the basement, with its indeterminate stain on the concrete floor. As you gingerly stepped towards the cupboard in the corner, the door of the tiny, dark room shut behind you. For a moment you panicked, struggling against the hopeless feeling that this was an underground prison from which you would never escape.

In the second house the experience was repeated. An identical twin to the woman in the first house still bent over the sink and ignored your existence, cut off by the wall of silence. I felt contaminated by the atmosphere of airless misery, of an unnameable, sickening anomie. Yet I could not quite give myself over to the experience, could not quite forget that this was not an installation. It was uncanny, but not quite uncanny enough, because I had been invited to be a voyeur. I had entered into another person's uncanny, but it was, in the end, staged. The truly uncanny is that

which comes upon you, unbidden, when the whole atmosphere changes from normal to strange, the uncanny emerging from your own imagination, your own unconscious.

'Die Familie Schneider' bore no relation to the surrounding East End, yet seemed consistent with it, consistent with the jumbled histories of the area, of the East End as a historical junk shop, a repository of everything that has been lost from sleeker districts. A grim edifice was once the famous men's hostel in which George Orwell stayed when researching his book *Down and Out in Paris and London*. Joseph Stalin also stayed there once, when in London for a Bolshevik conference. Now it was to become 'loft apartments'; gentrification was creeping in after all, even along the Mile End Road with its markets, its food outlets and its poverty.

Later I paid a second visit to the East End in search of the uncanny, visiting the Hawskmoor churches in Shadwell, Spitalfields and Limehouse, which for the psychogeographers Iain Sinclair and Peter Ackroyd were sites of 'occult London'. Peter Ackroyd's novel, *Hawksmoor,* described the satanic rituals in which a child was murdered and buried beneath the foundations of the churches when they were built at the beginning of the eighteenth century. Legend had it that the churches stood on occult ley lines, remnants with spiritual significance of the 'old religion', which Christianity crushed sometime during the Dark Ages.

At one time Christ Church Spitalfields was in danger of collapse, and was used as a sanctuary by meths drinkers and other down and outs, but was eventually renovated to its former glory and is now once more grand and beautiful, but in a gentrified way, as though it had become a pastiche of itself, its baroque splendour lacking a sense either of the occult and uncanny or of the spiritual in a Christian sense, a simulacrum of the baroque sublime, standing at the end of a new vista formed by the new, banal Spitalfields.

St George's in the east stands beyond a street of rundown council estates and sits alongside an expressway. In spite of this and although the interior, bombed in the war, contains a nasty 1960s' refit, the exterior has retained a sinister gloom. The pale, thickset columns and turrets squat belligerently from across a small green on a chill December afternoon as the twilight thickens around it. It exists on another time plane from the surrounding Asian community.

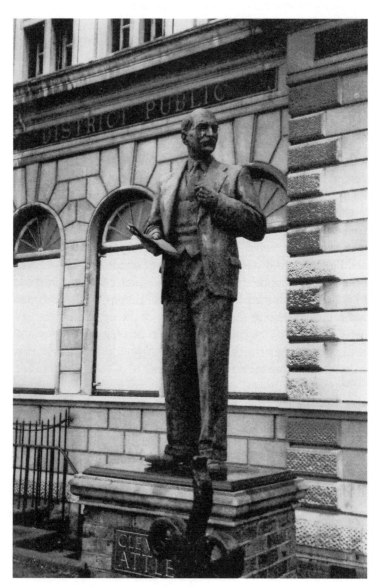

Figure 9: Clement Atlee lost in Limehouse, 2007.

St Anne's Limehouse seems more serene. Yet its churchyard contains a mysterious monument in the shape of a large, three-dimensional triangle, covered with words impossible to decipher.

It stands near a ganglion of roads heading traffic off towards the Blackwall Tunnel or the Isle of Dogs. I never quite experienced the uncanny as I loitered outside the empty churches any more than I had in Schneider's claustrophobic homes. Perhaps I was too unimaginative or too much of a rationalist. However, as I came away from St Anne's, I encountered an example of what might be called the political uncanny, a reminder of what has been lost.

Where the roads meet, a magnificent public building in the 'moderne' style stands unremarked, the relic of some former era of municipal grandeur. Opposite is a boarded-up public library, now derelict, and in front of it stood a life-size statue of a slight middle-aged man in a shabby, crumpled suit. I read the inscription and found it hard to believe that this was Clement Atlee, the greatest post-war prime minister, under whose premiership the NHS was formed, the railways and mines nationalised, the welfare state solidified, the commitment to full employment made. Here he was, almost as derelict as the ex-library behind him. The whole junction was a monument to the loss of faith in the public sphere: an anti-monument. Some months later I paid a return visit. Now it had been totally encased in a black box – truly a coffin for the memory of the welfare state. A third time I passed the site – this time in a car – but now it had disappeared completely.

PART FOUR

Magic Moments

13 Modern Magic[1]

It is the customary fate of new truths to begin as heresies and to end as superstitions.

THOMAS HUXLEY

Simon During's *Modern Enchantments: The Cultural Power of Secular Magic* is that contradictory text, a learned account of the origins of forms of 'modern' popular entertainment. Simon During is interested in 'secular' magic. By this he means primarily forms of magical performance that do not depend on actual belief in the existence of spirits, miracles and related phenomena: entertainment based rather on sleights of hand, tricks and conjuring.

His detailed history of the evolution of magic-related practices draws on the philosophies of John Locke and Ludwig Wittgenstein, among others, but he particularly favours Locke's pupil, the third Earl of Shaftesbury. Considered during his lifetime to be a deist or even an atheist, the Earl, whom During presents as a postmodernist before his time, distinguished between 'bad' magic and 'good'. For him, bad magic meant 'enthusiasm' when it leads to fanaticism and intolerance. Presumably this bad magic would include religious 'miracles' and other events promoting blind faith. Good magic served a benign purpose in that 'sublime ideas and passions "too big for the narrow human vessel to contain" will always reach out beyond the natural and the knowable towards the divine', even if this no longer requires 'supernatural inspiration'. For Shaftesbury, the best defence against fanaticism is 'a nurtured lightness of mood'. During believes this nurtured lightness of mood

will be crucial in his understanding of 'modern magic'. Furthermore, Shaftesbury showed an appreciation of popular entertainments, thus rejecting the hierarchy of taste between high art and low culture. In other words, Shaftesbury is 'a neglected cultural theorist' who appreciates 'the lightness and fun (to use a favourite term of the later eighteenth century) of a profane popular culture'.[2]

The Romantics further developed the attitudes that open us to an understanding of 'modern' magic. Coleridge called for the 'willing suspension of disbelief' in the audience faced with fictions involving supernatural or otherwise magical seeming events; Shelley thought of visions and seemingly supernatural appearances as a manifestation of the human imagination, and During argues that these new understandings amount to a secular reconfiguration of our relationship both to belief and to fiction.

The distinction between 'credulity' and 'disbelief' is sharpened and hardened even as fictional entertainments extend their reach and ambition. On the one hand, attempts are made to render religious belief more rational and to avoid the spectacular excesses of miracles and religious superstitions, but at the same time popular entertainments, many relying on the 'willing suspension of disbelief', develop rapidly in the fast-growing industrial economy and the society of consumption, making use of advances in technology to render their effects more 'believable'.

Simon During also distinguishes between fictions of the real and fictions of the true. Fictions of the real are performances; a conjuring show would be an ideal example. They are illusions. Fictions of the true, by contrast, represent the truth of belief and experience. The nineteenth-century novel in its serious description and exploration of Western societies, its psychological depth and social analysis, represents the fiction of the true. During believes that these have been exhaustively studied, while critics have neglected conjuring and other kinds of entertainment based on the manufacture of illusions. He aims to redress this balance and to give 'modern magic' the respect it deserves.

During attempts this by developing a critique of what he calls 'compensation culture', the idea that the magic of modern secular culture is a compensation for the loss of the sacred. Theodor Adorno, in his *Aesthetic Theory*, for example, believed

that art performs this compensatory function, so that art almost becomes a kind of religion. But he also held that the whole structure of seemingly rational capitalism was actually irrational and full of its own baneful magic and illusion. For Adorno, mass culture was an important dimension of the disenchantment and falsity of the capitalist world order, the sense of loss experienced in the disenchantment of a world ground down in the 'iron cage' of the bureaucratised state. For During, this Weberian idea and Adorno's pessimism are misguided in failing to recognise 'the spread of pleasures, competencies and experiences that flourish within the modern culture of secular magic', and because he also fails to understand 'the capacity of modernized individuals to fall almost simultaneously into enchantment and disenchantment ... at their own leisure and pleasure, with little subjectivity – or political agency – engaged'.[3]

Perhaps Adorno is too pessimistic about modern culture and perhaps he is also too optimistic in his belief that modernist art can reveal the truth and dissipate illusion. It does not necessarily follow that During is not also too optimistic when he so wholeheartedly celebrates the eclecticism of contemporary mass culture. He also does not acknowledge that mass culture has eliminated or at least marginalised many of the forms of entertainment that he rightly wants to celebrate: the circus, street entertainers, jugglers, magic lantern shows, ventriloquists and conjuring itself.

During offers a detailed account of the development of conjuring and related forms of 'entertainment magic' from the late seventeenth to the twentieth century, charting the rise of this culture as opportunities for new forms of urban leisure expanded and an urban audience greedy for novelty and excitement grew. In the Victorian era commercial interests also propelled the search for novelty, as magic became big business. These 'magic' entertainments, as well as being derived from older forms of magic and the supernatural, drew on popular science on the one hand, and spiritualism on the other. Trick mirrors, optical illusions and electricity were some of the scientific methods used in the production of magical effects; at the same time, During argues, the entertainment business undertook a 'crusade' against spiritualism, unmasking its fakery and thus advancing the cause of secularism.

That this was not as successful as During implies is suggested by the continuing appeal of spiritualism, even today. Fortune-tellers and psychics flourish, even if they have abandoned the startling theatrical performances beloved of the Victorians; they have moved away from their connections to entertainment and towards the world of therapy. (However, Hilary Mantel's novel *Beyond Black*, [2005], described the seedy side and credulity of this world.)

Most importantly of all, magic performances led at the close of the Victorian period to the emergence of film. By the 1880s, John Maskelyne and David Devant were the stars of the magic entertainment business. In 1882, Georges Méliès visited London, where he 'haunted' Maskelyne's Egyptian Hall, 'England's Home of Mysteries', in Piccadilly. Devant and his projectionist, C. W. Locke, showed 'animated photographs' as part of their entertainments. These inspired Méliès to make further experiments in this line, but although he was the first successful maker of films, he retreated in the face of the swiftly developing new techniques, since he disapproved of filmic illusions that did not announce themselves as such. Film was beginning to blur the boundary between illusion and reality.

During devotes a whole chapter to the question of whether there is a literary equivalent to secular magic as a way of considering the relation of magic to the wider culture, but incomprehensibly fails to explore the development of cinema. Perhaps it would have felt like a too daunting extension of his investigation, but a discussion of film would surely have opened up questions central to his project. But film, which uniquely can blend During's 'fictions of the real' and 'fictions of the true', is far from invariably 'light'. It would have undermined During's commitment to a view of the 'lightness' of 'secular magic' and therefore his whole thesis.

In any case, almost from the beginning, During finds it difficult clearly to demarcate the boundaries between his 'light' secular performances and events in which belief in some kind of supernatural power or event creeps in. He is so keen to emphasise the pleasures of popular entertainment that he completely disregards whole areas of contemporary life in which 'secular magic' continues to hold some kind of sway. The willing suspension of disbelief of which he writes appears to be distinct from the Freudian concept of

'disavowal'. Disavowal is having your cake and eating it; it is to both believe and not believe something simultaneously – ('I know that women do not have a penis, *and yet* ...'). But that kind of disavowal seems rife in contemporary life; from horoscopes to psychics, taking in alternative therapies of all kinds on the way, we moderns seem all too eager to embrace forms of magic that go beyond pure entertainment. They seem to provide some sort of placebo effect for our troubles.

Even more seriously, During makes a distinction between religious faith, and 'belief', the latter being 'a relation to the sense of propositions whose truth we can appropriately doubt'. This implies that we cannot doubt that form of the supernatural brought in under the umbrella of religious faith. The rigid distinction he makes between magical beliefs and religious faith is a failure to recognise the uncertain terrain between the two. On the one hand, magical beliefs stem from earlier religions that were 'defeated' (in the West) by Christianity, as Keith Thomas demonstrated in *Religion and the Decline of Magic.* On the other hand, by ring-fencing 'faith', During validates it in a fashion that no secularist could accept and which, more importantly in this context, exposes the weakness of his whole argument.

There is a case for arguing that religions are themselves a willing suspension of disbelief, aided by the often spectacular and theatrical rituals involved. Rather than setting religion aside, it might have been more interesting to explore the common ground between the two. For it is undeniable that 'entertainment magic' has roots in ancient beliefs that were taken very seriously in earlier times. Yet in siding in so partisan a fashion with the 'light' magic of entertainment, During disavows the continuing importance in an allegedly secular culture of surviving forms of belief in the supernatural. His attempt to make his 'secular magic' completely unrelated to any kind of religious or spiritual belief surely cannot succeed.

In keeping with this rigidity, During's choice of those whose work he discusses is highly partisan. Shaftesbury obviously qualifies because of his interest in the popular; other writers of the period that might have taken a different view do not appear. Much stranger is During's failure to mention other than passingly the Surrealists, when Surrealism was surely the modern movement above all

others that took magic and the occult seriously. But, again, that may be the reason for their omission: that they took it all too seriously for During.

During's commitment to a resolutely upbeat assessment of contemporary 'entertainment culture' prevents him from exploring what is really a more interesting field: the persistence and ubiquity of so many different kinds of superstition, occultism and other 'deviant' belief forms alongside both formal religion and secularism. In the end his assessment of 'secular magic' is Panglossian in emphasising its pleasures. Even if these are as harmless as he suggests, this central conclusion – that they *are* harmless – seems banal. This is a shame when his book is so rich in its exploration of many different kinds of belief and unbelief and of many and various literary and aesthetic experiences.

14 'Disoriented Agnosticism':
Reading the Tarot

Madam Sosotris, famous clairvoyante
Had a bad cold, nevertheless
Is known to be the wisest woman in Europe
With a wicked pack of cards.

T. S. ELIOT

During a brief hippy period (my khaki overcoat, mentioned earlier, acted as a transitional object between this and the move to political activism), a friend introduced me to the tarot. I was soon laying out Celtic Cross and triangular spreads, using the Waite Rider pack. This was designed in 1909 by the artist Pamela Colman Smith, influenced by the occultist A. E. Waite, and reflects the general interest at the close of the Victorian period in The Hermetic Order of the Golden Dawn, the most influential group to emerge from the occult revival at that time. Every card is pictorial, unlike the more traditional packs, such as the Tarot de Marseille, in which only the 'Major Arcana, (the cards special to the divinatory tarot) are illustrated, while the 'Minor Arcana', have numbered suits like ordinary playing cards – except that the suits are Wands, Cups, Swords and Pentacles instead of hearts, spades, diamonds and clubs. The colourful, aesthetically attractive images of the Rider pack, with their Arts and Crafts and Art Nouveau medievalism, excited my imagination, as well as reminding me, in my fortune telling capacity, of their divinatory and spiritual meanings.

No one admits to taking fortune-telling seriously. It could be – surely is – part of During's 'modern magic', although its association

with mountebanks and black magic hints at its darker side. The claim to foretell the future is surely to flirt with danger, to act the part of God. Yet seers were once revered and even today an ambiguity surrounds the practice. For those who take it seriously, it comes with its own sacred legends.

Ronald Decker and Michael Dummett have written an exhaustive two-volume history of the tarot. In the second volume particularly, *A History of the Occult Tarot, 1870–1970*, they describe how a whole fake history of the tarot was constructed by a series of nineteenth-century occultists who claimed to trace its legend back as far as ancient Egypt. It is not always clear how much these fantasists believed their own inventions, but for many the manufactured legends were as compelling as those of Christianity. The Waite Rider pack draws on these as well as referencing Egyptian, Christian and Greek myths and legends.

I do not believe it is possible to foretell the future, but, as a friend put it, the cards can be a useful way of thinking about your problems. The images act, like Rorschach test cards, as a trigger for thoughts and ideas about a dilemma. Even when fortune-telling is at its most demotic, on a resort pier, there is a sense of ritual that can range from something almost sinister to a form of meditation, in either sense a distinct practice.

In the late 1980s and 1990s, I gave occasional 'readings' at fund-raising events. In the earlier period these were for feminist causes, later at school jumble sales, but at none of these events was I ever short of customers. There was, naturally, a degree of disavowal, but the tarot was never quite seen as just a bit of fun. I dusted down skills I had once learned as a mental health worker and was soon hearing of domestic misery, occupational redundancies and anxious hopes for a different future. On more than one occasion my 'client' asked if she (it was usually but not invariably a woman) might consult me privately and at greater length, evidently assuming that I was an established clairvoyant. This was disconcerting and I eventually gave up the fundraising altogether, worried about the ethics of the enterprise, yet these requests convinced me that were I to set myself up in Camden Lock Market (a haven for hippies) or the seafront at Brighton I would without doubt be able to make additional income without

much effort. The idea even attracted me. Freudian psychoanalysis, after all, originally came with the trappings of the dubious, almost the occult, dark thoughts swimming up out of the great ocean of the unconscious. I never made predictions; I simply used my observational and interviewing skills to try to find out what the person opposite me needed to talk about and what might help her. Anyone, after all, may perfectly legally set themselves up as a psychotherapist, regardless of whether they have any relevant training or not. Yet in my case might it not be unethical because while my commentary could prove helpful, was it not also deceitful since I did not believe in spiritualism or that I was a psychic?

So I did not pursue the idea of a new career as a clairvoyant. It could only be done if you did take it seriously, and devoted time and energy to sharpening the skills of observation and intuition on which it depends. You would effectively become a therapist, but one without the support of the Association of Psychotherapists or the British Psychoanalytical Association. (There may be a society of clairvoyants – and the Order of the Golden Dawn now has a website – but I felt no desire to venture into any occult community.)

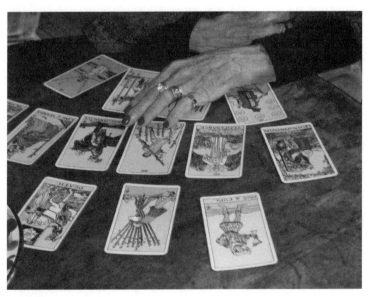

Figure 10: Tarot reader – after Brassai.

Nevertheless, the appeal of the tarot still draws me back. To hold and spread the cards is to enter a marginal space at the border between the imaginative and the real. The images act as a gateway to the different perception of emotions. You do not have to believe in the occult to see in the allegorical depictions of power, love, despair and expectation and hope a different mirror for your life, in that space between play and hidden meaning.

It may be that it attracts the non-religious by reason of its ability to suggest an 'enchanted realm' outside the iron cage while, unlike the established religions, not imposing a rigidly prescribed set of moral doctrines. In the 1980s, I was quite surprised by how many feminists referred to their astrological star signs (I'm a Virgo, you know, so ...) and I should therefore not have been surprised to read the obituary of psychic astrologer Henrietta Llewelyn Davies in *The Telegraph* (20 May 2011). She claimed to have psychic powers (she would often hear voices), she studied astrology in India and wrote horoscopes for a number of women's and other magazines. She was consulted by well-known women novelists and by lawyers and would give advice on any subject, from how to lead a better life to what car to buy. *The Telegraph* publishes comments on its obituaries; the 17 on this one were almost uniformly hostile. They were contemptuous of educated people who could believe 'dark ages superstition'. Several made the connection with organised religion, pointing out that an obituary of Archbishop Rowan Williams should be criticised on the same grounds. Some blamed the education system for making possible such credulity.

This leaves unanswered the question why educated secular intellectuals are attracted to this kind of 'magical' realm. For me, a non-believer, all myths are on a par. If they are imaginative and beautiful, if they resonate, then they may be valuable, but should not be misunderstood as any kind of literal truth. In *The Case for God*, Karen Armstrong makes a similar case for Christianity. She suggests that as a result of its encounter with science over the centuries Christianity itself became pseudo-scientific, believers reading the Bible for 'facts about God' and insisting on its literal truth. For her, by contrast, religion is a practice, a discipline, one that 'cultivates a perception based on imagination and empathy', and which, 'backed up by ritual and ... practice, can ... still produce the

sense of transcendence that gives meaning to [practitioners'] lives'. Religion as she describes it becomes an imaginative and receptive state that might equally be induced by art. It is essentially about feeling and God is, as Ludwig Feuerbach, the nineteenth-century German philosopher observed, a projection of human feeling. If it resonates, it has an emotional truth, and whether its stories are actually true or not is beside the point. This is postmodern religion, in which the truth or otherwise of its propositions is irrelevant. It is simply a receptive state that might equally be induced by art. It should follow that gazing at the tarot is as valid (or invalid) as Christian observance, although I wonder if Armstrong would agree that to practice the tarot is similar to following an established and powerful religion.

So, from the perspective of Karen Armstrong, it is hard to see why, if faith and belief are essentially subjective, a conviction of the power of the occult or the existence of ghosts or being a Judy Garland fan is not as valid as believing in the Trinity, why it is not as valuable to read Marcel Proust as the Bible. This is not a defence of subjectivism as such, merely the observation that all sets of beliefs in the supernatural, whether socially endorsed or not, fall at the hurdle of reason and evidence; conversely many, if not all, include myths and imaginings that may stir the imagination, clarify understanding and by their use of metaphor illuminate. Nostalgia too may be more like a projection on to the past of the longing for transcendence than merely a form of sentimentality.

15 Secret Worlds

*Objects of little value, furniture of questionable taste ...the most
common things, can reveal unexpected passions, even an old,
threadbare overcoat.*

LORENZA FOSCHINI

I entered the enchanted world into which, little by little he drew me.

CÉLESTE ALBARET

Simon During's celebration of entertainment culture opts for light-hearted enjoyment, largely disregarding the passion audiences bring to spectacle and the dark and deviant side of fan emotions. His is a sanitised view of mass culture, and in separating it so strictly from religious faith, he diminishes the enchanting power of which he holds it capable.

The word 'fans' calls up the image of crowds of thousands driven wild by the excitement of singers, footballers, film stars performing their hearts out. Fandom, however, is about much more than that. It is not just about spectacle. There are bookish fans, for example, that earn a little more respect than pop music groupies, although 'bookworms' too are a despised breed and too much reading is, or used to be, considered morally dubious. To lose yourself in the fantasy world of a book is to indulge in escapism; it is weak, cowardly, even dangerous. Book addicts should leave their ivory tower and engage with the real world, not waste time reading. Besides, to be a literary fan may even be more dangerous than the girl who languishes after a boy band, or the guy who follows

'his' team with grim devotion. To read a certain kind of book is to enter and inhabit an alternative reality in a way that attendance at a match or a concert is not. A book can mess with your mind.

Laura Miller's eloquent account of being a fan of C. S. Lewis's *The Narnia Chronicles* describes how she 'opened a book ... and ... found a whole new world'. Her love of *Narnia* survived the discovery that it was a Christian allegory while she is not a practising Christian. It had a magic independent of that. Its effect on her could be understood in secular moral terms. Immersion in an imagined world extends empathy and enlarges understanding. *Narnia* taught her, she insists, the necessity of struggle and of courage; through it she gained insights into her own behaviour. Above all, though, it responded to the 'universal ... desire to be carried away, to be something greater than ourselves – a love affair, a group, a movement, a nation, a faith. Or even a book.'

C. S. Lewis had been a hugely influential figure at Oxford when I studied English Literature there. Along with J. R. R. Tolkien, then publishing his *Lord of the Rings* trilogy, and the less well-known Charles Williams, he formed a conservative trinity whose eminence contributed to the already intensely religious atmosphere of the university. This infiltrated the city as insidiously as the dank and enervating mists that rolled up from Christ Church Meadow. Lewis' heartily facetious polemic in favour of Christianity, *The Screwtape Letters*, had repelled me and I was suspicious of what I could not quite articulate at the time, but which I now realise was the pervasive atmosphere of a masculine culture in which women were marginal. There were female undergraduates, of course, but no one knew quite what we were being prepared for, while women dons were more often than not caricatured as batty eccentrics: Enid Starkie, the eminent French scholar staggering drunkenly up St Giles in her French sailor's tam-o'-shanter; or Miss Anscombe the philosopher, who, it was alleged, used to set fire to her hair with her cigarette and who gave tutorials in her kitchen while mice scuttled across the floor. Another female eccentric was said, even less believably, to post her small children to their father in Cambridge; it was alleged they travelled with other parcels in the guard's van.

Finding Laura Miller's approach to Lewis sympathetic, I put my long-standing prejudices aside and reread *Surprised by Joy*,

Lewis' account of his return to Christianity. He describes the experience of

> an unsatisfied desire which is itself more desirable than any other satisfaction. I call it Joy, which is here a technical term and must be sharply distinguished both from Happiness and from Pleasure. Joy (in my sense) has indeed one characteristic, and one only, in common with them; the fact that anyone who has experienced it will want it again. Apart from that, and considered only in its quality, it might almost equally well be called a particular kind of unhappiness or grief. But then it is a kind we want. I doubt whether anyone who has tasted it would ever, if both were in his power, exchange it for all the pleasures in the world. But then Joy is never in our power and pleasure often is.

For a time he labelled this emotion 'aesthetic experience'. (It seems similar to Barthes' *jouissance*.) Eventually he interpreted it as the search for God and rediscovered his Christian faith. This led him to downgrade the importance of the subjective feeling of 'joy'. His Christian reinterpretation of it had led to an almost total loss of interest, because although 'the old stab, the old bitter sweet, has come to me as often and as sharply since my conversion as at any time of my life', he now knew that the experience, 'considered as a state of my own mind, had never had the kind of importance I once gave it. It was valuable only as a pointer to something other and outer (i.e. God).'[1]

This expresses the Puritanism inherent in the suspicion of aesthetic experience in and of itself and typifies the Christian insistence on interpreting moments of transcendence in religious terms. Yet Christians themselves often compare such moments to a concrete, sensual experience – great music or a wonderful landscape; and 'why exactly', asks Gregor McLennan, 'should experiences of cosmic awe, inner transformation, intimations of the sublime and so forth, be uniquely associated with religious revelation *rather than* humanistic-naturalistic sensibilities?':

> Countless powerful responses and heightened moments, after all, can be found in our lived practices of science, adventure, sport, parenthood and art, and they can be cultivated into practices of the self that require

no reference whatever to purportedly divine/transcendent influences, entities or qualities.[2]

The Christianity of Oxford when C. S. Lewis taught there was supplemented by the pervasive medievalism of the English school. Malory's *Le Morte d'Arthur* and *Sir Gawain and the Green Knight* could be imagined in lush pre-Raphaelite imagery. *The Lord of the Rings* – incomprehensibly to me – was even more popular throughout the undergraduate community. To many of my fellow undergraduates these legends offered entry into a richly romantic and glamorous world of the imagination, or in the case of Tolkien a reassuringly black and white world of moral certainty and warfare. But I had already been captivated by a different and much more worldly world. When, as mentioned earlier, I borrowed Proust's *Sodom and Gomorrah* from Hammersmith Library it may well have been for the 'wrong' reasons – deviant curiosity or the search for illicit thrills that had worried the post-war social planners discussed by Richard Hornsey – but it turned out to be the gateway to a society far more to my taste than the romantic tapestry of Lancelot and Guinevere, let alone the – to me – dismal realm of Middle Earth.

Marcel Proust's Paris of the *Belle Époque* was both more glamorous than the courtly heroism of Arthurian legend and more real than the hobbits and orks, who were not even human beings. Rather than enter Tolkien's world of male dominance and the certainties of Good versus Evil, I preferred to immerse myself in an urban society of emotional dilemmas, moral complexity and psychological subtleties. This was, in fact, apart from anything else – just as Abercrombie might have feared – the beginning of a sexual education, more appealing by far than the grim, self-pitying transvestism of Radclyffe Hall's lesbian novel, *The Well of Loneliness*.

It was also much more than that. Beginning with the mystery of sleep, its relationship to memory and to identity – the opening section on sleep and awakening seeming like a kind of birth, before the primal scene of the goodnight kiss and then the world of childhood – it unreeled, spooling forward, gradually revealing more and more of endless, secret worlds. It was like the magic

159

ball of thread that Ariadne gave to Theseus when he entered the Minotaur's labyrinth, except that the dangers in Proust's world were not fantastical monsters, but common human cruelties and passions. One of the most disconcerting things about the novel was (and is), in fact, its combination of descriptive beauty and merciless satire, an unusual if not unique combination. Above all, it was a novel of which, no matter how often you read it, you would never come to the end.

Without my realising it, *In Search of Lost Time* came to function as my 'bible'. It was a clinical and at the same time impassioned exploration of the whole variety of human behaviour and existence, unflinching in the clarity of its assessments of human behaviour, yet driven by curiosity rather than judgementalism. It had a quotation and a response, though not a solution, to every one of life's social and moral dilemmas. For Phyllis Rose, author of *The Year of Reading Proust*, which mixes autobiography with the project of her title, Proust's novel functioned as 'a sourcebook, the Whole Earth Catalogue of Human Emotions, the sacred text that seers consult for answers'.[3] It was paradoxical, encouraging a sceptical turn of mind, but this was balanced by scathing satire, depictions of human cruelty and venality, a devastating critique of a whole society, but yet of a world not only clothed in the richest glamour, but filled with astonishing beauty as well as ugliness, while over it presided the saintly figure of the narrator's grandmother. Aesthetically, it is a weird masterpiece, juxtaposing mad metaphors and combining erudite discussion with at times shocking humour.

Its aesthetic power is due partly to the way in which Proust is able to transform abstract concepts into concrete metaphor and to link myth to modern daily life. Memories, Proust says, for example, are like the Celtic belief

> that the souls of those we have lost are held captive in some inferior creature, in an animal, in a plant, in some inanimate thing, effectively lost to us until the day, which for many never comes, when we happen to pass close to the tree, come into possession of the object that is their prison. Then ... as soon as we have recognised them, the spell is broken. Delivered by us, they have overcome death and they return to live with us.[4]

(This surely has some connection with Breton's feeling for *objets trouvés.*) The result is that *In Search of Lost Time* is an astonishingly sensual as well as an astonishingly intellectual book.

Was Proust, then, a 'mere aesthete'? His contemporaries seem to have thought so. Indeed, his reputation contributed to his difficulties in finding a publisher. Céleste Albaret, his faithful companion and housekeeper for the last eight years of his life, when he had retired from the world to complete his great work, believed (as, she said, did Proust himself) that when the manuscript of the novel's first volume, *Swann's Way*, had arrived at the offices of the publisher, the Nouvelle Revue Française, André Maurois (later a great admirer of Proust and himself a prolific writer, but then an editor at the imprint) had refused even to open the parcel, on the grounds that the firm published only serious works, not the trivial scribblings of a society dandy and playboy.

The reputation has lingered to this day. There is still a view, or rather a caricature, of Proust as both snobbish and effete. The novel itself is equally caricatured as a tale of the gilded and decadent aristocracy of a bygone age, a literary classic maybe, but of little relevance to the modern world in its faded aestheticism and neurotic preoccupation with homosexuality, a nostalgia trip to the *Belle Époque.*

Maurois was hardly alone in confusing the writer and the work. The novel has a first-person narrator, which facilitates the confusion, as does the circular nature of the narrative: of the writer's life as the progress towards the point at which he recognises that its purpose is to write the work that the reader now has in front of her. Over the years the confusion has only been increased by the many attempts made to identify the real life individuals on whom characters in the novel were based. After his death both the Proust legend and the belief that his novel was a *roman-à-clef* were further amplified as his friends in the literary and society world crowded into the limelight with their volumes of reminiscences. His biographer, Jean-Yves Tadié, refers to these as 'legends', and what is more interesting than the anecdotes themselves is the need to which they respond: to create a mythical 'Proust', who is of more interest than his work and who has himself become a 'character'. There is a fascination in this sickly and effeminate being, the homosexual society butterfly

who was a ruthless dissector of human nature; the dilettante who produced a masterpiece. Nor was this in one sense surprising. As Walter Benjamin observes: 'nothing makes more sense ... than the notion that a great achievement is the fruit of toil, misery and disappointment'.

The implication of the phrase 'mere aesthete' is the Kierkegaardian idea that the aesthetic is concerned only with surface and novelty. A further implication is that the aesthetic individual achieves nothing, because he simply contemplates beauty passively. This was never true of Proust (nor had it been of the artists of the Aesthetic Movement in Britain). Yet this figure haunts the novel – and the narrator – in the form of Charles Swann, the aesthete who does not create a masterpiece, and who acts as a projection of what the narrator might have become.

Proust, who was already famous when he died in 1922 at the age of 51 – famous for his reclusion, his nocturnal writing in his cork-lined room and his crippling asthma – was famous because he had indeed become a stereotype of the 'genius' who sacrifices everything for his art. Perhaps such a figure was needed to set against the celebrities of the day portrayed in his novel. Perhaps there had to be something eccentric and yet endearing about him to blunt the edge of his exposure of human hypocrisy and cowardice. His friends loved to remember him seated huddled in his fur coat (which he never removed) all the way through a wonderful meal at the Ritz or the restaurant Larue, lavishing huge tips on waiters, sending extravagant bouquets to society hostesses and courtesans alike. They even invented a word to describe his exaggerated compliments and overdone, fervid amiability: to Proustify, or Proustification.[5]

Perhaps it was all too good to be true. When in 1965 the second volume of George Painter's biography appeared, it caused a sensation by describing Proust descending into a 'pit of Sodom' (a male brothel) where he watched rats (of which he had a phobia) being pierced with pins, this having to do, according to Painter, with the significance of rats for homosexuals, who, he asserted, regard them 'with dread as symbols of anal aggression and anal birth'.[6] Painter writes darkly of Proust's other 'heinous aberrations', but, as *The Times* obituary put it in 2005, his 'analyses of personality

have too markedly Freudian a flavour for current taste', which was putting it mildly. Painter's obituarist nevertheless regards the biography as still 'an essential companion to Proust's writings'. This is questionable, as, quite apart from its partisan moral judgements, it repeatedly collapses the novel and its characters into 'real life'. Phyllis Rose referred to Painter's book as 'an exhibit in an ideology museum' for its tremendous hostility to same-sex love and its reductive assumption that Proust's over-intense relationship with his mother caused this neurosis.

Proust's relationship with his mother certainly seems to have been very intense − and idealised. In the early 'goodnight kiss' episode, a Freudian primal scene ends when the child defeats the father, who allows the narrator to spend the night with his adored mother. Strictly speaking this is not a primal scene in the psychoanalytic sense. That would be the narrator (who certainly is a voyeur) witnessing his parents having sex. But it is a primal, or rather primary, scene in the sense of playing a key role in the narrator's moral scheme. It would also fit a Freudian explanation of Proust's later development (or at least the narrator's).

Proust's more recent biographer, Jean-Yves Tadié, appears not to place complete reliance on the more lurid reminiscences of Proust's friends and finally washes his hands of the controversy with the observation that: 'We should console ourselves with the thought that no historian has ever classified writers according to their sexual achievements.'[7]

Céleste Albaret wisely waited until the 1970s to give her account of her years with Proust, thus having the last word − although her reminiscences inevitably are as much part of the 'legend' as everyone else's. She doubted the seedier tales; at least throughout the years when she lived with him, Proust was interested exclusively in completing his novel. His increasingly rare sorties into the world outside his apartment were made solely in order to undertake further research, to add detail. Every incident in the work in progress was based on this minutely detailed research. She even believed that Proust induced a near-death experience in order better to describe the death of his character, the writer Bergotte.[8]

Whether or not André Gide and others exaggerated or embellished when they reminisced about their friend, the

163

accusations of sadism may have acted as displacement for an underlying but different truth: that Proust was a kind of Trojan horse in the aristocratic circles he – a bourgeois Jew, the son of a mere doctor, however distinguished – penetrated, using the weapons of his charm and strangely self-effacing seductiveness. He flattered his way in and then satirised them remorselessly. His novel revealed him as a traitor within the gates (although for the most part they seem to have forgiven him).

Proust's sadism – if that is the right word, ruthlessness might be a better one – was that he subordinated everything to the writing of his novel. The way in which, with infinite gentleness and the paws of a cat (killing you softly), he slowly drew Céleste Albaret into his orbit demonstrates how he bent others to his will. He gradually spun his web around her, starting when he heard about her from her husband, Odilon, Proust's chauffeur. A naive 20-year-old from the countryside, Céleste was unhappy in Paris, hardly went out and pined for her mother. Little by little Proust suggested she might run errands for him – that would get her out of the house – might undertake various tasks in his apartment – and when Odilon went off to fight in the First World War, Céleste found herself living with Proust as his paid housekeeper in a world that revolved totally round him. I used the word 'web', but the idea of the spider is too sinister, since Céleste was as dedicated to Proust and his work as he was. She was utterly devoted to him; his willing slave, whose life was ordered and dictated by Proust's needs and desires. Because he rose at tea time and went to sleep at dawn, she spent night after night talking to him and listening to his accounts of his sorties into the social world beyond the rooms where it was perpetual night (the curtains were always closed), and the cork-lined walls maintained a hermetic silence. Claustral, but evidently for her not claustrophobic; for he told her marvellous stories, the employer as a Scheherazade in reverse, warding off his own death until he had completed his work.

I read the novel a second time in my 20s and became determined to visit the village near Paris, Illiers, on which Combray, where the narrator spent his holidays as a child, was based. The pilgrimage was to be part of a Paris weekend with two companions.

We caught the train on a damp spring day. One of my friends was already in a bad mood, the result of an unsuccessful (homo) sexual adventure the previous evening. We left the station at Illiers and trudged through flat, grey, empty streets and past a bleak church. This was far from being the magical location of an enchanted childhood.

We found the house where Proust had stayed as a child, knocked on the door and after a long wait heard shuffling footsteps. The door opened to reveal an unbelievably ancient figure, who swayed like a scrap of paper in the draught from the open door. He explained courteously that his age and illness made him hesitant to show us round, however, as sincere *jeunes Proustiens* … At this point a woman's hand with painted nails began to drag him away from the entrance and a haggard but much younger woman appeared, shouting: 'You will kill an old man – I have to keep them away from him – what are you trying to do, vultures and murderers.' The old man protested weakly: 'They are only young Proustiens – they have come from faraway'; and waveringly to my friend: *'vous n'êtes pas de la region?'* My friend of the unhappy sexual pick-up was flattered, rightly or wrongly taking this to mean that his French was so wonderful he had been mistaken for a Frenchman, even if from another part of the country, but by this time the old man was being slowly dragged away from the door, which was slammed in our faces.

The day did not improve as we consulted our map and tried to work out how to follow the two famous 'walks' taken by the young Proust. As a child, he had believed they led in totally different directions, only to discover, as an adult, that they met – just as individuals who he had encountered in diverse situations often eventually turned out to be connected in unexpected ways. We set off on what we hoped was the shorter of the walks: 'Swann's way'. It turned out to be much longer and duller than we had expected – there were no may trees blazing with blossom – and before long was abandoned as we first flung ourselves moodily down on the dank verge and then returned, defeated, to the station, where there was no café and we had a long wait for the train back to Paris.

Years later, I bought a new edition of the novel and found placed inside it a flyer advertising a Proust trip to Cabourg, the Normandy

165

Figure 11: Proust's hotel in Cabourg, 1990: Author and daughter in foreground.

resort that became Balbec in the novel. You could stay in the Grand Hotel, where the narrator had stayed with his grandmother, and see the very bedroom where he had slept, number 37, or even spend the night in it. Indeed, to this day, you may 'enjoy a plate of madeleines – stirring up Proustian memories – ... one delectable bite of the buttery pastry will send you into a state of reminiscence – which embodies the concept of involuntary memory, formulated by the author ... while mourning the loss of his mother'.[9]

I never made the trip, but some years after that I happened to take a family holiday at a Normandy Eurocamp. Finding that we were quite near Cabourg, we paid a visit to the now provincial and unexciting seaside town.

The Grand Hotel had been restored with red wallpaper and potted palms, but it was a poor pastiche of the past. In one corner of the salon stood a grand piano around which a little group of young gay men was gathered, one of them playing faded *chansons*. I stole a little milk jug as a memento (or rather, perhaps, as a relic), but it was not very pretty and soon broke. I hardly needed these visits to learn that – like Narnia – Proust's world can exist nowhere but in the reader's imagination.

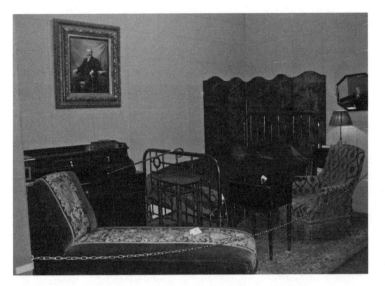

Figure 12: 'Evocation' of Proust's bedroom in Musée Carnavalet, Paris.

I also visited the Musée Carnavalet in Paris, where Proust's bedroom has been recreated with his furniture, retrieved by the collector Jacques Guérin. The museum describes it as an 'evocation' rather than a recreation, since it is simply a corner of one of the salons.

Some of Proust's own bedroom furniture, including the table he wrote on, has been reassembled and the walls lined with cork. Gazing at the dark blue silk counterpane and black lacquered table, I experienced that mixture of awe and anti-climax that all relics must, I think, produce: at the distance between the marvel of knowing that Proust himself actually rested under that coverlet, that his hands played over it as he wrote – and the ordinariness of the objects themselves. Their magic, if there is any, lies in the space between the invisibility of their aura and their mundane appearance.

I have yet to experience the sight of Proust's overcoat, which is kept at the Musée Carnavalet, but is not on show, on account of its dilapidated condition. Lorenza Foschini, who has told the story of Jacques Guérin's miraculous acquisition of Proust's effects – which Proust's sister-in-law had got rid of – describes the sight of the

fur-lined overcoat, removed from its coffin-like box, as akin to an exhumation or the identification of someone deceased; and the coat itself as like both a shroud and a corpse: the uncanniness of a person's effects, above all clothing, when that person is no longer there. That coat had been so much a part of Proust's persona, and yet had survived him by so many years as his ghost: Proust's witness, and yet a testimony to his absence:[10] the strange, half life of clothes no longer lived in.

These excursions were as much pilgrimages as the trips to Arsenal away matches described by Nick Hornby in his football novel, *Fever Pitch*. Yet I never thought of myself as a *fan* of Proust until, one day, opening an anthology on memory, I found an article by Craig Raine, a writer unfamiliar to me. I read with growing indignation as Raine dismissed Proust as 'laborious' and 'muzzy'. Proust, asserted the impertinent stranger, had misunderstood memory, by contrast with Vladimir Nabokov, 'a much greater writer'. Proust, it seemed, did not understand that 'metaphor is memory', although Raine did not care to explain what that meant. His incoherent article consisted in large part of the repetition of sneers by other famous writers who did not like Proust – D. H. Lawrence and Evelyn Waugh, among others. He also indulged in digs at Virginia Woolf, claiming on the basis of apparently no evidence that she had never read *In Search of Lost Time* to the end.

In my rage at these gratuitous insults, I flung the book across the floor, and it was this gesture that revealed me to myself as a hardcore fan. A mere detached 'connoisseur' might have shrugged off the article, indeed might simply have regarded Raine's comments as a matter of intellectual taste, but I, like any loyal fan, would not tolerate a slur against Proust's greatness. (It followed that I was now an anti-fan of Craig Raine, so I was spitefully pleased when in 2010 his first novel, *Heartbreak*, was shredded by reviewers, mocked for its 'schoolboyish anal fixation' and dismissed in the *Times Literary Supplement as* 'bellelettrist blather of the worst kind'.)

Piqued by the comparison with Nabokov, I reread Nabokov's autobiographical *Speak Memory*. It is certainly a beautiful book, but its purpose, or so it seemed to me, was entirely different from that of *In Search of Lost Time*. In the first place it *is* an autobiography

and not a novel, so that Craig Raine had made the elementary but common mistake of treating Proust's work as not fictional. Nabokov creates a series of exquisite pictures of the pre-revolutionary Russia from which he was forever cut off, since it no longer existed – it might as well have been Narnia. It is a truly nostalgic book in the best sense of the word, a work of mourning for that which was irretrievably lost: an idyllic and idealised past of rural beauty, benign aristocrats and happy peasants. While I am not suggesting that this was not a truthful picture of the Nabokov family, such recollection entirely lacks the steely Proustian gaze.

Proust's, too, was a vanished world, as he and Céleste used to acknowledge to each other, but Walter Benjamin suggests a further difference: that Proust, unlike Nabokov, was not recreating lost happiness. His was a 'blind, senseless, frenzied quest for happiness. It shone from his eyes; they were not happy, but in them lay fortune as it lies in gambling and in love ... this paralysing, explosive will to happiness.'[11] That is why Nabokov's account seems relatively static, snapshots from a perfect past, whereas Proust's narrative is (for all it is so long-winded) dynamic. It is a quest.

Mine is not a critical analysis. Phyllis Rose came across Jarrod Hayes' queer theory reading of Proust in the October 1995 issue of *Publications of the Modern Language Association*, 'Proust in the Tearoom'. There the author reveals that 'to "take tea" meant to have homosexual sex in slang contemporary to Proust, with "teapot" and "teacup" both referring to public urinals, popular sites for "homosex"'. This hardly seems to advance our understanding of Proust; on the contrary, it seems reductive, as if all the stuff about the retrieval of time is subordinate to – or even effaced by – the fact that Proust was gay. But Proust himself, his family, his contemporaries and his readers already knew or know he was gay, so the pseudo revelation of this in slang terms is pointless.

Nor could I possibly compete with Malcolm Bowie's brilliant *Proust Among the Stars*; nor, indeed, with the many other studies of Proust. I am not a Proust scholar; I am a Proust fan.

To be a fan involves something beyond appreciation of the work. In the case of a performer – singer, sportsperson or actor – this is understandable. The novelist Susie Boyt, for example, in her account of being a Judy Garland fan, *My Judy Garland Life*, describes

how the star's singing inspires her, but it is about much more than the music, for like all good fans, her heart 'melts at the thought of Judy's lack of belief in her own persona'. The true fan loves *everything* about the star, even, or especially, his or her imperfections, so just as Susie Boyt reinterpret's Garland's addictions, I can forgive Roger Federer for calling one of his twin daughters Charleen and spending time in Dubai. Boyt transforms Judy's life as well as her art, her setbacks and tragedies – the mess of her life – into an ennobling struggle that only intensifies the sense of warmth with which her fans respond to her. Susie Boyt happily admits:

> I've always been a hero worship person. I thrive on all the enthronement and ennobling ... all the startling extraordinariness of those I admire. I turn to my heroes as others turn to alcohol and cigarettes. Hero worship can be seen as a modest and ill-adjusted form of love, but it can be so productive.[12]

So to be a fan is never just about the performance, but always – of course – about the star; and perhaps most of all about the fan. It is the point at which the aesthetic becomes emotional, and the emotional, the desire to worship, emerges as the very opposite of Kierkegaard's idea of the aesthetic as surface and novelty; in deep commitment and loyalty.

It seems odder that this should be the case with an author. Yet Proust is one of those writers who has also become a star, whose fans are fans of him, not just of his work. Perhaps it is because it takes less effort to read gossipy memoirs about him than to embark on the novel, which Phyllis Rose felt was like watching a feature film in slow motion. It may be because celebrity culture, already at work in Proust's lifetime, has overwhelmed our sensibilities. Yet it does not happen with all fans of literature. I may be wrong, but I did not get the feeling that Laura Miller was a fan of C. S. Lewis because she was a *Narnia* fan. But certain writers – Byron would be an obvious example – evidently speak to some need in their audiences, and it may be that Proust, himself a quasi-fictional 'character' – Proust the 'proustifier', Proust the pathetic invalid, the sexual failure, the bourgeois social climber and martyr to his work – excuses or counterbalances the reader's own voyeuristic curiosity,

her immersion in the world he describes, which is ultimately an illicit one. Perhaps she can identify with him as a fellow fan, for wasn't Proust originally a fan of the magical world with which he eventually became so disillusioned?

Walter Benjamin suggests that the figure of Proust is so significant because it expresses 'the irresistibly growing discrepancy between literature and life'. He seems to be a magician because he bridges this gap. He is a Pied Piper of Hamelin (indeed, his last address was the rue Hamelin), a seemingly benign character who leads his followers astray, bewitches them (as he bewitched Céleste) into following him on an infernal journey: to a place where we are forced to confront the wickedness, boredom, beauty and transience of this our life.

How much easier it would be not to follow him. How much more comfortable to let him persuade us to stay at his side at his table at the Ritz, where he sits in his moth-eaten fur coat. There we can gently mock him, at the same time feeling the cosy warmth of our affection for 'little Marcel', a reassuring and harmless individual. 'Little Marcel' the character was of course partly, if not wholly, the creation of Proust himself. It was his disguise, like that of the wolf in the story of Little Red Riding Hood. Only too late, when we have plunged through the thickets of the wood and reached the little cottage (no queer theory pun intended), do we realise what very big teeth he has.

The Proust persona is even akin to the fandom that connects with worship in the side to his character that was distinct both from the society butterfly and from the ruthless dissector of human nature: his self-effacing saintliness. Céleste Albaret recalled how, during the First World War, Proust sometimes visited his friends on foot, walking home fairly long distances through the unlit streets, disregarding the possibility of air raids. On one such occasion he was returning from a visit to a friend who lived near Les Invalides. He had reached the Place de la Concorde when, he said: 'It must have been your protection, Céleste, who sent me an angel.' A stranger came up to him and observing that Proust seemed uncertain of the way, offered to accompany him. They walked along, chatting, until at one point the stranger took his arm to help him cross the rue Boissy-d'Anglois. It was then that Proust realised his companion

was a shady character of some kind, but he said nothing until they separated. 'How nice of you to have accompanied me', said Proust. Then he added: 'Will you permit me to ask why you didn't attack me?' To which the ruffian replied, 'Oh, not you sir, I'd never attack a man like you.'

There is the faintest trace of the gospel story of the disciples who met the resurrected Christ on the road to Emmaus. It is as if the thief had sensed something saintly in the slight, fur-coated figure, had known, at least, that the encounter was with someone extraordinary.

16 Temporary Gods

I admire her from afar but ... familiarity ... has the quality of an embrace ... her magic is ... a collaboration between us, as if she's in some way my own creation, a dream born of my own responsibilities.

SUSIE BOYT

The two ever-recurrent forms in which civilisation grows in and as play are the sacred performance and the festal contest.

JOHAN HUIZINGA

Long after our civilisation has sunk and disappeared, future races or explorers from Mars may come upon buried relics of the twenty-first century. Then they could mistake Elvis Presley and Angelina Jolie, Serena Williams and Roger Federer for ancient deities. They could misinterpret scores, posters and photographs as elements of religious ritual, while Roman Catholicism, say, with its spectacle and imagery, might be misinterpreted as some kind of entertainment. Myopically up against contemporary culture, we lose sight of the similarities between spectacles that to us have very different meanings, and cannot imagine how the categories could ever be rearranged or interpreted in some radically different way.

Celebrities are partly created by their congregations of fans. Fans therefore wield a certain power, but their power is restricted by the organising economic institutions that direct the various branches of mass culture, just as religious institutions organise the enthusiasm of the faithful.

It might seem that fans have come into their own now that Twitter, Facebook and hundreds of thousands of blogs publish 'amateur' critics' assessments of any and every cultural experience. As we saw earlier, passionate engagement and subjective partisanship replace the reasoned assessment of professional journalists.

Optimists see web-based amateur punditry as a democratic trend, in which fans have an influence over the media, but this is to ignore its limitations. The power of the 'amateur' critic, who may well also be a fan, is, after all, limited to that of a consumer. She can vote with her wallet, or by turning on the TV and swelling the viewing figures, or even by publishing her views in a blog. These may result in changed plot lines or rescheduling, but only, ultimately, for a perceived economic benefit.

Change in sport is even more likely to be top-down, initiated by professional bodies or by those interested in its profitability. For example, a change in tennis scoring, the introduction of the tie-break to end long sets, introduced in 1965, was at the instigation of the International Tennis Federation, in an attempt to make the sport more attractive. Just as unpopular political regimes can withstand a great deal of rebellion and discontent from their subjects, particularly if they inoculate the body politic with a minimum of reforms to ward off greater unrest; and just as religious hierarchies can stifle dissent, so the entertainment industries are responsive only up to a point. They are adept at incorporating and assimilating criticism to their own ends. Fans may have power, but it is only the power of the tactician, not the strategist. Fans respond. It is harder for them to initiate.

Fandom is impossible to separate from consumerism. Walter Benjamin observed that Proust's *In Search of Lost Time* was a panorama of the world of the consumer, populated largely by the wealthy classes and their servants – although the artisans and service workers who created this consumer world litter the pages of the novel. This was a perverted, a 'satanic and magic' world, Benjamin thought, because the source of the objects and means of consumption – that is, capitalist production – was concealed.

In their collection of fan fantasies, *Star Lust*, Fred and Judy Vermorel also gesture to the hidden economic motor that propels consumer society. They suggest that the history of consumerism

might be linked to 'the mutations of hysteria', that consumer society produces an insatiable cycle of desire, which tantalises with endless 'phantom horizons and fantastic expectations'. They see celebrity as the religion of our hysterical consumer society: 'And fans are the mystical adepts of this religion, who dramatise moods, fantasies and expectations we all share.'

Capitalist economies depend on inflamed and continuous consumption and an ideology of desire is required to propel this onwards. Stars and celebrities are major figures in inciting this desire. If this consumption is a form of religion, as the Vermorels suggest, and if celebrities are its deities; if these stars of the pitch, the court, the screen and the arena resemble gods, theirs is not the monotheistic puritanism of Protestantism or Islam, nor the stiff upper lip of nineteenth-century British 'Muscular Christianity', but the ancient deities, Jupiter, Venus and the rest of the classical crowd. Womanising, rape, extravagance, capriciousness, revenge and even murder were common among the Greek and Roman gods, their lives a celestial soap opera of extravagant proportions, Ovid's *Metamorphoses* the *Hello!* magazine of the pantheon. So too with modern celebrities – although only one tennis star was ever actually convicted of murder.[1]

The stated aim of consumer society is rationally to satisfy the needs and desires of consumers and to 'extend choice'. Consumerism is not meant to be hysterical. Yet the secret purpose of this 'satanic world' is quite other: to generate a chain of desire that can never be satisfied. It is not simply the 'built in obsolescence' of washing machines and cars; it is the obsolescence of everything, of lifestyles, of marriages, of jobs, of friendships, of locations, an accelerating process of continual change, which becomes a perpetual itch of dissatisfaction, and truly a form of hysteria. The trick is that in consumer society intangible longings are disguised as the desire for an endless succession of concrete goods and exotic experiences: Proust's 'explosive will to happiness' translated into the acquisition of things. It has even been argued that fans have become integrated into the marketing and advertising strategies of the creative industries, so that in a sense fandom as an amateur activity is coming to an end.[2] Thus is the mad passion of fandom diluted or deflected; after the art exhibition, the shop and after the match – again, the shop.

Yet consumerism *is* ambivalent. There is no government in the world that does not take it for granted that its economy must grow, hopefully faster than any other (as is all too clearly illustrated by the economic problems engulfing Europe since the banking crash). The global expansion of capital is the point on which the world spins. Consumption is the means of that expansion and is therefore not an option, but an imperative. At the same time, consumerism is condemned, sometimes on spiritual, sometimes on environmental, grounds. The motor that turns the world is also destroying it – and our souls into the bargain – and the basis of consumer society is, at least in the long term, a contradiction between insatiable demand and finite resources. The common response to this dilemma is a kind of disavowal. The public frets about consumption in general, yet continues to consume, giving excuses of need, convenience and the absence of alternatives.

The passion of the fan endorses but at the same time undercuts consumer society. The normal consumer is portrayed as a rational hedonist, *consuming* an object or experience and then moving on without regrets. The fan is also a consumer, but his or her behaviour defies the logic of consumerism. The fan does not move on. Instead of buying, enjoying and then discarding the latest object of desire, s/he settles on one impossible object of desire. The fan's impossible longing for 'his' or 'her' star therefore acts out the ultimate impossibility of satisfaction in consumer society.

The fan acts out a truth about consumer society that is everywhere concealed. The fan could therefore be a tragic or radical figure, but instead is despised, belittled as an addict in thrall to an insatiable and impossible passion. True enough, in *Fever Pitch*, football fan Nick Hornby described as the ultimate chemical 'high' the occasion when his team, Arsenal, won the 1990 Championship: more intense than orgasm, more astonishing and unexpected than childbirth; no steady state pleasure, but Barthes' *jouissance*. Nothing else could possibly provide the 'suddenness' and no other experience had 'the *communal* ecstasy of football', nor such potential for 'unexpected delirium'. Like the junkie, the fan also needs the continual repetition of the 'fix'. This is the 'triumph effect': the primitive feeling of tearful exultation, utter joy, glee and *Schadenfreude*, because 'your' star has won and his enemy has bitten the dust.

As well, then, as being thwarted yet compulsive consumers and thus undermining the logic of consumption, fans, like addicts, offend against the enduring philosophy of moderation in all things and condemnation of excess.

'Addict' and 'addiction' were originally derived from the Latin term meaning to 'legally deliver over', as when an indentured servant or slave was attached to his master; thence it came to mean make over (something or someone) to another person, or give something up to someone, but from there it came to mean to be devoted; one could be attached by one's own act to a person (or an experience), its meaning now almost the opposite from its original sense. According to this definition (no longer the current one), to say that a fan was addicted to the object of his adoration would be merely to say that he was a devotee – although possibly a dependant, even a slave.

As well as being an addiction, fandom is a form of obsession. Today, an addiction would probably be considered worse than an obsession, but originally obsession was the greater evil. The dictionary defines 'obsess' as 'of an evil spirit, to beset, to haunt; to haunt and trouble as a "fixed idea"'. It came from the Latin 'to sit down in front of', hence to besiege, so that metaphorically the obsessed person both besieged and was besieged by his or her obsession, which, said the dictionary, could amount to 'actuation by the devil or an evil spirit; a fixed idea that persistently assails or vexes'. Today, we would use the word 'possessed' rather than obsessed for such a situation – when your whole being is taken over by an obsession.

This is the religious idea of haunting or possession by evil spirits. To be a fan is to suffer from longing; to be haunted by longing. All sense of pleasure and joy is lacking from this. At the same time the fan besieges the object of devotion. This is fandom as witchcraft – or religion.

Fandom is often compared to religion; and it is a kind of religion. The origins of fandom are located in the sacred myths of the ancient world. The first fans were the Maenads ('the raving ones') or Bacchantes, the followers of Dionysus (Bacchus), the god of wine. Euripides' play, The Bacchae, describes how they murdered King Pentheus in revenge for his having banned the cult of Dionysus; in

a state of intoxication these women experienced ecstatic frenzy in the worship of their god, an exalted state that involved both miraculous powers and murderous violence. They were fanatics.

'Fanatic', too, has its origins in religion; derived from the Latin term for 'pertaining to a temple', and meaning 'inspired by a god' or 'frenzied'; and 'fan' is simply short for fanatic. So, from these early definitions, the modern figure of the fan emerges as immediately recognisable: a worshipper.

Ancient Greek drama grew out of the dithyrambic choruses at the Dionysian festivals, which developed originally as religious rites. Dionysus was therefore also celebrated as the god of tragic drama and the theatre, and to this day fandom is a product of theatrical spectacle in the widest sense.

'Religion' comes from the Latin verb meaning 'to join back together' and thus implies a collective experience, which fandom is: an audience, often huge, passionately committed to the success of the performer(s). Like the adepts of any religion, too, fans participate in outward, collective ritual. Each uses the aesthetics of spectacle and music to intensify the emotions of the assembled adepts. For the football fan there is the cathedral of the stadium, there are prescribed forms of dress – the colours of the team that may be incorporated into entire outfits – and there is the singing of anthems and ritual chanting. There are the personal shrines made up of flags and photographs that adorn the windows of many homes. There is even an Argentinian cult devoted to the former footballer, 'Saint' Maradona, in which his effigy is paraded at a festival in his honour akin to the saints' festivals of the Catholic Church.

The personal, subjective side of religion is faith: an inner conviction that rests not on reason but on belief. The religious individual commits himself to belief in the existence of God and also in the superiority of his God over all others. Similarly for the sports fan, his team or player is superior to all others. It is faith, not reason, which keeps him on side when his team loses match after match.

Established religions are fenced off from other forms of discourse, placed in a category that cannot be challenged, having managed to define themselves as *beyond argument*. Atheists such as Richard Dawkins attempt to refute religious belief on rational grounds, but this ultimately misses the mark, because it is impossible to argue

with 'faith'. Were it possible to escape this bind, it would become clear that every religion is a form of fandom, however blasphemous this may seem to the religiously minded. That believers are apt to become so angry when their beliefs are challenged or someone is rude about their faith is proof of this – just as was my flinging a book across the floor in rage and disgust because Proust's greatness had been challenged.

The difference is that the certainties of religious faith are defined as normal. No one sees anything odd in, as the White Queen in *Alice in Wonderland* put it, 'believing six impossible things before breakfast' so long as those beliefs constitute, say, Christian theology.

As Alexander Chancellor points out, there is a widespread assumption that it is better to 'have' a 'faith', to the extent that even those who have little themselves (e.g. politicians) believe it is good for other people. But, he goes on: 'It is a very strange idea that to believe in anything, whether it exists or not, is better than not believing ... How can it be virtuous to believe in something that is not true?' He resents the way in which atheists and agnostics are made to feel guilty because it is still more respectable to be godly and because they trample so brutally on people's vulnerable beliefs.[3]

Fans, on the other hand, who worship a being who does actually exist in the real world, are dismissed as irrational, although their passions arise from the same yearnings as religion itself, passions that are no more nor less an 'opium of the people' than religion itself, a yearning for consolation in a 'heartless world'. Further, if, as Karen Armstrong suggests, religious faith is largely a matter of subjective feeling, then the cult of Judy Garland or Rudolph Valentino is surely as valid as any 'official' religion. You could even argue that fandom is superior to religion by reason of its active and creative potential, its invention of rituals, its bricolage and craft aspects and, notwithstanding its passion, its sense of humour, so often lacking in the faith world.

It was not until after I had had this idea that I came across *Homo Ludens* by Johan Huizinga. In this book, devoted to the analysis of 'play', he advances a much more developed thesis incorporating a similar idea: that sacred ritual on the one hand and 'play' on the other – whether sports, theatre or any other form it takes

– are indeed similar. He cites Plato in support of his contention that religion is 'play consecrated to ... the highest goal of man's endeavour ... The ritual act ... will always remain within the play category, but in this seeming subordination the recognition of its holiness is not lost.'[4]

There is no denying that religions of various kinds have inspired individuals to devote their lives to the relief of suffering and to helping their fellow human beings, and I am not sure that the 'bibles' of Proust or Narnia have had such beneficial effects. On the other hand, religions have inspired wars and murder as well as good deeds, prejudiced bigotry as well as benevolence.

The problem, however, with religion is not so much its basis in arbitrary and sometimes objectionable beliefs. It is its huge and undemocratic political worldly power. If individuals gain consolation from beliefs that seem incredible to others, that is their business. What matters is when such beliefs are enshrined in political constitutions, law and the state. There is a parallel here too with the entertainment industry. Music, sports and media multi-national companies – the worldly motors promoting fandom – equally wield huge economic and political power. Secular fans are subject to their imperatives, just as the faithful are subject to the absolutism of church or faith.

To compare fandom to a religion invites the criticism that, unlike religion, sport, music or Hollywood lack any moral basis in the form of a coherent set of precepts and guides for living. That religions provide guidance for behaviour is a central argument in their justification (although recently a new argument, more consistent with the consumer society, has been introduced: that religious individuals are *happier* than atheists, an argument that would have been deeply alien to the nineteenth century, when society approved of duty, not happiness).

Fans, however, *do* have bibles and precepts for living. 'Trekkies' used Star Trek as a guide for living. Fans of *Buffy the Vampire Slayer* bought the book *What Would Buffy Do?* to aid their path in life. Roger Federer fans have looked to his biography for inspiration and guidance.

Sport generally *is*, in fact, burdened with an implicit set of values and moral virtues inherited from Victorian imperialism. The

nineteenth-century British, who, when they dominated the world, invented modern sport, also invented its accompanying ideology of 'Muscular Christianity': the belief that sport 'developed character' and was a bulwark against 'effeminacy'. Sport would develop men of action and leaders ready to rule the Empire, men worthy of the master race; and to this day the English language enshrines the belief that sport equates with morality: 'play the game', 'it's not cricket', 'foul play' and 'below the belt' bear witness to such views, and Rudyard Kipling's poem, 'If', sums it up.

The poem celebrates stoicism, endurance and self belief, admirable qualities, up to a point, but is imbued with an unshakeable sense of superiority:

> If you can talk with crowds and keep your virtue,
> Or walk with kings – nor lose the common touch,
> If neither foes nor loving friends can hurt you
> If all men count with you, but none too much;
> If you can fill the unforgiving minute
> With sixty seconds' worth of distance run,
> Yours is the Earth and everything that's in it,
> And – which is more – you'll be a Man, my son.

This poem does not simply celebrate the stiff upper lip. It does not only advocate the control of emotion, rejecting its expression; it rejects emotion itself. It is an ode to a particular kind of masculinism. There is no place on this world-as-playing-field for aesthetes, intellectuals or bohemians. Lord Byron would not be welcome in Kipling's 'If' universe, not to mention Oscar Wilde. But then all gay men are ruled out; nor is this a world where any woman would find a place. Even Jesus Christ, with his penchant for lilies of the field, might meet with a frosty welcome.

Nostalgia for lost greatness may partly explain why 'If' was voted Britain's favourite poem in 1995, an otherwise surprising choice given that society promotes none of the virtues Kipling extols; but perhaps the British, who suffered a collective emotional breakdown two years later when Princess Diana died, still like to think of themselves as manly homophobes, who despise women, prefer physical exercise to thought and do not get too fond of anyone.

To this day, the discourse of sport remains a gruesome parody of Kipling's Edwardian world. We are led to believe that sport is not just good for physical well being, but it also has astonishing moral benefits.

Joe Humphreys has comprehensively demolished these pretentions in his *Foul Play: What's Wrong with Sport?*, which should be required reading for all sports enthusiasts and above all for sports journalists. He points out that, in practice, contemporary sport is good neither for health nor intelligence, nor for society as a whole. Far from promoting brotherly love across the globe, far from helping to end conflicts:

> *sport has tended to trigger and prolong them ... has sometimes directly caused bloodshed and frequently acted as a safe haven for forms of intolerance and hatred long-since dispatched from other realms of society ... a last refuge for racism, sexism, homophobia, animal cruelty ...*[5]

It is a huge and often corrupt industry, whose *raison d'être* is money. Yet sportsmen are promoted as role models, when it is plain to see that many of them destroy their bodies by leading a life that is excessively one dimensional, given that sport has become so competitive; and all too often by using illegal performance-enhancing drugs. Sport, so far from improving character, promotes intolerance and bad behaviour. Cheating and gamesmanship: sledging, tampering with the ball, betting scams, bribery, hand balls and fouls are ubiquitous, and instead of teaching players and spectators how to lose gracefully and be generous in winning, many players hate their rivals. It inflames nationalism and is irredeemably sexist. Lynne Truss, in her account of her years as a sports writer, *Get Her Off the Pitch*, describes with loathing and contempt the awful sexism of that world, which appears little to have changed since the 1990s, when she was part of it.

No one expects film stars, musicians, actors or indeed artists of any kind to be reincarnations of the British Raj; in fact, they have carried forward the tradition of bohemianism that in a previous age accompanied the creative individual, given licence to live lives of excess and damnation. No one expects great actors to function as 'ambassadors' for acting. No one believes the theatre needs 'ambassadors'. But, apparently, sport does because the reality is

so far from the Victorian ideal. Today, in addition, it is as much the sponsors of sport, the business organisations, that pull the strings, that insist on a squeaky clean image for the stars they sponsor – as Tiger Woods discovered to his cost.

In view of Joe Humphreys' trenchant criticisms of the whole ideology of sport, it is surprising to find that he is a puzzled, even anguished sports fan himself. There are legions of feminist sports fans too, in spite of the crushing machismo of sports culture.

This is partly because sporting events have a pull absent from most spectacles: *Hamlet* and *Harry Potter* will always end in the same way, but the outcome of the match is uncertain until the last point, because the spectacle takes place in real time. This creates sport's uniquely tense excitement and that in turn generates passionate partisanship. At the same time, the ongoing nature of sport may prevent the true 'catharsis' that Aristotle felt was generated by the contemplation of tragedy or music. In one sense there is no resolution at the end of a match. There will be another match next week; a state of perpetual deferral prevails. Yes, Rafael Nadal may have lost seven times in a row to Novak Djokovic, but his fans remain convinced that *next time he will win*. (And indeed he did, at the French Open in 2012.)

The brief career of the sports star, especially in those sports that pit individuals in a one-to-one contest, further heightens the tension and the commitment of the fans of specific stars. The football or baseball team essentially goes on forever, but even the most enduring stars of the tennis court have only a short time in the spotlight; and their career ends always in defeat, unlike that of singers. The voices of sopranos may wear out, but they can retire on a high note. Their voices, like those of the film stars on celluloid, are preserved on recordings. A Pavarotti aria produces the same effect even after his death. A film is an artwork in its own right. By contrast, recordings of what were live performances on stage or arena can never fully recreate the actual experience and that is especially true of a sporting contest, where the excitement derives from the outcome being unknown. That level of excitement cannot be achieved when a match is watched for a second time. So what sport shares with theatre and dance is the quality of being the most ephemeral of spectacles: embodied transience.

The ideology of sport, then, is baneful, yet the contest is addictive. Is it possible, then, to be a fan without signing up to the ideology of 'If'? One of the greatest stars of tennis, Roger Federer, is habitually discussed in its terms – 'sporting gentleman', 'ambassador for the game' and all the other clichés. Yet perhaps an alternative reading is possible.

If I am a Proust fan I am also a tennis, and specifically a Roger Federer, fan. I have sometimes wondered how the two of them would get on in my sparsely populated pantheon. Federer has been filmed apparently reading a book entitled *The Elegant Universe*, but it seems unlikely he has much time for reading 12-volume novels, while Proust's view of the only character in his novel approximating to a sportsman, the golf-playing Octave, is negative to say the least: his 'knowledge of everything that pertained to clothes and how to wear them, cigars, English drinks, horses ... had been developed in complete isolation, unaccompanied by the least trace of any intellectual culture' is how Proust describes Octave. My only hope is that each would find the other amusing, that Proust would 'Proustify' and Federer display the sunny side of his nature.

Few outside the tennis world had heard of Roger Federer until he defeated Pete Sampras, the reigning champion (indeed, seven times champion) at Wimbledon in 2001. Insiders recognised Federer's potential, but, as John McEnroe put it, he seemed more interested in playing the most beautiful shot in the tournament than in actually lifting a trophy. So he did not burst into the public consciousness in the way Boris Becker had, winning Wimbledon as an unknown, unseeded qualifier at the age of 17 in 1985. Whether Federer would actually fulfil his potential hung in the balance. Indeed, one journalist recalled the early Federer as a forlorn and lonely figure, oppressed by the burden of vast but unfulfilled talent.

At the time, Federer's defeat of Sampras looked like a flash in the pan. The then British hope Tim Henman defeated Federer in the following round; while in 2002, Federer did not win a single match at the All England Club. It was only later that its symbolic significance was understood; the match entitled 'the changing of the guard'.

To revisit the Sampras/Federer encounter today is a journey back in time, to the beginning of the *new millennium* – a concept

hard to grasp when it happened, since it was such an anticlimax. Everything went on exactly as before; it was still like the end of the 1990s, a banal and shallow decade in which everyone talked of 'dumbing down'. The American sociologist, Francis Fukuyama, announced we had arrived at the end of history and focus groups replaced democracy.

Yet this match took place less than three months before the twenty-first century began in earnest with the destruction of the World Trade Center. The merry sports' fans in the packed stands, with their union jacks and floppy hats, their T-shirts and camisoles, had no inkling of the world of terrorism into which they were about to be propelled.

A more innocent, or at least more heedless time; but then Wimbledon seems always innocent. Albert Einstein (apparently) said all time exists together, so somewhere in parallel time a game of tennis continues eternally on the Centre Court. Trees thick with foliage droop over winding suburban roads that echo with the thrilling 'thwock' of ball on racquet, punctuated by bursts of polite applause as the umpire sonorously intones the score and the sun slants low in the early evening. And once inside the airless claustrophobia of the packed court for the duration of a match, you live utterly in the present, all other worry, hurt and doubt screened out, so that *nothing matters* except the next point, the next game, the *outcome*.

Sampras trudges doggedly round the court like a Gordon Brown of tennis, in contrast to the unfamiliar Federer, who presents himself as a hippy. He wears a bead necklace and, with his long hair bound up in a white fillet and pulled into a ponytail, cuts a strangely girlish figure. He is so lanky and thin and he has beautiful hands with long fingers. The thrill of his play, the romance of it, lies in the startling contrast between the languid elegance of his shots and their blistering power. And he is so quiet. No bicep-pumping for him when he hits another perfect shot; he simply returns to the baseline, looking down modestly, even shyly, at his racquet strings as he pushes them back into place.

Only at the end does he wipe away his tears with those long fingers and bury his head in his hands. As the players leave the court he almost forgets to bow to the royal box. Then, by the exit,

he pulls his hair loose and does something men players never do. He blows a kiss to the centre court audience, just like a girl.

David has slain Goliath; Jack has killed the giant. The prince has dispatched the dragon. It is a symbolic moment, slotting into ancient traditions of folklore and fairy tale.

Ten years on: the figure in a white suit reclines lazily on a diving board suspended above an azure pool. He trails his long fingers in the water. He turns his head and smiles into the camera: winner of 16 'slams', the 'greatest player of all time'; ambassador for Credit Suisse, filmed by Mario Testino.

In 2006 an upcoming American player, John Isner (to become famous in 2010 for winning the longest match ever played at Wimbledon), started a blog: 'If tennis was a religion, Federer would be God.' And ,actually, he was a god. No other star created to the same extent what sports journalists called 'the religion effect'. He was good-looking enough, but not a hunk, like the Spanish player, Rafael Nadal. His Swiss fellow countrymen were proud of him, but he did not carry a nation's pride on his shoulders as did the Serbian player, Novak Djokovic. The banners that appeared at every match told a different story.

Swiss flags were waved to signify Federer fandom as much as Swiss allegiance. Like another Swiss star, Martina Hingis, a decade earlier, Federer achieved 'transnational' status, appealing to an international fan base and transcending national chauvinism.[6] The home-made banners demonstrated the more complicated form of fan worship Federer attracted. These banners, lettered with individual messages, tellingly illustrated the unique, 'religious' status of the star:

If tennis is a religion Roger Federer is god (less conditional than
 John Isner)
I came 3,000 miles to see you King Federer
SSh! Quiet! Lord Federer is at work
Hush! Genius at work
90 year old Roger Federer fan!
GREATEST OF ALL TIME
Roger Federer – the Legend of our Age
Evolution: First there was Tennis. Then there was Roger Federer

World class God
Roger Tennis God I came from Mumbai to see You
Roger is my God.

The contrast with the banners for Rafael Nadal was striking. These ran the gamut from:

Just one kiss, Rafa
Rafa, marry me
I love you Rafa

to:

Forza Nadal
Vamos Rafa

Federer's fans adored him because of this something about his game that went beyond: its creativity. He represented more than national pride or sexual longing.

The late David Foster Wallace tried to capture what made Roger Federer something more than just a tennis player. The publicity his article, 'Federer as Religious Experience', received suggested that the idea chimed with a general feeling that Federer's game was somehow beyond sport, was otherworldly.

Figure 13: Federer, simply the best.

Figure 14: Federer, off to Valhalla. Courtesy Paulo Camara.

Federer, wrote Foster Wallace, could hit impossible shots, 'like something out of the Matrix'. This to him was a metaphysical, 'kinaesthetic' experience, going beyond human possibility. The term I would use for this would be supernatural rather than religious, but he who performs a miracle, does the impossible, can be said, I suppose, in some way to create a religious moment; and Foster Wallace demonstrated how – far from being in opposition to the miraculous and the religious – the aesthetic is its concrete expression.

A New York sports writer took up the cyborg idea (originally I believe mooted by Pete Bodo, a journalist with the online magazine, *Tennis*). Federer, he suggested, might be 'part of a Matrix-like artificial reality, a computer-simulated perfect tennis player, a science fiction hero'. The writer muses that Federer must be made of flesh and blood because he broke down when he lost the Australian Open

final in January 2009 and later that year in Miami when he lost the plot and smashed his racquet (the incident became the headline story on CNN and had within seconds circled the globe). 'He rages, he cries, he gets sick, he has back aches and doubts', but then another thought occurs. Perhaps this apparent suffering was 'only further proof of the devious genius of Federer's cyber-creators, who imbued him with a touch of human vulnerability'. And Federer-as-cyborg, intended as a joke, nevertheless contributed to the configuration of the star as a quasi-mythological, even religious character, drawing on the blurring between science fiction and religion illustrated by fans' reactions to the *Matrix* films and the way in which *Star Wars* generated a quasi-religion, the Jedi.

However, for Federer's fans, the most important thing of all about him was his style of tennis. This, also, was at the root of the contrast between the Swiss star and Rafael Nadal, Federer's grotesque other. To be a Federer fan was to be an anti-fan of Nadal. The Spaniard roared onto court like a bull, a muscle-bound thug with a hefty bottom, dressed (in his early years) like Freddie Mercury in sleeveless tops that showed off biceps the size of Tim Henman's head. In play he glowered, he snarled, he glared, he grunted, he scowled. He celebrated winning shots with gross groin thrusts and phallic arm pumps. No wonder 'youth' loved him; he was a gargoyle set loose from some violent computer game. He was Caliban to Federer's Ariel, Loki to Siegfried; this was Good versus Evil, God versus the Devil.

But this was not just about superficial differences in style or personality. This was a struggle about the future of tennis. In an interview with the *New York Times* in 2005, Federer had himself described his tennis as 'retro-style'. 'He is really bringing tennis back to an era when it was a game characterised by wood racquets, artistry, tactics and athleticism',[7] explained his biographer, René Stauffer. His was not the brute strength style advanced by Nadal. Everything about his game is beautiful and there would not be a match during which at some point his movements would not be described as 'balletic'. The 'new tennis' as exemplified by Rafael Nadal has been compared to boxing, but Federer's comes much closer to dance. If Nadal is companion to Mike Tyson, Federer's soul mate would be Carlos Acosta or Rudolf Nureyev.

189

Pete Bodo, of *Tennis Magazine*, in a grudging yet in the end generous tribute after Federer won his 15th major tournament or 'slam' at Wimbledon in 2009, remarked with some astonishment that Federer did not play the 'new tennis', indeed seemed 'utterly unconnected ... from the way tennis has evolved in the past few years'. To watch Federer made Bodo feel he was watching an old black and white film. The man's a period piece, who could never win today. He contrasts him with Nadal, who is popular with youth because he seems so very 'now': 'he's some sort of evolutionary step forward, something tennis has not seen before and for which it has no answer ... tennis has somehow gone to some mythical "next level", which may not exist and maybe never did'. As against the brutal appeal of Nadal's bionic über-tennis, Federer had 'sprezzatura',[8] the art of making the difficult look easy, a lightness of touch, an effortless perfection that Hingis also had in her prime. Hingis' game was like that of a chess master, it was said; she was an intellectual player who set up intricate points; for John McEnroe she was 'a step or two ahead of all human beings out there on the court ... mentally she sees things no-one else sees'.[9] But eventually she was outgunned by the Williams sisters and their one-dimensional power tennis, just as the new power tennis threatened Federer's dominance.

Pete Bodo suggested that 'puritanical critics tend to regard *sprezzatura* as a suspect quality, a polish in manners that indicates over-refinement or even feyness, the transparent self-justification of the fop. But such judgments ignore the real edge that must remain beneath the polish.'

Yet the perfection of this classical style of tennis came under attack from Nadal's ferociously macho style of play. Not for him the languid restraint of the Swiss player. His was a mechanical, manufactured style. Schooled by his Svengali and coach, uncle Toni, since the age of five, Nadal, a natural right-hander, played left-handed, thus essentially operating a forehand on both wings, while his left-handed spinning serve with its high bounce undermined Federer's exquisite one-handed backhand.

The New Tennis, a version of the baseline rallying, defensive, clay court game as opposed to the traditional serve-volley grass court style, was developed originally by Bjorn Borg in the 1970s and further perfected by Ivan Lendl in the 1980s. It has been advanced

since then by the new technology that has transformed every aspect of the game in the last two decades. Racquets, racquet strings, balls and the courts themselves were all revolutionised. Players could now hit the ball much harder with the result that soulless, robotic tennis was replacing the scintillating wit of the traditional all-court game. The loss that this represents was especially evident in the women's game, in which players rally like navvies while dressed as *Pretty Woman*.

These changes may have been due partly to pressures from the commercial promoters of the new technology, or may have been introduced because the tennis authorities hoped a cruder, more turbo-charged kind of tennis would increase its popularity with the young as competition from other sports grew, that brute force would be more popular than elegance and finesse. Yet many spectators and fans complained of the crudity of the 'new tennis', comparing it to a boxing or wrestling match, devoid of the subtlety and variety of traditional tennis. True, tennis in the 1990s was becoming something of a serving contest, but ten years later the pendulum had swung too far the other way, virtually eliminating the volley in the process.

No Federer fan could comprehend how anyone could prefer Nadal's relentless but one-dimensional onslaught, his war of attrition, to Roger's repertoire of strokes, his dazzling movement, his wonderful improvisation. Nadal was to Federer, said David Foster Wallace, as Metallica to Mozart. Or, as the former Czech star Ion Tiriac put it, Federer was a piano, Nadal a drum roll. And while a drum roll can be magnificent, the piano is by far the more flexible, more multifarious instrument.

The difference is perhaps most marked in early round matches. When Nadal meets an inferior opponent the spectacle tends to be a grind as the Spaniard slowly crushes the weaker player into the dust, an event that seems enjoyable for no one, including the audience. When Federer plays a neophyte, commentators speak of an exhibition, a dazzling display, of brilliance and entertainment, and not only the spectators but also the beaten opponent has a good time and often plays above his normal level.

Yet commentators raved over Nadal's warrior-like aggression, his ability to get every ball back, his pit bull determination to win

every point, his 'animalistic hunger', his *intensity*. 'He's an animal!', they cried, dazzled by his quite abnormal level of competitive aggression. Federer's dandyism and his aesthetic play were disturbing to the macho culture of sport, to which Nadal offered a simpler attraction. In fact, he was almost too macho to be true: pure testosterone, no troubling ambiguity.[10] (Nadal has revealed in his autobiography that behind the on-court image cowers a player bullied for years by his uncle into a sense of his own inferiority, but this does nothing to disturb the power of the contrasting imagery.)

By contrast, Federer's anti-fans have always held it against him that he was too much of a dandy, too keen to embrace the celebrity lifestyle, when sports stars are supposed to be 'normal' and 'one of the lads'. Deep down, the sporting world and its followers still want sportsmen (women are an altogether more troublesome category) to be Muscular Christians, even if they no longer believe in God. Pete Bodo of *Tennis Magazine*, for example, was quite frank about his prejudice. He never liked 'Federer as a girly man', did not like 'the cardigans, hair-care products, runway gawking and man purses', and could not abide the player's friendship with Anna Wintour, editor of American *Vogue*, 'and the usual gaggle of fashion industry courtesans'. Federer was only saved because 'there's plenty of junkyard dog in this guy'.

At the height of his success, Federer's slightly camp, parodic Wimbledon outfits of embroidered white jackets and long trousers, his 2008 retro cashmere cardigan, and in 2009 a gold and white carrier bag, caused consternation. When in 2010 he wore a pale pink polo shirt in the USA the sports commentators became so agitated that fans retaliated with banners claiming that 'Real Men Wear Pink'. For pink, of course, signals the great fear of male sport: actual homosexuality, anathema in a world that is so deeply homoerotic.

Big Bill Tilden, a star of the 'golden age' of tennis between the two World Wars, wore a cream-coloured Melton overcoat onto court. (Nike, who provide Federer with his sportswear, might take this on board as a future style for the Swiss star.) Tilden was homosexual, and was twice imprisoned as a result. Another 1930s' tennis star, Baron Gottfried von Cramm, who was no supporter of the Nazis, was also briefly incarcerated by Hitler on account of his sexuality (although he avoided the concentration camp fate of many of his

fellow gays). The tennis-watching public was probably unaware of these stars' sexuality, although it was known within the sport.

In the twenty-first century there are still almost no 'out' male gays in any sport. Tennis players Martina Navratilova and Billie Jean King had huge difficulty in acknowledging their lesbianism in the 1970s and 1980s. Footballer Justin Fashanu came out in 1990 and later committed suicide. In recent years a lone rugby player, Gareth Thomas, has been open about his homosexuality, but only after he retired, and although he was followed in 2011 by cricketer Steven Davies, who voluntarily outed himself, there is still huge resistance. An attempt to make an anti-homophobia DVD for educational purposes was thwarted, because no closeted gay premier league footballer could be induced to take part. The would-be sponsors spoke of 'a final taboo', which did not appear close to breaking, while one football club manager said that while he would support any gay player in his club, he felt the fans were not ready for it, the sport was too macho and crowds would have to become 'more civilised' before things could change.[11] However, it is not just the crowds. It is the whole Kiplingesque 'If' culture of sport.

Federer could afford to have gold manbags and hang out with the fashion 'courtesans' because he has had the same girlfriend, Mirka Vavrinec, now his wife, since the age of 19 (the emotional stability provided by this relationship being unquestionably one reason for his success and largely unacknowledged by sports writers). It is unlikely that his metrosexual style has done anything to ease the situation of the closeted gay tennis player – there must surely be one or two – but the hostile reaction in some quarters to his dandyism does expose the continuing macho culture typical of the sporting world. Lynne Truss was scathing about the way the sports commentariat damned tennis star André Agassi as insufficiently manly on account of his bleached ponytail and spandex shorts, although, given his well-publicised affairs with film stars Barbara Streisand and Brooke Shields, he was never suspected of being queer. That was in the 1990s, but the general prejudice seems hardly to have changed nearly 20 years later. (And in January 2012 a new controversy erupted when Margaret Court, one of the most successful women players of all time and now an evangelical pastor, chose the Australian Open to denounce homosexuality and all its works.)

Given his enormous fame, it was not very surprising that in 2011 Federer came second in an American poll, voted most 'admired and respected' individual after Nelson Mandela. (Tellingly, Mandela was the only individual on the list who could possibly be described as a politician or statesman – the other names being of philanthropists from the business or entertainment world; for example, Bono and Richard Branson. Twenty-first-century politicians are held in such contempt that they could never even appear on such a list.)

However much or little such an accolade means, it is a testimony to the charisma of performance. Federer's charitable activities are to be welcomed, but the general public cannot know what he is 'really like' or what sort of person he is. His place in the public heart – he has been voted the fans' favourite for nine years running – is ultimately due to the spectacle, to the exquisitely supernatural movement of what you see, the dance of tennis, which veteran doubles' champion and commentator, Frew McMillan, has compared to a painting, but it has always seemed to me the closest thing in terms of movement to a tenor singing a passionate operatic aria.

From 2003 to 2007, Federer was so dominant that to be a fan was a miraculously untroubled experience. He almost always won, so that the fan had frequent injections of the 'triumph effect' – that feeling of warmth and exultation, the addictive high when 'your' player defeats all his rivals yet again. Since 2008 his progress has been less triumphant, but the reactions of his fans only serve to demonstrate the way in which, for all sports fans, their passion is far from being the source of steady-state pleasure and is more like Barthes' *jouissance*, risky and fraught with uncertainty.

Federer's followers worried and suffered, crossing a pain barrier beyond which fandom became agony. One fan confessed she never watched a Federer match, because the pain of seeing him lose was unbearable: she became the supreme contradiction, a fan that ended up renouncing the very spectacle that had made her a fan in the first place. On the morning of Federer's final at the Roland Garros stadium in Paris in 2009, where he was poised finally to win this, the only slam he had never won, the veteran *Sunday Times* sports correspondent, Hugh McIlvanney, expressed with puzzlement his devotion to the player: 'It doesn't make sense for somebody flush with years but not with money [i.e. McIlvanney

himself] to be agonising over the professional fortunes of a young multi millionaire [Federer] ... but there is nothing to be done ... about the lifelong affliction that condemns me to excessive emotional identification.' 'Agonising', 'affliction', 'excessive' – these emotions go far beyond pleasure and delight.

After Wimbledon 2009 one fan reacted almost in desperation at the excess she felt was being expressed on Roger's website:

> I'm the biggest fan in the world, but this hero worship borders on sick ... how so many people need to live through someone else ... I'm taken aback by the worship, like we ALL don't have our own strengths. Like we need to live vicariously through Roger. I'm an emergency room nurse, helping to save lives every day ... I LOVE ROGER and I've disorganised my own life to watch his matches, but I'm wondering, what does it all mean? ... people who worship others to such a degree have low self-esteem and need someone ELSE to look up to. If Roger teaches anything ... it's to find what is beautiful and noble, humble and self-defining in YOURSELF and make it YOURS. I think he teaches MORE than we see.

She admitted that she was talking about her own devotion and her need to back off from her own obsession. It was too much, she felt, the way she could not sleep during the Majors, was shaking in the shower before the French Open final. And yet: 'I think Roger has something extraordinary. Something other worldly. It's strange. He is magnificent in so many ways.' Another fan replied:

> I don't worship Roger, but I am strangely touched by who he is as a person and his game. He is tremendously enriching my life ... But there is something that comes through with Roger, sort of like Roger gives expression of something through his tennis that is truly extraordinary. In fact, something other worldly comes through when Roger plays, someone called it a religious experience. There is a brilliance and beauty and effortlessness in his game that makes all the others look like hackers and whackers.

Many of Federer's fans will, even if they reject the term worship, have internalised an idealised image of their hero that inspires them in the way Judy Garland inspired Susie Boyt, as I discussed earlier. For example, another fan writes:

Whenever I really need you, you're always there for me. Last time things were rough, you won the French Open, and before that the US Open when everyone was giving you a hard time...

Anyway, even though it may seem like 'just a game' you're playing, I'm here to remind you that you do actually make a massive difference in people's lives.

And a Swiss fan described a visit to Aelggialp, the geographical centre point of Switzerland, in the mountains. There is a monument on which the name of Swiss personality of the year is inscribed each year – the list, of course, includes Federer, so that this visit was a little like a kind of pilgrimage. And, after all, there is something not just to thrill to but to admire in all great stars.

There is a heroism in the performer who stakes everything on the high wire and has the courage repeatedly to risk reputation. That may be one reason Federer's fans are so passionate, especially when the tennis commentariat has been increasingly grudging, seemingly preferring the uncomplicated sex 'n' violence appeal of Nadal to the more complex and perhaps more pretentious claims made for Federer.

The distinguished *New Yorker* columnist, Calvin Thompson (who had been taken at the age of 11 to see Bill Tilden play in the 1930s), admitted that he could not bear to watch Federer lose a match, yet believed that being upset and agonised every time Federer lost was a mistake:

For five years his more besotted admirers have counted on him to [win every match], and our expectations, as I'm coming to realise, have interfered with the unique privilege of watching him play ... the beauty of tennis, like the beauty of dance, is kinaesthetic.[12]

This, though, is not 'art for art's sake' as Simon Barnes, chief sports writer for *The Times*, pointed out in January 2011, defining the difference between being 'exquisite' and being an artist. For the aesthetic exquisite, art is the aim, but for the artist it is simply the method towards the creation of something that has depth, meaning and purpose. Federer may be the greatest shot maker, but he delivers 'substance as well as style, victory as well as beauty [and] for all his fancy skills, Federer is a real artist, 'solid, purposeful and passionate'.

The clichéd term 'living legend' has often been used to describe Roger Federer, but cliché notwithstanding, this modern 'legend' reworks an ancient pagan myth that was incorporated into Christianity. I first encountered myth as a child when I won a dancing competition, for which the prize was an illustrated book of Norse legends. There were the three Valkyries, all with magnificent thick hair down to their knees: the blonde Olrun robed in white; the brown-haired Alvit in mauve; and the raven-headed Hladgrun in red and orange. There were the Rhine maidens with the wicked goblin, Loki. There was Brunnhild on her flaming pyre; there was Odin, king of Valhalla, and his queen, Freya. And there was Baldur the Bright and Beautiful; a radiant youth in an embroidered tunic and magnificent blue cloak, with brown hair curling round his ears. Baldur's legend was tragic, for he was slain. Only if everyone in the whole world wept for him could he be resurrected – a symbolic version of the cycle of life and death.

Roger Federer re-enacts in secular terms the legend of Baldur the Beautiful, whose destiny was to die. Federer, superseded by newer stars, must sooner or later retire to his Valhalla in the Swiss mountains. His life as a transcendent performer is inevitably a short one. Some may object that a tennis player's career is a pedestrian and vulgar version of the beautiful Norse myth. But, as Proust understood, it is rather that the secret of an aesthetic vision of life that is also transcendent is to find the myth in the modern every day.

Writing of the early telephone service, Proust pointed out that it takes only a short time to strip the sacred forces with which we are in contact of their mystery.[13] Yet these modern inventions – to be able to speak to or even see someone who is far away – are miracles. For him the telephonists were Vigilant Virgins, guardian angels of the shadowy realms whose portals they guarded so zealously, Danaids of the invisible empowered with the ability to connect you to absent friends. They were thus agents of the miraculous, as powerful as any Arcadian goddess.

Believers rely on established and official myths to put them in touch with the miraculous. Secular individuals, perhaps more creative and resourceful, must surely be allowed the possibility of finding the marvellous in the everyday world, or as Charles Baudelaire put it, the eternal in the ephemeral.

17 Conclusion

Things, I reflected, are tougher than people. Things are the changeless mirror in which we watch ourselves disintegrate.

BRUCE CHATWIN, UTZ

Comfortable: A refuge; a nostalgia; the calm before or after.

JUDITH CLARK AND ADAM PHILLIPS

Fans, like fashion and fortune-telling, inhabit a disturbing inter-space between the material and the spiritual: they depend upon concrete aesthetic objects and experiences, but these are given an intense and ultimately even spiritual meaning. Billie Jean King's 'lucky' dress became more than just a dress; it was a talisman, a fetish object. Less dramatically, 'successful' garments – garments in which the wearer feels good, attracts positive attention, erotic or not, or achieves a success – have a special significance that goes beyond mere flaunting. The Japanese dress designer, Yohji Yamamoto, said that he wanted to design clothes that became as it were part of the wearer's personality, worn and worn until someone seeing a jacket, for example, hanging up, would say 'that is Tom' (the jacket's owner).[1] But for many, fashion, forgivable if it is just 'fun', becomes pretentious, absurd or sinister if loaded with too much meaning. The occult is mere superstition because it does not conform to the precepts, neither of the dominant world religions nor of reason, and is therefore also downgraded to the status of a joke. Fans are equally ridiculous because they value the wrong things. To take such obsessions seriously offends not only reason, but also a taken-for-granted moral and ethical system that divides the serious from the trivial in established ways.

There is another way of understanding material culture. The objects warehoused in the Victoria and Albert Museum Repository

198

had lost their meaning, becoming an accumulation of, at best, understudies for similar but more valuable or interesting articles on display in the museum itself. Merely sorted into categories, they bore little relation to one another. Only when objects are ordered and displayed and given a pattern, in a museum or a private house, do they acquire human meaning, a meaning acquired through their connexion with the relationships and narratives provided by their owners or curators, and by the audience for whom the displays, whether private or public, are intended.

Ian Woodward makes use of the 'object relations' theory of the psychoanalyst, Donald Winnicott, to explore a similar view. He rejects the pessimism of those writers, such as Jean Baudrillard,[2] who have seen only a form of false consciousness in the attachment to things. Woodward argues that human-object relations are crucial to the development of a sense of self. Winnicott, he says, suggests that 'object consumption is located in an emergent space bridging inner and outer worlds, human and non-human, that is "made" from play, invention and engagement with objects in ones environment'.[3] Objects may be largely perceived in contemporary society as commodities, yet can be 'decommodified through subjectification practices'; that is, by being given non-commodity meanings. Winnicott observed how the infant, in clinging to a piece of cloth, which might be its own shawl or might be part of its mother's discarded clothing, was negotiating the separation of self from mother. So, 'the magical element of everyday consumption is that the most banal, emptied-out, seemingly trivial thing can be a most powerful container of cultural values and ideologies'. The relationship of human with object creates a 'third space' in which creative transformation is possible. For Winnicott, and, following him, for Woodward, this is where the human imagination transforms the banal and brutally concrete into meaning. Ultimately, it is the search for the sacred object, 'for that which allows us to transcend the profane, everyday or prosaic'.[4]

In *The Comfort of Things,* Daniel Miller[5] acknowledges the ways in which engagement with objects is deeply meaningful, at once aesthetic and symbolic. He suggests that the inhabitants of cosmopolitan centres like London – those, at least, who live above the poverty line – have been freed by a relatively well-functioning

state and the loosening grip of common moral values, to create meaningful lives in any number of different ways, and that what he calls 'the comfort of things' is essential to this creation of meaning. Far from being 'materialistic', the significance and value given by individuals to objects and aesthetic practices is how they make sense of their lives, and how they cement their freely chosen relationships or heal themselves from damaging ones. Holiday souvenirs, a laptop, tattooing, a music collection, cherished clothes, resemble the found objects of the Surrealists, imbued by chance or memory over time with magical, even religious qualities. They come to contain the meaning of a life distilled to its essence.

Miller argues that these individual and personal talismans become especially potent in individualistic and fragmented societies such as exist in the West, except that he rejects the idea that they are fragmented. He concedes that the normative sociological idea of 'society' as cohesive and relatively homogenous may be outdated, but denies that contemporary 'post society' is anomic, that its citizens are isolated, or that the social fabric has lost all 'sense of purpose and order'. We do not live in a 'broken society'. For him, our lack of a common identity facilitates more varied forms of self-expression, but it is not individualism or a cult of the individual. It is rather that the search for and cultivation of fulfilling relationships has become more important than ever now that it is not restricted to family and kin, though these may (but may not) remain central.

Individual tastes of course reflect our socialisation, which includes class background, education and other variables, as well as our response to and reinterpretation of these. Nevertheless, the objects that individuals gather round them, and the practices, hobbies and entertainments they enjoy, are intimately connected to their own sense of identity and to the relationships they form and, perhaps particularly in the case of aesthetic objects, express these relationships, creating a life narrative.

Miller does not mention the work that goes into the production of material culture. One form that hostility to fashion takes is to denounce it for the often hideous work practices that go to its making. Victorian seamstresses, Lower East Side sweatshops and lock-in factories in Asia are rightfully attacked. That does not invalidate the skilled craft that invests well-made objects with meaning even

before they have found an owner. Material culture is about making – fashioning – as much as it is about owning and preserving.

Miller acknowledges that the freedom to live an aesthetic but also emotionally and spiritually meaningful life involves something of an amnesia towards the state structures that support it. We become aware of them 'only when they break down and disappoint our quite extraordinarily high expectations of them' (as when blaming the government for blizzards, volcanic eruptions and floods, or at least its inability to deal instantaneously with the inconvenience they cause): 'Politics is reduced to that which we blame for whatever and whoever lets us down.' The idea of allegiance to political party is lost: 'People do not need to believe in society; they may not even bother to vote and they may treat politics more as a spectator sport, on a par with football.'

This is a compelling defence of material culture, but there is a crucial caveat. Where an 'advanced' society breaks down, as happened after the end of the Soviet Union or during the Great Inflation of the Weimar Republic, the benign state of affairs described by Miller also breaks down, as families camp on the street trying to sell the precious objects they cherished so much and which gave their life such meaning. Even in less dramatically collapsing societies, political apathy extracts a price sooner or later, threatening the way of life citizens have come to take for granted. It is dangerous for a people to become politically apathetic, because they are then weak or even defenceless when their taken-for-granted way of life comes under attack.

In 2011, faced with a reign of austerity and the fragility, even the possible breakdown of the global economy, it is easy to fault Miller for not taking more seriously the perilous foundations of this personalised culture. Yet although he underplays the dangers of political apathy and of taking the welfare state for granted, he mounts a strong challenge to the Western suspicion of the aesthetic. He uses this term with hesitation: 'By choosing this term I don't mean anything technical or artistic, and certainly I hope nothing pretentious.' But why should 'aesthetic' equate with pretentious? In his uses of the word he simply hopes to convey 'something of the overall desire for harmony, order and balance that may be discerned in certain cases – and also dissonance, contradiction and irony in others'.

The very fact that our aesthetic choices reside in concrete objects and practices is what constitutes their seriousness. Dress is ritual; it is expressive of a stance in relation to the conduct of one's life (whatever that stance may be). The life of the hardcore fan is suffused with ritual. To explore the occult (admittedly a world full of fakery and deceit) is to protest against the normative constraints of what is considered reasonable and rational in modern society, just as the defiant behaviour of the post-war pervert, charted by Hornsey, was a protest against the behavioural norms of the 1950s, as well as against the rationalisation of the urban fabric and the utopian desire to eliminate every unplanned corner and forgotten cul-de-sac.

Daniel Miller's assessment of the ways in which individuals create meaning in their lives is an optimistic one. Ien Ang, in her 1985 study of fans of the TV soap opera, *Dallas*,[6] took a more melancholy view. She wrote of a 'tragic structure of feeling', which responds to the melodrama of the fiction that gripped the imagination of the audience. Fans responded to the soap because it was true to the way in which life 'is characterised by an endless fluctuation between happiness and unhappiness', tragic 'because of the idea that happiness can never last forever but, quite the contrary, is precarious'. This is close to Adorno's view of aesthetic experience as compensatory, as consolation.

Dallas is melodrama and for Ang melodrama is 'a form of the tragic ... for a world in which there is no longer a tenable idea of the sacred'. The tragic structure of feeling responds to melodrama because melodrama is not about great heroes or large-scale sufferings, but heightens and dignifies domestic, small-scale tragedies. 'There are no words for the ordinary pain of living of ordinary people in the modern welfare state, for the vague sense of loss', writes Ang. 'There is a material meaninglessness of everyday existence, in which routine and habit prevail in human relationships', but its fans valued *Dallas* because it took seriously the everyday tragedies and ups and downs of life, rescuing them from anomie and giving meaning to the previously meaningless. That is not to say that they were incapable of satirising the over-the-top quality of the wealthy setting and the exaggeration of situations. They enjoyed it ironically as well as with a straight face.

Daniel Miller and Ien Ang unite in challenging the 'comfort' of contemporary Western societies, or at least they challenge the common view that its popular cultural manifestations provide a kind of undemanding security blanket. 'Comfort' is a word with a lot of traction. It has expanded from its core meaning of a physical sensation of ease (a comfortable chair) and an earlier emotional meaning (he comforted the bereaved) of a response to loss, into its present meaning. 'I'm not comfortable with this' is euphemistic, since it can actually mean 'this greatly offends me' or 'I totally disagree', or can suggest moral unease. On the other hand, to 'be in one's comfort zone' implies that this is not a state to which one should aspire and implies disapproval of perceived laziness or moral cowardice.

Miller and Ang imply that the 'comfort' provided by modern welfare states has drawbacks. However, it is not necessary to be in favour of slashing welfare to understand how material comfort might inadvertently limit the imagination and become a brake rather than a springboard, might suffocate a sense of the sacred. Abercrombie's post-war plan for London, as interpreted by Hornsey, was just such a brake, its intention to limit behaviour that was judged subversive and dangerous to the utilitarian purposes of society. Abercrombie, one feels, would have had no time for Ang's 'tragic structure of feeling' and would have struggled to appreciate the camp irony of Federer's Credit Suisse celebrity.

The attack Stauth and Turner mounted on the melancholic intellectuals Adorno and Horkheimer strikes a similar note. Melancholy certainly implies a passivity in the face of life's brevity, boredom and often cruelty. Miller, on the other hand, affirms the strength in the way in which individuals find affirmation and self-expression. Nor is the aesthetic merely a decoration on the surface of life. The film *Trouble the Water,* directed by Karl Deal and Tia Lessin in 2008, told the story of an African American couple, Kimberley and Scott, caught in the New Orleans floods. They survived their life-threatening ordeal – and their already existing problems – partly by their determination that Kimberley should succeed as a rap artist. It was an artistic project that carried them through and at the same time expressed the political meaning of the New Orleans disaster when they documented it in a second artistic project, the film.

Both film and music were more than 'art for art's sake'. In fact, art is never just 'for art's sake'. Those who adopted the slogan in the nineteenth century meant that art did not need moral justification, not that it had any other meaning than beauty. Art always reaches beyond itself.

There is, also, more than 'comfort' in 'things'. The value system that finds manliness in stoicism, but only frivolity and 'feminine' weak-mindedness in fashion, beauty and fandom, is flawed, unbalanced and one-sided. Yet this suspicion of the aesthetic remains embedded in popular culture. At the conclusion of John le Carré's *Tinker, Tailor, Soldier, Spy*, the traitor states that he chose the Soviet Union for 'aesthetic' reasons: 'The West has become so ugly' – a remark full of irony, given the ugliness of the USSR at the time. But le Carré here endorses an enduring misconception: that the aesthetic is somehow the antithesis of moral virtue. The traitor is a traitor *because* he values beauty (as he sees it) over and above – and against – patriotism, loyalty and truthfulness. This begs the question of why 'the aesthetic' should be posed as the opposite of moral values.

The 'postmodern' enthusiasm for mass culture, represented by Stauth and Turner, was equally flawed. It claimed to defend mass culture on the grounds that popular forms gave a voice to minorities and demoted the allegedly oppressive dominance of the 'white western male' traditional culture, but often seemed to defend mass culture simply because it was popular, capitulating to the tyranny of the majority.

My selective explorations of – mostly – popular cultural forms and practices defends them for a different reason: that they speak a longing for beauty that is at the same time a search for meaning and transcendence. They mount a challenge to the overwhelmingly utilitarian values that dominate contemporary society, proclaiming that there is more to life than 'value for money' or the growth of the economy (even if paradoxically they partly depend on this). Finally, it is poignant to look at the perfectly preserved gown of a woman that died 200 years ago, or at a vase carefully fashioned 2,000 years before we were born, or at a DVD of Federer's greatest match. These remind us as much as any religious sermon of the transience of life, yet more than any sermon a defence of life's value.

Epilogue: Danse

A Japanese dancer from the Sankai Juki group dances with a peacock. His whole body is very white, powdered with chalk, and his head is shaven, all he wears is a loincloth of ecru muslin tied round his waist. He steps out in front of a wooden panel on which have been fixed varnished fish tails, monstrous cetaceous fins. He enlaces the peacock like a woman fainting, and the fabric of his loincloth unwinds, elongating in a train seeded with gold, one sees how the peacock has muscled feet and legs, like those of an ostrich, but the dancer keeps them bent, and immobilised in his left hand, held against his thighs, while with his right hand he stretches and encircles the peacock's neck, playing on it like a very delicate instrument, but gripping it tightly so as almost to strangle it, everything depends on a few brief contractions, on a rush of blood that he must feel and control against his palm: the Japanese dancer dances with the peacock a sort of slow motion tango, he dances with the fear of the peacock, with the bird's vivid fear of death. It is an unbelievable moment of great tension and great beauty. But, when the dancer releases the maddened bird you no longer know where to look, the eye oscillates between the man and the bird: and now the peacock is only a great frightened fowl that pecks stupidly and gets entangled in the cord that binds his feet; and the dancer is only a dancer making slow gestures. The fascination has dissolved and in disappointment you prefer to look at the empty space between the two figures where the magic was produced. That is where there lurks a possible photograph.

When the Sankai Juki group came to Paris many people, especially photographers, flocked to the spectacle, their cameras

205

at the ready, having secured front row positions where they awaited the appearance of the peacock. They fired their shots, let loose their volleys – the click of the cameras – they were confident of the beauty. And yet they could not capture this image eminently suited to photography (what is it that escapes photography here, apart from the tiny contractions of the peacock's neck, which were in fact the essential feature of the dance?): it belonged to the dancer, and he had decided that it would be a dance and not a photograph, and one was reminded that beauty, like the theatrical spectacle, is linked to the ephemeral, and to loss, that it cannot be captured and recorded. But I would just like it if photographers put more of the dance into their images (or of the theatre of the cinema) in the way that the dancer put photography into his dance.

Hervé Guibert, 'Danse', from *L'Image Phantôme*[1]
Reproduced by permission of Éditions de Minuit, Paris.

Notes

Chapter 1: Introduction

1. Furedi, Frank, *Where Have All the Intellectuals Gone?* (London: Continuum, 2004).
2. Breward, Christopher, 'Cultures, Identities, Histories: Fashioning a Cultural Approach to Dress', *Fashion Theory*, Volume 2, Issue 4, 'Methodology Special Issue', December 1998, p.301.
3. Fiske, John, *Understanding Popular Culture* (London: Routledge, 1987), p.130.
4. Furedi, Frank, *Where Have All the Intellectuals Gone?*, p.63.
5. 'The Death of Cultural Criticism', the New Review section, *Observer*, 30 January 2011, pp.9–11.
6. Calloway, Stephen and Lynn Federle Orr (eds), *The Cult of Beauty: The Aesthetic Movement 1860–1900* (London: V&A Publications, 2011), provides an extensive overview of the Aesthetic Movement.
7. Mitchell, Rebecca N., 'Acute Chinamania: Pathologising Aesthetic Dress', *Fashion Theory*, Volume 14, Issue 1, March 2010, pp.45–64.
8. Pater, Walter, *The Renaissance: Studies in Art and Poetry* (Mineola, NY: Dover Publications Inc, 2005 [1873]) pp.83, 154.

Chapter 2: Pleasure's Dangers

1. Schwarzkopf, Stefan, 'The Political Theology of Consumer Sovereignty: Towards an Ontology of Consumer Society', *Theory Culture and Society*, Volume 28, Number 3, May 2011, pp.106–129.
2. Lucretius, *On the Nature of the Universe* (London: Penguin Books, 1994), trans. R. E. Lathem, p.40.

3. Cooper, David E. (ed.), *Aesthetics: The Classic Readings*, Plato, 'The Republic' (Oxford: Wiley-Blackwell, 1997), p.103.

4. Lukacs, Georg, 'Lenin: Theoretician of Practice', available at: http://www.marxists.org/archive/lukacs/works/xxxx/lenin.htm, accessed 21st April 2010.

5. Quoted in Wendy Steiner, *Venus In Exile: The Rejection of Beauty in Twentieth Century Art* (New York: Free Press, 2011), p.42.

6. Ferguson, Harvie, *Melancholy and the Critique of Modernity: Sören Kierkegaard's Religious Psychology* (London: Routledge, 1995).

7. Holmes, Richard, *The Age of Wonder: How the Romantic Generation Discovered the Beauty and Terror of Science* (London: Harper Press, 2008), p.92.

8. Ferguson, Harvie, *Melancholy and the Critique of Modernity: Sören Kierkegaard's Religious Psychology*, p.84.

9. For an account of this see Frances Stonor Saunders, *Who Paid the Piper? The CIA and the Cultural Cold War* (London: Granta, 1999).

10. Barthes, Roland, 'Le Plaisir du Texte', *Oeuvres Complètes*, Volume 2, 1966–73 (Paris: Éditions du Seuil, 1994), pp.1495–1529.

11. Ang, Ien, 'Feminist desire and Female Pleasure: On Janice Radway's *Reading the Romance*', in Ien Ang, *Living Room Wars: Rethinking Media Audiences for a Postmodern World* (London: Routledge, 1996), pp.103, 104.

12. Pearson, Roberta, 'Bachies, Trekkies and Sherlockians', in Jonathan Gray, Cornel Sandvoss and C. Lee Harrington (eds), *Fandom: Identities and Communities in a Mediated World* (New York: New York University Press, 2007), p.107.

13. Beaudouin, Tom, 'The Ethics of Research in Faith and Culture: Scholarship as Fandom?', in Christopher Deacy and Elizabeth Arweck (eds), *Exploring Religion and the Secred in a Media Age* (Burlington, Vermont: Ashgate Books, 2009), p.35.

Chapter 3: Looking Backwards: Nostalgia Mode

1. The 'coda' to 'looking backward: Nostalgia Mode' appeared in an earlier version as 'Nostalgia Mode', *The Measure*, Louise Clarke, (ed.) (London: London College of Fashion, 2007).

2. Natali, Marcos Piason, 'History and the Politics of Nostalgia', *Iowa Journal of Cultural Studies*, 2007.

3. Lowenthal, David, 'Nostalgia tells it like it wasn't', in Christopher Shaw and Malcolm Chase (eds), *The Imagined Past: History and*

Nostalgia (Manchester: Manchester University Press, 1989), p.20. See also David Lowenthal, *The Past is a Foreign Country* (Cambridge: Cambridge University Press, 1985).

4. Stauth, Georg and Bryan Turner, 'Nostalgia, Postmodernism and the Critique of Mass Culture', *Theory Culture and Society*, Volume 5, Numbers 2–3, June 1988, Special Issue on Postmodernism, pp.509, 520.

5. Huyssen, Andreas, *Present Pasts: Urban Palimpsets and the Politics of Memory* (Stanford: Stanford University Press, 2003), p.5.

6. Hutcheon, Linda, 'Irony, Nostalgia and the Postmodern', available at: http://www.library.utoronto.ca/utel/criticism/hutchinp.html, accessed 2 November 2010.

7. Louis Aragon, *Paris Peasant* (London: Picador, 1971), p.29. Trans. Simon Watson Taylor,

8. Boym, Svetlana, *The Future of Nostalgia* (New York: Basic Books, 2001), p.55.

9. Boym, Svetlana, *The Future of Nostalgia*, p.49.

10. Laura Miller, *The Magician's Book: A Sceptic's Adventures in Narnia* (NY: Little Brown and Company, 2008), p.3.

11. Claude Lévi-Strauss, 'New York in 1941', in Claude Lévi-Strauss, *The View from Afar*, (Harmondsworth: Penguin Books, 1987). Trans. Joachim Neugroschel and Phoebe Hoss.

Chapter 4: Magic Fashion

1. An earlier version of 'Magic Fashion' appeared in *Fashion Theory*.

2. Richard Martin, *Fashion and Surrealism* (London: Thames and Hudson, 1988), pp.14–15.

3. Foster, Hal, *Compulsive Beauty* (Cambridge, Ma: MIT Press, 1993), pp.xvii, 7.

4. de Beauvoir, Simone, *The Second Sex* (London: Jonathan Cape, 1953), p.512. Trans. H. M. Parshley.

5. Benjamin, Walter, *The Arcades Project* (Cambridge, Ma: Harvard University Press, 1999).

6. Quoted in Ulrich Lehmann, *Tigersprung: Fashion in Modernity* (Cambridge, Ma: MIT Press, 2000), p.40.

7. Martin, op. cit., p.9.

8. Lomas, David, *The Haunted Self: Surrealism, Psychoanalysis, Subjectivity* (New Haven: Yale University Press, 2000), p.70, quoting Charles Baudelaire, 'Le Voyage'.

9. At the All England Lawn Tennis Club Museum it is a conservation issue whether or not to wash the garments of former champions. Some argue that the bodily secretions of the athlete are part of the garment or its meaning and should be preserved.

10. Benjamin, Walter, *Charles Baudelaire: A Lyric Poet in the Era of High Capitalism* (London: Verso, 1973), p.166.

11. See Keith Thomas, *Religion and the Decline of Magic* (Harmondsworth: Penguin Books, 1971).

12. This is an extremely abbreviated summary of the work of William Pietz, 'The Problem of the Fetish 1', *Res*, 9, Spring 1985, pp.12–36; 'The Problem of the Fetish 2: The Origin of the Fetish', *Res*, 13, Spring 1987, pp.23–47; and 'The Problem of the Fetish 3: Bosman's Guinea and the Enlightenment Theory of Fetishism', *Res* 16, Autumn 1988, pp.105–124.

13. Quoted in Jennifer Mundy (ed.), *Surrealism: Desire Unbound* (London: Tate Publishing, 2001), p.41.

14. Adorno, Theodor, *The Stars Look Down* (London: Verso, 1999), p.116.

15. Cf., Caroline Evans, 'Masks, Mirrors and Mannequins: Elsa Schiaparelli and the Decentred Subject', *Fashion Theory*, Volume 3, Issue 1, March 1999, pp.3–32.

16. Baudrillard, Jean, *Seduction* (Montreal: New World Perspectives, 1990).

Chapter 5: Glamour: The Secret Behind the Sheen

1. An earlier version of 'Glamour: The Secret Behind the Sheen' appeared in *Fashion Theory*.

2. Walden, George, *Who is a Dandy?* (London: Gibson Square Books, 2005).

3. Milly Williamson, *The Lure of the Vampire Gender, Fiction and Fandom from Bram Stoker to Buffy* (London: Wallflower Press, 2005).

4. When I researched the word in the British Library catalogue, the majority of titles I accessed were of books of female models posing in semi-undress; these dated mostly from the 1940s and 1950s.

5. Postrel, Virginia, 'A Golden World', in Joseph Rosa, Phil Patton, Virginia Postrel and Valerie Steele (eds), *Glamour: Fashion + Industrial Design + Architecture* (New Haven: Yale University Press, 2005), p.24.

6. Warwick, Alexander and Dani Cavallaro, *Fashioning the Frame: Boundaries, Dress and the Body* (Oxford: Berg, 1998), pp.xvii, xvi.

7. Arnold, Rebecca, *Fashion, Desire and Anxiety: Image and Morality in the Twentieth Century* (London: I.B.Tauris, 2001), p.125.

Chapter 6: Dressed to Kill

1. 'Dressed to Kill' previously appeared in Marketa Uhlirova (ed.) *If Looks Could Kill: Cinema's Images of Fashion, Crime and Violence* (London: Koenig Books, 2008).
2. Light, Alison, *Forever England: Femininity, Literature and Conservatism Between the Wars* (London: Routledge, 1991), p.95.

Chapter 7: Camouflage and its Vicissitudes

1. 'The Vicissitudes of Camouflage' previously appeared in *Fashion Theory*, Volume 12, Number 2, June 2008, Special Issue, 'Fashion Curation', edited by Alistair O'Neill, pp.277–283.
2. Pine, Julia, 'Exhibition Review: Camouflage', *Fashion Theory*, Volume 15, Issue 3, September 2011, p.385.
3. Proust, Marcel, *In Search of Lost Time*, 'Finding Time Again' (London: Penguin, 2002), p.30.

Chapter 8: Fashion and Memory

1. Quoted in Sung Bok Kim, 'Is Fashion Art?', *Fashion Theory*, Volume 2, Issue 1, March 1998, p.52.
2. Quoted in Sung Bok Kim, 'Is Fashion Art?', p.55.
3. Gill, Alison, 'Deconstruction Fashion', *Fashion Theory*, Volume 2, Issue 1, March 1998, pp.25–50.
4. Walter Benjamin, writing many years before Andy Warhol did precisely that, 'A Small History of Photography', *One Way Street* (London: Verso, 1979), p.255.
5. Benjamin, Walter, 'A Small History of Photography', p.243.

Chapter 9: Urbane Fashion

1. Hunt, Lynn, 'Introduction: Obscenity and the Origins of Modernity, 1500–1800', in Lynn Hunt (ed.), *The Invention of Pornography* (New York: Zone Books, 1993), pp.3, 38.

2. Sinclair, Iain, *Hackney: That Rose Red Empire* (London: Penguin Books, 2010).

3. Baker, Phil, 'Secret City: Psychogeography and the End of London', in Joe Kerr and Andrew Gibson (eds), *London From Punk to Blair* (London: Reaktion Books Ltd, 2003), p.323.

4. Hill, Andrew, 'People Dress so Badly Nowadays: Fashion and Late Modernity', in Christopher Breward and Caroline Evans (eds), *Fashion and Modernity* (Oxford: Berg, 2005), pp.67–78.

5. Segre Reinach, Simona, 'China and Italy: Fast Fashion versus *Prêt à Porter*. Towards a New Culture of Fashion', *Fashion Theory*, Volume 9, Issue 1, March 2005, pp.43–56.

Chapter 10: Austerity in Retrospect: The Glamour of Masochism

1. An earlier version of 'Austerity in Retrospect: The Glamour of Masochism' appeared in *AA Files No 57*.

2. Esher, Lionel, *A Broken Wave: The Rebuilding of England, 1940–1980* (London: Penguin, 1983), p.54.

3. Quoted in Elizabeth Wilson, *Only Halfway to Paradise: Women in Postwar Britain, 1945–1968* (London: Tavistock, 1980), p.46.

4. See, in particular, Steve Fielding, 'Don't Know and Don't Care: Popular Political Attitudes in Labour's Britain, 1945–1951', in N. Tiratsoo (ed.), *The Atlee Years* (London: Pinter Publishers, 1991), pp.106–125.

5. Thomas, Donald, *An Underworld at War: Spivs, Deserters, Racketeers and Civilians in the Second World War* (London: John Murray, 2003), p.390.

6. See Patrick Marnham, *Wild Mary: The Life of Mary Wesley* (London: Chatto and Windus, 2006); and Mary Wesley's series of bestselling war novels, beginning with *The Camomile Lawn*.

Chapter 11: Post-war Perverts

1. An earlier version of 'Post-war Perverts' appeared in *AA Files No 61*.

2. See Judith Clark and Adam Phillips, *The Concise Dictionary of Dress* (London: Violette Limited, 2010).

3. Hornsey, Richard, *The Spiv and the Architect: Unruly Life in Postwar London* (Minneapolis: University of Minnesota Press, 2010). See also Frank Mort, *Capital Affairs* (New Haven: Yale University Press, 2010).

4. Hornsey, Richard, *The Spiv and the Architect: Unruly Life in Postwar London*, p.55, quoting 'The Exhibition as a Town Builder's Pattern Book', *Architectural Review* 110, August 1951, p.108.
5. Newsom, John, *The Education of Girls* (London: Faber and Faber, 1948), p.103.

Chapter 13: Modern Magic

1. 'Modern Magic' previously appeared in *Journal of Consumer Culture*.
2. During, Michael, *Modern Enchantments: The Cultural Power of Secular Magic* (London: Routledge, 2002), pp.48, 54–56.
3. During, Michael, *Modern Enchantments: The Cultural Power of Secular Magic*, p.66.

Chapter 15: Secret Worlds

1. Lewis, C. S., *Surpised by Joy, The Shape of My Early Life* (London: Geoffrey Bles, 1955).
2. McLennan, Gregor, 'The Posstsecular Turn', *Theory Culture and Society*, Volume 27, Number 4, July 2010, p.10.
3. Rose, Phyllis, *The Year of Reading Proust: A Memoir in Real Time* (London: Vintage, 1998), p.19
4. Proust, Marcel, *In Search of Lost Time*, Volume I, 'The Way by Swann's' (London: Penguin Books, 2002), p.47.
5. de Botton, Alain, *How Proust Can Change Your Life* (London: Picador, 1997).
6. Painter, George, *Marcel Proust: A Biography*, Volume 2 (London: Chatto and Windus, 1965), p.269.
7. Tadié, Jean-Yves, *Marcel Proust: A Life* (London: Penguin Books, 2000), p.66–70. Trans. Euan Cameron.
8. Albaret, Céleste, *Monsieur Proust: Souvenirs Recueillis par Georges Belmont* (Paris: Robert Laffont, 1973), p.337.
9. See also Esther Élionore Haldimann, 'Cabourg's Grand Hotel, in the footsteps of Marvel Proust', CI Commerce International, available at: http://www.actu-cci.com/?pg=mag_article&id_m_a=3076&ver=en, accessed 29 October 2009.
10. Foschini, Lorenzo, *Proust's Overcoat* (London: Portobello Books, 2010).
11. Benjamin, Walter, 'The Image of Proust', *Illuminations* (London: Pimlico, 1999), p.199.

12. Boyt, Susie, *My Judy Garland Life* (London: Virago, 2008), p.111.

Chapter 16: Temporary Gods

1. This was Vere Thomas St Leger Gould, beaten Wimbledon finalist in 1879, who was later convicted in France with his wife of the murder of Emma Levin, and died in prison on Devil's Island.
2. Jenkins, Henry, 'Afterword: The Future of Fandom', in Jonathan Gray, Cornel Sandvoss and C. Lee Harrington (eds), *Fandom: Identities and Communities in a Mediated World* (NY: New York: University Press, 2007), p.364.
3. Chancellor, Alexander, *Guardian*, G2, 16 November 2011.
4. Huizinga, Jan, *Homo Ludens* (London: Temple Smith, 1970), p.46.
5. Humphreys, Joe, *Foul Play: What's Wrong with Sport?* (Cambridge: Icon Books, 2008), p.188.
6. 'Global Hingis', in David L. Andrews and Steven J. Jackson (eds), *Sports Stars: The Politics of Sporting Celebrity* (London: Routledge, 2001), pp.201–17.
7. René Stauffer, *The Roger Federer Story: Quest for Perfection* (New Chapter Press).
8. Bodo, Pete, available at: www.tennis.com, accessed September 2009.
9. Andrews, David L. and Steven J. Jackson (eds), op cit.
10. Lynn Barber wrote a highly unflattering account of her interview with Nadal, questioning many of the clichés normally used to describe him; Lynn Barber, 'Anyone for Tension?', *Sunday Times*, Magazine, 5 June 2011, pp.14–20.
11. *Guardian*, Sports Section, 22 September 2011.
12. Thompson, Calvin, 'Beauty on the Grass', *New Yorker*, 20 June 2010, p.37.
13. Proust, Marcel, *le Coté de Guermantes I* (Paris: Gallimard Folio, 1988), p.125.

Chapter 17: Conclusion

1. In the Wim Wenders film, *Notebook about Cities and Clothes* (1989).
2. For example, in Jean Baudrillard, *The System of Objects* (London: Verso, 1996 [1968]). Trans. J. Benedict.
3. Woodward, Ian, 'Towards an object-relations theory of consumerism: The aesthetics of desire and the unfolding materiality of social life',

Journal of Consumer Culture, Volume 11, Number 3, November 2011, p.168.

4. Woodward, Ian, 'Towards an object-relations theory of consumerism: The aesthetics of desire and the unfolding materiality of social life', p.377.

5. Daniel Miller, *The Comfort of Things* (Cambridge: Polity Press, 2008).

6. Ien Ang, *Dallas: Soap Opera and the Melodramatic Imagination* (London: Methuen, 1985).

Epilogue: Danse

1. Guibert, Hervé, 'Danse', *L'Image Phantôme* (Paris: Éditions de Minuit, 1981). Trans. Elizabeth Wilson.

Index